The Razing of Romania's Past

The Razing of Romania's Past was sponsored by the Kress Foundation European Preservation Program of the World Monuments Fund; it was published by US/ICOMOS.

The World Monuments Fund is a U.S. nonprofit organization based in New York City whose purpose is to preserve the cultural heritage of mankind through administration of field restoration programs, technical studies, advocacy and public education worldwide.
World Monuments Fund, 174 East 80th Street, New York, N.Y. 10021. (212) 517-9367.

The Samuel H. Kress Foundation is a U.S. private foundation based in New York City which concentrates its resources on the support of education and training in art history, advanced training in conservation and historic preservation in Western Europe.
The Samuel H. Kress Foundation, 174 East 80th Street, N.Y. 10021. (212) 861-4993.

The United States Committee of the International Council on Monuments and Sites (US/ICOMOS) is one of 60 national committees of ICOMOS forming a worldwide alliance for the study and conservation of historic buildings, districts and sites. It is an international, nongovernmental institution which serves as the focus of international cultural resources exchange in the United States.
US/ICOMOS, 1600 H Street, N.W., Washington, D.C., 20006. (202) 842-1866.

The text and materials assembled by Dinu C. Giurescu reflect the views of the author as supported by his independent research.

Book design by DR Pollard and Associates, Inc.
Jacket design by John T. Engeman.
Printed by J.D. Lucas Printing Company, Baltimore, Md.

93 92 91 90 89 5 4 3 2 1

Library of Congress Cataloging-in-Publication Data

Giurescu, Dinu C.
 The razing of Romania's past.

 "A Project of the Kress Foundation European
Preservation Program of the World Monuments Fund."
 1. Architecture—Romania—Mutilation, defacement, etc.
2. Architecture—Romania—Conservation and restoration.
3. Architecture and state—Romania. 4. Urban renewal—
Romania. I. Title.
NA1421.G58 1989 702'.8498 89-4965
ISBN 0-911697-04-7

Distributed by The Preservation Press
National Trust for Historic Preservation
1785 Massachusetts Avenue, N.W.
Washington, D.C. 20036
(202) 673-4058

THE RAZING OF ROMANIA'S PAST

DINU C. GIURESCU

A Project of the Kress Foundation European Preservation Program
of the World Monuments Fund

World Monuments Fund
New York, N.Y.

US/ICOMOS
United States Committee
International Council on Monuments and Sites
Washington, D.C.

DEDICATION

To the memory of my parents
Professor CONSTANTIN C. GIURESCU
and MARIA SIMONA GIURESCU

Frontispiece:
The area around Banu Maracine
and Negru Voda streets.

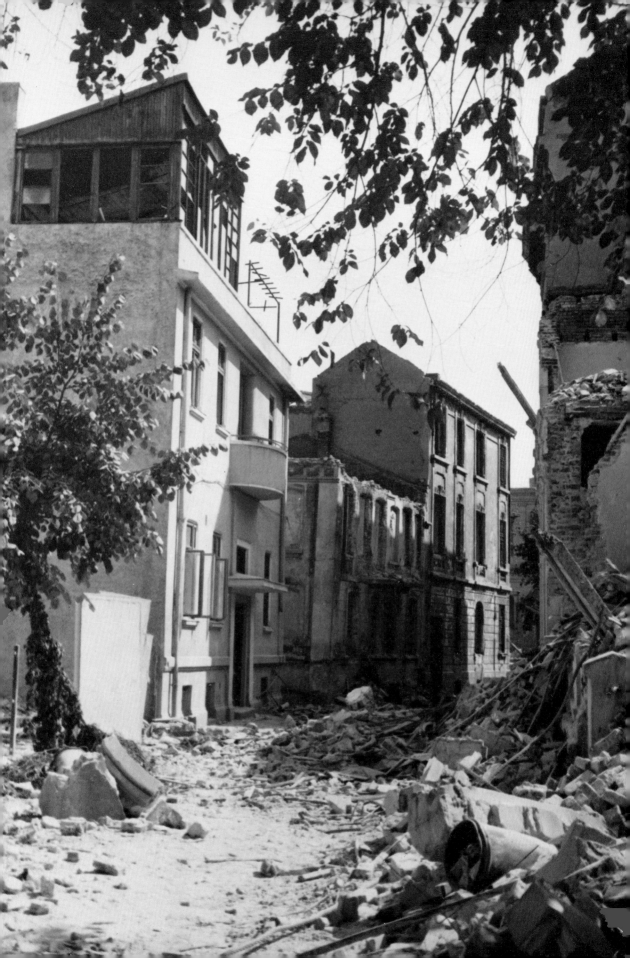

TABLE OF CONTENTS

ACKNOWLEDGMENTS

I wish to express my deep gratitude to Bonnie Burnham, Executive Director of the WORLD MONUMENTS FUND, and to Marilyn Perry, President of the SAMUEL H. KRESS FOUNDATION, for commissioning this study, for their dedication and commitment to the preservation of the architectural heritage and for their constant support in my task.

Heartfelt thanks to Rebecca Anderson, Program Administrator of the WORLD MONUMENTS FUND, for her assistance throughout the various phases of this work. I would also like to express my gratitude to Terry B. Morton and Ellen Delage, President and Program Officer respectively, of the United States Committee, International Council on Monuments and Sites (US/ICOMOS), for their guidance in seeing this study through to publication.

I wish to express my appreciation to the librarians of the following institutions for their unfailing and courteous assistance: the Library of Congress, Washington, D.C.; Avery Library, Columbia University; New York Public Library; and the Library of the School of Law, New York University, the latter three of New York City.

The responsibility for the selection of the materials and photographs and the treatment of the topics is entirely my own.

Dinu C. Giurescu, Ph.D.
Professor of History
New York, N.Y. September 7, 1988

INTRODUCTION

*A*s witnesses of human civilization, monuments and sites contribute to the strengthening of the historical awareness and cultural identity of individuals and communities. Monuments and sites are of local, national and international importance as an expression of culture and lifestyle, as a significant part of world heritage. Therefore, it is the responsibility of all people to ensure protection and preservation of monuments and sites at all levels at all times.

<div align="right">

The Declaration of Rostock-Dresden
7th ICOMOS General Assembly, May 12–18, 1984
Rostock and Dresden, German Democratic Republic

</div>

The city of Bucharest has long been known as one of the pearls of Europe—a graceful city whose character was defined by its mixture of architectural styles, from Byzantine and classical Renaissance to 19th-century Belle Epoque apartment blocks with wrought iron balcony rails. Beyond the capital, too, towns and villages throughout the country conserve a broad range of international, local and ethnic styles that contribute to the rich variety of Romania's historic architecture. This architectural heritage, an irrefutable reflection of the multifaceted history of the Romanian people, is today being destroyed by the country's own government in an attempt to homogenize the national cultural experience and to eliminate the history of the nation.

Participation in cultural life is a human right. This right also includes the enjoyment and educational benefits of monuments and sites.

During the past six years large areas of old Bucharest have been destroyed almost in their entirety and rebuilt. In the reconstructed areas, a few historic monuments have been spared, encased in concrete blocks of apartments and often screened from the street. Simultaneously approximately 30 towns throughout the country have been razed and rebuilt according to new principles enacted by decree. Thousands of villages and scores of towns are scheduled to follow the same fate.

National and international policies should be directed not only at the material factors of welfare. These policies should also be directed at the preservation and protection of monuments and sites which make specific and significant contributions to the quality of life as a whole.

The Romanian government has stated openly and for the record that the entire rural population of the country, including Romanians, ethnic Hungarians, Germans and Serbians, will be resettled in order to eliminate the differences between the urban and rural standards of living. Families will be relocated from their modest sin-

gle-family, privately owned houses to poorly equipped apartment buildings as state tenants. The rural resettlement process is already underway, from the rural areas surrounding Bucharest to the foothills of Transylvania, erasing an intricate history of ethnic identities.

The international community has in the past lamented the loss of great works of art, important monuments and historic urban centers destroyed by wars and human neglect. We have questioned the bombing of Dresden, wept over the explosions that have leveled Beirut, voiced our concern about the fate of Angkor Wat. But never in our century has a human agency put into action a blatant and conscious peacetime program for the willful destruction of the artistic heritage of an entire nation, such as we now witness in Romania. To this momentous threat the international community must respond and convert outrage into tangible action.

We hope this International Preservation Report will provide a catalyst to the movement already underway to protest the government-sanctioned assault on the architectural heritage of Romania and the citizens of Romania. The architectural heritage and cultural traditions of a nation are not negotiable.

Marilyn Perry
President
The Samuel H. Kress Foundation

Bonnie Burnham
Executive Director
World Monuments Fund

Terry B. Morton
President
US/ICOMOS

FOREWORD

At this writing the architectural urban fabric of at least 29 Romanian towns has been 85–90 percent demolished and replaced by apartment buildings with a completely different urban character. Large scale demolitions are underway in an additional 37 towns.

Since 1984 vast areas of central Bucharest, the capital city, have been leveled and rebuilt along patterns with no connection to the past. A few listed historic monuments and other buildings have been integrated with or screened off by these new structures. Around the year 2000, a whole nation will live in towns in which almost nothing will remain from the country's history and its traditional civilization.

At the same time an overall rural restructuring plan has been put in motion: 7,000–8,000 villages out of 13,123 will disappear and the others will be reconstructed with the one-family, privately owned house replaced by the collective tenement apartment. The process has already started around Bucharest and in other areas.

The Romanian nation in its entirety—the Hungarian, German and Serbian minorities who have lived beside the Romanians for centuries—will therefore be uprooted from its own urban and rural heritage, from its own history and identity.

The present study is an attempt to analyze the different phases that in the last 20 years have resulted in this nationwide destruction and reconstruction. This calamity is the result of an effort to implement, through state authority and decrees, a social engineering feat never before accomplished in European history.

Dinu C. Giurescu

ABBREVIATIONS

A.—Arhitectura, a bimonthly journal published in Bucharest by the Romanian Union of Architects; each reference includes the following: volume, number, year, pages, English summary or title (if translated), as for example *A.,* XVII, 6 (121), 1969, pp. 58–59 (English summary, p. 5), see note 3.

Arch.—Architect

Monuments Bulletin—Buletinul Monumentelor Istorice (The Historic Monuments Bulletin), Bucharest, Romania; each reference includes the volume, number, year and pages, as for example *Monuments Bulletin,* XLII, 3/1973, pp. 54–58.

Monuments Review—Revista muzeelor si monumentelor. Monumente istorice si de arta (The Museums and Monuments Review. Historical and Art Monuments), a biannual journal issued since 1975 in Bucharest and continuing the former *Buletinul Monumentelor Istorice* (see above). Each reference includes the volume, number, year and pages, e.g., *Monuments Review,* XLV, 2, 1976, pp. 47–51.

Buletinul Oficial al Republicii Socialiste Romania (Official Bulletin of the Romanian Socialist Republic), Bucharest, Romania; each reference includes the volume, number, date and pages, e.g., XI, 15, part I, January 23, 1975, pp. 1–5.

Opris, *Heritage*—Ioan Opris, *Ocrotirea patrimoniului cultural. Traditii, destin, valoare (The Preservation of the Cultural Heritage. Traditions, destiny, value),* Editura Meridiane Bucuresti, 1986, 243 pages, (English summary, pp. 211–213.)

Whenever an *English summary* or *English title* is mentioned, translations done by the Review *Arhitectura* are reproduced. Otherwise the title translations have been made by Dinu C. Giurescu.

THE URBAN ARCHITECTURAL HERITAGE

THE URBAN ARCHITECTURAL HERITAGE

Planning an overall urban and rural reconstruction.

In September 1985 it was officially stated that by 1990, 90–95 percent of Bucharest's inhabitants would live in new apartment buildings, thus providing a model for other Romanian towns(1). It was simultaneously announced that the reconstruction of the villages must be completed within the next 15 years(2). Figures released in March and June 1988 project the disappearance of approximately 900 communes, out of 2,705, and a reduction in the number of villages, from the present level of 13,123, to a maximum of 5,000–6,000. A commune is an administrative unit composed of several separate villages. A village where the town hall and other institutions are located has the rank of commune, whereas the others in the unit remain villages. Time-limit: the year 2000(3). Thus, approximately 7,000–8,000 rural centers will vanish from Romania's map and the remaining ones will be approximately 90–95 percent demolished and reconstructed. This is the outcome of a process which started in the postwar years.

Industrialization and urban expansion.

Romania's industrialization began in 1949–1950; it developed at a rapid pace with people streaming from the countryside into the cities. The urban population rose from 3,486,995 in 1948, 22.0 percent of the total, to 5,667,559 in 1965, 29.8 percent of the total and to 11,540,494 in 1985, 50.6 percent(4).

In the late 50's and in the 60's the Romanian communist party and state leadership launched an extensive housing program in order to meet the pressing demands of the new town dwellers. For 15 years, 1955–1970, these apartments extended into the outskirts, built on open fields, in run-down suburban areas and along ring-boule-

2

vards and main roads into cities. Proximity to recently built industrial units and better housing opportunities were the main criteria for urban reconstruction in Bucharest(5) and other centers.

In this first phase, up to the early 70's, it is fair to assume that the historic centers were generally not affected. The first major demolition of traditional architecture took place in Suceava(6), capital city of the state of Moldavia in the 14th–16th centuries; Pitesti(7); Vaslui(8); Giurgiu(9); and Tirgoviste.

Romania's traditional urban architecture.

Sixty-eight towns are documented on Romania's territory between the end of the 10th and the middle of the 15th century. New ones emerged after 1700 and 1800. The one-family house was the basic unit for both the Romanian urban and rural setting. In the central urban zones, along with stores and workshops, the houses were close to one another. In other areas, the dwellings emerged amidst trees, bushes and multicolored flowers expressing the link between the human and the natural environment. This is why travelers from Western Europe viewed Romanian towns as big villages. Churches, monastic complexes, princely and noble residences, all constructed of masonry, formed points and centers of interest in the overall urban image(10); other buildings were made of inexpensive construction materials.

The states of Wallachia and Moldavia were founded at the beginning and the middle of the 14th century: Wallachia between the Southern Carpathians, the Danube River and the Black Sea; and Moldavia from the Eastern Carpathians to the Danube River, the Dniester River (Nistru) and the Black Sea. The two states were autonomous political bodies within the Ottoman Empire's area of dominance. They were united in 1859–1861 into the modern Romanian state. From the Middle Ages to 1800 the urban population was composed of up to 10 percent of the overall population of the two Romanian states. Unprotected by walls, the towns of Wallachia and Moldavia stretched into the nearby farming land and settlements as their populations increased. The first modern principles of urbanization were implemented in the last decades of the 18th century.

The gradual building up of the modern Romanian society and state(11) brought about extensive town renewal, too. The old dwellings were 80–85 percent replaced by one-family brick houses, in a variety of styles aligned to the European trends and favored by younger generations of owners. Neoclassical, neo-Gothic, eclectic, Art Nouveau, neo-Romanian at the end of the 19th century, and a few old styles prior to 1800–1830 were all included in the urban architecture.

The one-family house and its garden continued to form the basic unit of this large-scale reconstruction and represented a link with the pre-modern town. A second trait of continuity was the street network, which in its chief components remained much the same, though a number of streets disappeared and new ones were opened (for example, the north-south and east-west boulevards in Bucharest).

The apartment buildings, limited to a maximum of 8–10 stories, made their first appearance around 1900 and expanded in the interwar period. In Bucharest the Bratianu Boulevard (now, Nicolae Balcescu and Magheru Boulevards between University and Romana Plazas) was almost entirely remodeled; it represents a well-balanced and harmonic insertion of interwar architecture into the city's fabric(12). In other areas of the capital or in different towns, these constructions were usually 3–4

floors high with 6–12 apartments. They were in fact a superposition of individual houses with some amenities in common, such as central heating and hot water.

The traditional Romanian urban architecture consists, in short, of churches in the Byzantine tradition, many listed as historic monuments, some with Baroque or neoclassical traits; and houses and other civil buildings, a few built prior to 1800, the others from the 19th century and the interwar period (neoclassical, neo-Gothic, eclectic, neo-Romanian, Bauhaus and Cubist styles). The traditional urban scene also involves the network of streets with old routes and the overall urban fabric which resulted from a centuries-long evolution. The architecture and environment taken as a whole exceeds the values of each of its component parts(13). This heritage is an intrinsic and essential component of Romanian identity and history and part of the European heritage.

At the same time, Romania's traditional urban architecture includes another, different type. In the second half of the 12th century, Saxons from various parts of the German Empire were invited by the Hungarian kings to settle in Transylvania, at that time part of the Hungarian realm. They settled in villages and towns, such as Brasov (Kronstadt), Sibiu (Hermannstadt), Sighisoara (Schassburg), Medias (Mediasch), Bistrita (Bistritz), Sebes (Muhlbach) and Rodna. Built after German patterns, they were walled-in later and provided with defensive towers. At the turn of the 16th century, Sibiu had a 3,400 m. long, inner-wall with 47 towers, 7 bastions and 4 barbicans. Bistrita's walls were 2,500 m. long with 19 towers, 2 bastions and 3 barbicans; in Brasov the figures were 2,750 m., 30 towers, 9 bastions and 3 barbicans.

By the beginning of the 13th century the Szekelys, a distinct Hungarian community, were living in the eastern and southeastern parts of Transylvania in seven districts. These include the towns of Tirgu Mures (Marosvasarhely), Sfintu Gheorghe (Sepsiszentgyörgy), Miercurea Ciuc (Csikszereda) and Odorheiul Secuiesc (Szekelyudvarhely).

These Transylvanian centers were inhabited by Saxons and/or by Szekely-Hungarians, later mixed with Armenians, Jews and others. Few Romanians were allowed a permanent residence within these centers, so they clustered in suburban and nearby rural communities, for instance around Brasov and Sibiu. Romanians were in the majority in other towns, as in Blaj, Turda, Lugoj and Caransebes. This centuries-long coexistence of different communities(14) shaped a specific cultural urban environment with architectural values shared by Romanians, Hungarians and Germans. Over the centuries, the impact of these communities on urban development differed. In some towns the Hungarian characteristics were prevalent; in others, the German ones; and in others, the Romanian. But in all cases the other two ethnic groups existed alongside the predominant one(15). New areas were built in the interwar years. The traditional Transylvanian architecture is a setting of historic monuments: churches (Gothic, Renaissance and Baroque styles), houses from the 16th–18th centuries and mainly post-1800 (Baroque, neoclassical, eclectic and Secession/Jugendstil styles) and interwar constructions. They too form a historic and artistic patrimony, part of the European heritage.

Reconstruction, renovation, restructuring.

As industrialization and urban growth continued, so did the need for more housing. Where and how should one proceed? Architects and urban planners focused on the

central areas. The concepts of reconstruction, renovation and restructuring were examined. Answers were given mostly along accepted lines, but with some interpretations, also. The following alternatives were considered:

First, demolition and reconstruction. Is en masse demolition followed by integral reconstruction a solution? How can one control the arbitrariness of decisions that may erase the past? How can gross errors in projections for the future, mainly for traffic, be avoided? Special care should be given to the present architectural fabric, which is a vivid testimony of history, a link between yesterday, today and tomorrow, a genuine component of the national heritage. As has been said often, "A people without history, without a past, is like a boat without a helm plunging windward."

Second, urban renovation applied to whole areas and not to single monuments only.

Third, restructuring with a three-fold approach: preservation of every valuable building; removal of those considered inadequate; new construction, infill, harmonized with the architectural heritage.

Fourth, modernization as required by contemporary standards, the adaptation of towns to increased traffic and the introduction of amenities in old buildings.

Renewed interest in historic town centers.

In the early 70's, some essential questions were raised. Is the high-rise building the only path to progress? Is height a symbol of modernity? What kind of a relationship is there now between humans and the built environment? Encompassed by massive volumes of concrete and bricks, humans could be alienated, crushed and choked by these buildings that were meant to bring about a better quality of life. An out-of-scale architecture never encountered in the country's past could possibly change these humans into automatons of modernity(16)—creatures who only produce, eat and sleep with reflex responses to social commands. In order to avoid such possible trends, a rational set of principles needed to be applied:

—The reappraisal of whole urban areas based on historic, artistic, architectural, cultural, economic and archeological criteria.

—Modernization of present dwellings.

—Evaluation of changes required by traffic and industrial development.

—A higher population density per square kilometer. This refers only to the peripheral and to other town areas with houses made of short-lived materials.

—A multidisciplinary approach and extensive public debate in order to understand the citizens' reactions to the restructuring process(17).

There was a practical approach for the protection of specific sites. A preliminary study in 25 historic centers was completed by the Institute for Town Planning, Architecture and Standardization, at the request of the Directorate of Historic and Artistic Monuments (Bucharest, 1973)(18). Proposals were set forth to integrate these centers into contemporary active life through restoration, introduction of modern technical installations (water and electricity) where lacking, maintenance of the old street network and of the overall traditional architectural profile, and the establishment of connections between the inherited and the contemporary building stock.

Areas of historic interest were estimated to represent between 4 and 8 percent of the present town surfaces. Money for modernizing the interiors of this heritage

was appraised at between 20 and 40 percent of the cost of a new apartment. Speaking of financial aspects, it is noteworthy to recall an official opinion expressed in 1966: the preservation of historic centers is twice or three times less expensive than their total demolition and reconstruction(19).

"This architectural-historical urban space is our life and our culture: many a time we carry on our professional and cultural activity here."(20). Our present and future civilization "is not based upon a leveling of traditional structures; . . . our cultural activity is channeling its dynamism, its force, toward the awareness of the national traditions. . . and why isn't the architectural heritage able to shape new values," a senior Romanian architect asked in 1973. Some professionals went further to advocate an urban architecture based on the Romanian traditions of the 17th–18th centuries(21).

Conflicting views on the architectural heritage.

A different perspective was drawn up at the same time. It asserted that old towns with their specific fabric and street network cannot be adjusted to the requirements of contemporary life(22). The principles to reshape urban areas should be: an increased density, more people per square kilometer; reduction of the surfaces occupied by industries; demolition of run-down parts; new solutions for traffic without a radical change in the road setting; and conservation of cultural and historic properties.

For a time, the old houses should be maintained but the future profile of these centers will be and is already determined by new apartments, erected along main boulevards and around squares(23).

In 1966, at a symposium held by the union of architects on systematization and reconstruction of the central urban zones, two major categories were established. First, there were towns with important monuments and well-defined dwellings, such as Brasov, Sibiu, Medias, Sighisoara, Bistrita, and Cluj-Napoca (Kolozsvar), all located in Transylvania. These centers were to be maintained, adapted, modernized and connected to the contemporary buildings.

Second, there were the towns with important historic monuments but with no significant architecture (from the second half of the 19th century and post-1900) and with "no clearly designed urban structure," such as Tirgoviste (former capital city of the state of Wallachia), Suceava and Iasi (the capital cities of the state of Moldavia in the 14th–16th centuries), Sebes-Alba and Baia Mare. On this second group a more radical intervention by urban planners is expected (see, for example, Tirgoviste), keeping nevertheless in place historic monuments and possibly some characteristic segments of an old street(24). The debated alternative was the radical demolition of the existing centers and their reconstruction on a completely different scale and fabric for the following reasons: some architects and urban planners considered the 19th and 20th-century architecture of no real value; administrators and some specialists viewed modernity and progress as embodied solely in apartment buildings. No town had systematic records of its heritage, and comprehensive studies were missing.

This theoretical alternative became a reality and was put into practice, though not yet pushed to its ultimate consequences, in Suceava, Pitesti, Vaslui, Giurgiu and Tirgoviste centers, in the early 70's, as stated above.

What the statistics reveal.

There was also a different approach based on the March 15, 1966, census. Approximately 30 percent of the urban houses made of inexpensive materials, such as wattle and daub, were obviously the first targets of the reconstruction. These were houses with 2 rooms, average surface of 25 square meters, less than 50 percent provided with a kitchen, 2 percent with running water, 1 percent with a bathroom. Nearly 40 percent, made of brick with wooden floors, could partly provide the required housing accommodations. These were houses with an average of 2 rooms, 29 square meters, 2/3 with a kitchen, more than 1/4 with running water, 13 percent with a bathroom. The last 30 percent included solid constructions and were to be maintained as such(25).

Conclusions concerning urban architecture were clearly expressed in 1973: first, the need for a comparative analysis of costs, namely for a total reconstruction, including the price of integral demolition, vs. improvements to the existing stock; second, given the low-density population per square kilometer of urban area, the population density within the town perimeter should be increased; third, that by 1976–1980, when the number of new apartments would exceed the natural growth of the population, the restructuring process would start. There was no documented explanation, however, of the areas that were to be completely rebuilt, those that were to be maintained and remodeled, or the extent of remodeling.

Other figures were published in 1975(27). Overall Bucharest area is 9250 hectares of which there were:

650 hectares of sound constructions prior to 1943; 2,150 hectares of new constructions, 1944–1970; 800 hectares of new constructions, 1971–1975; and 5,650 hectares of the remaining area with old substandard constructions lacking conveniences.

The official viewpoint was therefore that architecture prior to 1943 and in good condition represented 7.02 percent of the town area only, whereas 61 percent was old, substandard, and inconvenient. As for the dwellings, there are 621,000 units with 410,000 (approximately 66 percent) good ones and 211,000 (approximately 34 percent) substandard ones. The meaning of "unit" is not defined in the article. Is it possible to have approximately 61 percent of the surface with substandard constructions and concomitantly 66 percent of the houses to be in good condition?

It was estimated moreover that 54 percent of the dwellings were in good technical condition and 10 percent in an advanced state of decay. Thirty-six percent were supposed to be in intermediate condition though the article does not mention them explicitly.

The conclusions set forth reflect the official perspective. The remodeling process would be directed into the central perimeter of the capital in the 1975–1990 interval. This perimeter is not delineated but a reduction of the built area was announced from 9,250 hectares to 7,800 and even to 6,200 hectares. There would be a rational use of the territory marked by an increase of population density, by better housing conditions and by a change in the street network. Historic monuments, architectural values and older constructions that do not hamper principal urban functions would be maintained and connected to the newly constructed areas.

To sum up, the discussions carried out in the 60's and the first half of the 70's brought forward arguments, principles and guidelines for two options: a) a radi-

cal, almost integral demolition of the present urban areas and their replacement by components of a totally different concept, scale and style, keeping in place isolated historic monuments and other buildings; b) the preservation of the traditional architecture with a rational renovation and infill.

The architectural heritage was at stake and the outcome was undecided around 1975.

Comprehensive studies on Bucharest's historic central zone.

A group of professionals continued to advocate and plead for the protection, the restoration and a balanced restructuring of traditional urban areas.

The editorial board of the review *Arhitectura,* edited by Romania's Union of Architects, polled 130 architects, urbanists and town-planners(28). A questionnaire with 72 points established criteria for a comprehensive definition and delimitation of Bucharest's central zone. The answers broadly validated the proposed criteria and outlined a somewhat ring-shaped central zone limited by avenues as follows: north, Nicolae Titulescu (former Ilie Plintilie) and Stefan cel Mare; east, Mihai Bravu and Vacaresti; west, Orhideelor, Grozavesti, Panduri, Tudor Vladimirescu, and Viilor; south, Serban Voda and Oltenitei. Within this central zone a core, more or less extended, and additional local centers were perceived as well. Should this central zone be extended? Yes, answered some 40 percent of the polls; no, it should be reduced, according to 20 percent; the present limits are acceptable and should be maintained, 40 percent. A large majority, 86.15 percent, agreed on a polycentric development of the capital city with 83.08 percent new buildings, to be constructed within the same central zone. There was no poll at all on what part of the traditional architecture had to be kept in place, what had to be demolished and how the new construction should be planned and shaped.

A possible polycentric development of Bucharest was examined by a team(29). Special importance was placed upon a detailed knowledge of the architectural heritage through a spatial inventory(30).

Another poll involving 3,200 residents of the Bucharest center was organized in July 1974. How do they perceive and limit their living space? There was a central zone which covers a larger area with a central core in it. The central core outlined by the citizens was rather close to that of the architects and urban planners.

Understandably, the boundaries of the central zone set forth by the average individual perception were more restrictive than those traced by professionals(31).

A comprehensive study was carried out for several years and completed by a team from the Ion Mincu Institute of Architecture, Bucharest(32). Theoretical and methodological rules were set forth in seven criteria relevant to defining the functional, urbanistic, historic and memorial values. Subsequently, various sets of pertinent data were assembled, street by street, on some 1,600 hectares, then processed, synthesized and discussed in a public session(33) and eventually published(34). The historic zone was determined on historic, functional, urban, architectural and memorial criteria, amounting altogether to 20 points. The buildings were divided into three groups: prior to 1848; 1848–1880; 1880–1910. More recent construction was divided into three phases: 1910–1930; 1930–1945 and post-World War II. Those buildings

prior to 1880 and between 1880 and 1910, all chronologically listed, were considered relevant for the historic center—approximately 400 hectares, 1.9 percent of the city's surface.

Those from post-1910 to 1945 were landmarks for a larger historic zone—around 1,000 hectares or 4.8 percent of the city's surface. An additional 27 local areas of historic interest were listed in the greater Bucharest zone(35). From 1846 onward, the network of streets remained almost the same in the historic zone, but new avenues were opened on the east-west and north-south axes and alongside the Dimbovita river. Endorsed and emphasized by other professionals as well(36), the study's conclusions were drafted into operational guidelines for any further preservation, restructuring and remodeling action(37).

Throughout the early 70's, a special restoration was undertaken at the Old Court (Curtea Veche), 10 hectares of Bucharest's historic core where Wallachia's ruling princes had their residence in the 15th–18th centuries. The work included 12 historic monuments and their entire urban environment and was carried out with great competence, skill and dedication(38). 34.4 percent of the buildings that made up this urban environment were found to be in good or very good condition; 64.1 percent mediocre; 9.6 poor and unsound.

The urban architectural heritage in Romania.

Projects were drawn up for other towns, too. In Tirgoviste, a former capital of the state of Wallachia, some 19th-century buildings were to be maintained, and well-known monuments restored(39). The notion of an area of historic and artistic interest was reiterated, although a limited number of constructions appeared to have been chosen for preservation(40).

In Pitesti, the restructuring of the whole center except one church was planned(41) and was implemented later.

In Cimpulung-Muscel, a former residence of the Romanian ruling princes in the 14th and 15th centuries, the conservation project (1973) included buildings on several streets to be restored and adapted to contemporary requirements(42). This involved the streets Negru Voda, Dezrobirii, Matei Basarab, Lascar Catargiu, Riului and Constantin Brincoveanu. The ratio was 1 to 2 in favor of new construction in the center.

Some years later (1976) the significance and relevance of the traditional architecture in Cimpulung and Pitesti was explicitly documented although without any practical effect(43).

In Craiova, the 1971 planning scheme fulfills the need for new housing with buildings between 5–12 floors high. "The organization of the residential zone by complex units" refers to apartment buildings(44). The central area is outlined in the 1971 scheme, with no details. The area was bordered by the streets Oltetului, Ialomicioara, M. Kogalniceanu, 23 August, Cimpia Islaz, Matei Basarab, Ion Maiorescu and Unirii. Craiova was the former official residence for Oltenia, the western part of the state of Wallachia; Oltenia is limited by the Olt (east) and Danube Rivers (south) and by the Carpathian mountains. The town included valuable traditional architecture in the historic center with the "Old Market," the "Buzesti Plaza," the "Commercial axis" (M. Gorki, 30 Decembrie, and Romania Muncitoare Streets), and the "Bania" area (former residence of the province's governor). In the mid-70's the

preservation and integration of the historic center were duly requested and were put in motion for a few buildings(45).

In the very center of the Danubian town of Braila, two restricted areas were Republicii Street (the former Strada Mare—Main Street) and Lenin Plaza. These areas were thoroughly studied with proper solutions for conservation, renovation and restoration(46).

There was little hope to keep significant parts of the architectural heritage in the well-known industrial town of Ploiesti, according to a 1973 prospectus(47). Ploiesti is approximately 60 kilometers north of Bucharest. Since 1973, vast surfaces have been completely demolished and rebuilt.

For old Constanta, Romania's main harbor at the Black Sea, the outlook seemed to be better, whereas for Curtea de Arges, the first capital in 1330 of the state of Wallachia, a historic district of approximately 60 hectares was suggested(48). The boundaries were the streets Cuza Voda, Zorilor, Eliade Radulescu, Filimon Sirbu, and Negru Voda.

The reconstruction of Suceava's center, which had been the main residence of Moldavia's ruling princes in the 14th–16th centuries, started in 1961. The guidelines called for the leveling of almost every structure except historic monuments, and the construction of apartment buildings (6–8 stories high). There was discussion as to whether the surroundings of Sfintul Dumitru (Saint Demeter) Church should be saved, since the local authorities were opposed to this kind of preservation. The buildings, primarily from the 18th and 19th centuries in neoclassical style with wrought-iron balconies, were highly characteristic of Romanian traditional urban architecture. In 1973 the Directorate for Historic Monuments and some local conservationists suggested a protected status for this tiny area of the town as well as for areas of the towns of Siret, Falticeni, Botosani, Dorohoi, Cimpulung and Vatra Dornei(49). The proposal was never implemented.

Hopes were raised for the northern Moldavian town of Botosani where the preservation of a historic center seemed to have been accepted initially(50). The special importance of the residential mansions, most of them dating from the 19th century, and of the urban fabric as a whole was conclusively demonstrated in a monograph on the medieval town, on the center's evolution and on the historic, urban and architectural values of the town(51). However, this better knowledge of the past proved to be of no avail. Once Botosani was promoted to county center (1968), the demolition was started in order to clear ground for the buildings requested by the new local authorities. Astonishingly, the marginal run-down areas were left intact and buildings totally different in style and scale were constructed close to the historic center. The two parts look rather askew.

Historic areas within 25 towns were identified by the Institute of Studies and Designing for Town Planning at the request of the Directorate for Historic and Artistic Monuments. Proposals were made for restoration, for renovation of the facades through appropriate operations, for an improved architectural setting, for vehicles and pedestrian traffic and for the adaptation of these centers to contemporary requirements(52). The areas enclosed by the former ring walls at Brasov (85 hectares) and Sibiu (98 hectares) were suggested for the planned operations(53). A distinction was made between buildings to be kept in place and those to be studied further. Similar aims were expressed for the town of Sebes-Alba with its 14th-century ring-wall fortifications and other important monuments(54). At Sfintu Gheorghe the center was

limited to 16 hectares(55), 2 percent of the overall surface of the town (801.3 hectares) whereas at Tirgu Secuiesc (Kezdivasarhely) approximately 16.5 hectares have been considered for the renovation(56). At Oradea approximately 50 percent of the town was regarded of historic interest(57).

The extent and significance of Timisoara's (Temeschwar, Temesvar) architectural heritage was stated repeatedly(58). Timisoara is the main city in the Banat, in southwest Romania. Poor, spare references were made for the value of Arad, a western town with major significance in Romanian history(59), whereas the center of Satu Mare was briefly mentioned for conservation and a better setting(60).

NOTES: CHAPTER 1

1) Speech of the President of the Socialist Republic of Romania, published in *Scinteia,* the official daily of the Romanian Communist Party, Bucharest, September 12, 1985.

2) Ibid.

3) Nicolae Ceausescu's speech at the National Conference of the Popular Council's presidents, Bucharest, March 3, 1988, *Romania Libera,* XLVI, no. 13, 475, March 4, 1988; Nicolae Ceausescu's speech at the joint session of the Workers' National Council and the Council for Agriculture, *Romania Libera,* XLVI, no. 13, 553, June 3, 1988.

4) *Anuarul Statistic al Republicii Socialiste Romania (Statistical Yearbook of the Socialist Republic of Romania),* 1987 edition, Directia Centrala de Statistica (Central Direction of Statistics), Bucharest, p. 17, table 15. For the number of communes and villages, see the same *Statistical Yearbook,* 1985 edition, p. 10, table 8.

5) In Bucharest the new Titan district, planned for more than 200,000 inhabitants, was built in connection with the industrial plants 23 August Republica and Policolor in the Dudesti district; the new Drumul Taberei district is near plants located in Militari and Ghencea areas; similarly for Jiul or Berceni districts whose construction also started in the 1960's. These numerous new apartments were erected on open fields, such as in Jiul district, or by demolishing entire suburban streets with one-family houses, such as in Militari, Ghencea, Giulesti, Berceni and Balta Alba districts. Some main thoroughfares were bordered by buildings of 6–10 stories built in a row. The one-family houses along these borders, approximately 150–200 yards in width, were demolished on Calea Grivitei, 1 Mai and Muncii Boulevards, and Giurgiului and Oltenitei Avenues, all in Bucharest.

 For new one-family houses built in the late 60's and in the early 70's: Arch. Mircea Moroianu, "Despre unele proiecte de locuinte individuale," *A.,* XVI, 1(110), 1968, pp. 66–67 (On one-family house projects); Arch. Mariana Bucur and team, "Noi proecte de case de vacanta proprietate personala" (New types of privately owned holiday houses), *A.,* XVI, 3(112), 1968, pp. 54–59; Arch. Mircea Enescu, Engineer Stefan Angelescu, "Case de vacanta prefabricate" (A prefabricated holiday house), ibid., pp. 60–64; Arch. Gheorghe Negreanu, "Locuinte duplex cu elemente prefabricate (Semidetached houses with prefabricated components), *A.,* XVII, 6(121), 1969, pp. 58–59 (English summary, p. 2).

6) A short reference to these extensive interventions in the town of Suceava in Professor Dr. Arch. Grigore Ionescu, "Sa punem in valoare vechile ansambluri arhitecturale" (Making the most of old architectural developments), *A.,* XIV, 1(98), 1966, p. 9 (English summary, p. 10).

7) The town of Pitesti was razed and rebuilt in the 1966–1988 interval on the grounds that: "the existing prewar architecture has no special value;" three important buildings needed to be built in the center; and to end the present urban disorder; Cezar Lazarescu, "Studiu pentru sistematizarea zonei centrale a orasului Pitesti" (Study for the planning of the center of Pitesti), *A.,* XIV, 6(103), 1966, pp. 50–51 and 71 (English summary, p. 2).

 For Pitesti see also: Arch. Pompiliu Soare, "Studiu centru-Pitesti" (Replanning of the central zone in the city of Pitesti), *A.,* XXI, 2(141), 1973, p. 4; Arch. Victor Popa, "Studii de asamblare urbanistica intre cartierele noi si zona centrala a orasului Pitesti" (Studies of urban assemblages between new wards and the central zone of the town of Pitesti), ibid., p. 5 (both with English summaries).

8) The center of Vaslui was razed and rebuilt in the late 60's and early 70's: a hint in Dr. Ioan Ciobotaru's, "Reconstructie, renovare sau restructurare urbana?" (Reconstruction, renovation or urban restructuring?), *A.,* XXI, 4(143), 1973, p. 60 (English summary, p. 6).

 For the new Vaslui center: Arch. Nicolae Munteanu, "Centrul Vasluiului" (The center of Vaslui), *A.,* XXIX, 5(192), 1981, pp. 64–69 (English summary, p. 7). This arti-

cle does not mention the traditional architecture, at least 90 percent of which was demolished.

9) Giurgiu's center was demolished in the early 70's. One tower survived. This area was highly characteristic of 19th-century urban plans: Arch. Alexandru Sandu, "Pentru o intelegere complexa, stiintifica a restructurarii urbane" (For a complex scientific understanding of urban restructuring), *A.*, XXI, 4(143), 1973, p. 7 (English summary, pp. 2–3).

10) Architects Radu Serban and Marilena Serban, "Integrarea imaginii urbane. O incercare de analiza a spatiului urban in partea veche a Bucurestiului" (The integration of the urban image. An attempt to analyse urban space in the historic area of Bucharest), *A.*, XXI, 4(143), 1973, pp. 92–102 (English summary, pp. 10–11): a study of component elements, their combination and variations which ultimately resulted in a characteristic image of traditional Bucharest architecture, as in most Romanian towns.

11) The gradual evolution of Romanian society toward a market-oriented capalistic structure which started in the last decades of the 18th century was stepped up in the second half of the 19th century and accelerated in the interwar period (1919–1939). The modern Romanian state was built in four phases: union of the states of Wallachia and Moldavia (1848–1861); winning and recognition of state independence (1877–1878); proclamation of the Kingdom (Carol I of Hohenzollern, 1881); union of 1918 at the end of World War I. For details: Dinu C. Giurescu, *The illustrated history of the Romanian People*, Sport-Turism Publishing House, Bucharest, 1981, pp. 341–398.

12) Arch. Horia Creanga. "Catre o arhitectura a Bucurestilor" (For Bucharest's architecture), Tribuna Edilitara, Bucharest (undated, pre-World War II); Arch. Mircea Lupu, "Expresivitatea arhitecturii si caracterul urban" (Architecture's expressivity and urban character), *A.*, XXII, 4(155), 1975, pp. 30–33 (English summary, p. 3). Dr. Arch. Radu Patrulius, "Contributii romanesti la arhitectura anilor '30" (Romanian contributions to the architecture of the 30's), part I and II, *A.*, XXI, 6(145), 1973, pp. 44–52 and *A.*, XXII, 1(146), 1974, pp. 53–59.

13) Arch. Doina Cristea, Dr. Alexandru Sandu, Serban Popescu Criveanu, Dr. Sanda Voiculescu, "Centre si zone istorice. Studiu de delimitare a zonei istorice a orasului Bucuresti" (A survey aimed at establishing the borders of historic sites in Bucharest), *A.*, XXV, 6(169), 1977, pp. 38–47 (English summary, pp. 2–5). For the chronology of buildings, see p. 42. The authors point out that the network of streets existing in 1846 has been maintained in the historic zone of the city, approximately 1,000 hectares and in the historic center, approximately 400 hectares, except for the north-south and east-west boulevards and along the Dimbovita River, all opened at the end of the 19th century (see pp. 44–45).

14) Dinu C. Giurescu, op. cit., pp. 106, 233, 249 and 285.

15) Arch. Dr. Eugenia Greceanu, "Rolul studiului istoric in procesul de renovare urbana" (The role of historic studies in urban renovation), *A.*, XXVIII, 3(184), 1980, pp. 57–61. Based on archival and field data, the study outlines the existence of several components in the city of Arad: the Romanian district around the Old Market, Tirgu Vechi, dating from 1329 to the 18th century; the 18th-century German district around Avram Iancu Plaza and in the south-eastern nearby 19th-century area; the Serbian district, the Serbian market; the Hungarian district on Republicii Boulevard and Mihai Eminescu Street; the Jewish district with the synagogue and its surrounding buildings. The aim of two proposals for restructuring was to raze parts of the German and Romanian districts.

16) Dr. Ioan Ciobotaru, "Reconstructie, renovare sau restrucurare urbana?" (Reconstruction, renovation or urban restructuring?), *A.*, XXI, 4(143), 1973, pp. 60–62 (English summary, pp. 6–7).

17) Dr. Ioan Ciobotaru, op. cit.; Arch. Alexandru Sandu, "Pentru o intelegere complexa, stiintifica a restructurarii urbane" (For a complex scientific understanding of urban restructuring), *A.*, XXI, 4(143), 1973, pp. 4–11 (English summary, pp. 2–3): a balanced analysis and rationale of the concept of urban renovation-restructuring; thus, the need

for a complex operational, analytical, philosophical and systematic approach. The author calls attention to possible erroneous estimates of future needs (pp. 10–11).

In favor of traditional urban architecture, see also: Arch. Horia Hudita, "Constructia si reconstructia oraselor si noile ansambluri de locuit" (Town development and redevelopment, and new residential districts), *A.*, XIV, 1(98), 1966, pp. 21–23 (English summary, p. 2); Arch. Alexandru Iosif, "Orasul reprezentant al societatii si civilizatiei" (The town as a representative of society and civilization), *A.*, XV, 4(107), 1967, pp. 26–28. Arch. Traian Stanescu, "Remodelarea contemporana a oraselor din tara noastra," (An adequate relationship between tradition, continuity and innovation), *A.*, XV, 3(106), 1967, p. 7 ; Professor Arch. Gustav Gusti, "Renovarea urbana si viitorul oraselor" (Urban renovation and the future of towns), *A.*, XVI, 2(111), 1968, pp. 70–72; idem, "Principii si tendinte in sistematizarea teritoriala in Romania" (Principles and trends in Romania's territorial systematization), *A.* XVI, 4(113), 1968, pp. 32–34; sociologist Max Lupan, "Conditii pentru dezvoltarea sociologiei locuintei si un mod sociologic de abordare a problemei specificului" (On the sociology of the dwelling) *A.*, XVII, 2(117), 1969, pp. 3–4; sociologist Georgeta Bucheru, "Aspecte sociologice in abordarea diferentiata a temelor de locuinte" (Sociological components in the house planning), *A.*, XVII, 2(117), 1969, pp. 5–6; Dr. Architect Mihail Caffe, "Aspecte de aplicare in proiectare a cercetarii sociologice de arhitectura" (Sociology and architectural planning), ibid., p. 7; Arch. Mariana Celac, Cristian Bruteanu, Sisarh RV 74—un program pentru remodelare urbana" (Sisarh RV 74—a program for urban remodeling), *A.*, XXI, 4(143), 1973, pp. 16–17; Professor Dr. Architect Octav Doicescu, "Orasul si substanta lui" (The town and its essence), ibid., pp. 2–3.

An entire issue of *A.*, XXII, 3(147), 1974, pp. 10–71, developed "Probleme actuale ale sistematizarii" (Present problems of systematization), a theoretical-methodological approach to urban renovation and systematization.

Arch. Alexandru Sandu, "Unele implicatii ale determinarii specificului culturii in aprecierea fenomenului de arhitectura si urbanism" (The national character in architecture), *A.*, XXIV, 4(161), 1976, pp. 14–19.

18) Dr. Arch. Virgil Bilciurescu, "Unele probleme in legatura cu valorificarea zonelor istorice" (Some problems in relation to the rehabilitation of historic areas), *A.*, XXI, 4(143), 1973, pp. 20–23 (English summary, pp. 4–5).

19) Dr. Arch. Virgil Bilciurescu, "Sistematizarea centrelor istorice ale vechilor orase" (Planning of historic centers of our old towns), *A.*, XIV, 6(103), 1966, pp. 46–49 (see p. 48). (English summary, p. 2).

There might be divergent views on the figures; nevertheless, in the late 60's and early 70's some architects and urban planners gave priority to the preservation and adaptation of traditional urban areas also on economic and financial grounds.

20) Dr. Arch. Virgil Bilciurescu, *A.*, XXI, 4(143), 1973, p. 23. Cf. Professor Arch. Dr. Grigore Ionescu, "Sa punem in valoare vechile ansambluri arhitecturale" (Making the most of old architectural developments), *A.*, XIV, 1(98), 1966, pp. 8–9 (English summary, p. 1).

21) Arch. Constantin Joja, "Punerea in valoare a unei vechi arhitecturi urbane romanesti" (How to vitalize old Romanian urban architecture), *A.*, XVI, 4(113), 1968, pp. 17–21 (different opinions expressed by Arch. Aurel Doicescu, ibid., pp. 22–23 and by Arch. Ion Dumitrescu, ibid., pp. 23–24); Arch. Constantin Joja, "Actualizarea traditiei urbane romanesti," *A.*, XVII, 2(117), 1969, pp. 32–33.

22) Arch. Cezar Lazarescu, "Probleme actuale ale dezvoltarii oraselor," *A.*, XV, 4(107), 1967, p. 3, opinion expressed during a plenary session of the Romanian Union of Architects on "Topical problems of town development."

23) Cezar Lazarescu, President of the Union of architects, "Probleme actuale ale urbanizarii in tara noastra" (Present planning problems in our country), *A.*, XXIII, 4(155), 1975, pp. 9–11 (English summary, p. 1–2).

24) Dr. Arch. Virgil Bilciurescu, "Sistematizarea si reconstructia zonei centrale a oraselor" (Planning of historic centers of our old towns), *A.,* XIV, 6(103), 1966, pp. 46–49 (English summary, p. 2).

25) Arch. Gheorghe Sebestyen, "Note preliminare despre remodelarea urbana si eficienta ei in conditiile tarii noastre" (Preliminary notes on urban remodeling and its efficiency in the conditions of our country), *A.,* XXI, 4(143), 1973, p. 14–15.

26) Idem, page 15. According to the 1966 census at least 50 percent of urban dwellings provided acceptable or good conditions of living and required meager state expenses to be kept in normal conditions.

27) Arch. Constantin Jugurica, "Probleme ale dezvoltarii zonelor centrale ale Municipiului Bucuresti in etapa 1976–1980" (Problems raised by the development of Bucharest central zones during the 1976–1980 stage), *A.,* XXIII, 4(155), 1975, pp. 34–36 (English summary, p. 3). The article reflects an official viewpoint since the author was, at that time, technical director of Proiect-Bucuresti, the main institution in charge of capital city reconstruction.

28) "Centrul actual al municipiului Bucuresti" (The present center of Bucharest municipality), *A.,* XXI, 4(143), 1973, pp. 104–109 (part I) (English summary, pp. 10–11) and part II, idem, XXI, 5(144), 1973, pp. 23–28 (English summary, pp. 4–5).

29) Architects Peter Derer, Dumitru Guarnieri, Mircea Lupu, Serban Popescu-Criveanu, Alexandru Sandu and Paul Stanescu, "Unele observatii si idei privind centrul Capitalei" (Some observations and ideas regarding the capital city center), *A.,* XXI, 4(143), 1973, pp. 110–119 (English title in p. 12).

30) Ibid., pp. 118–119.

31) Architects Serban Popescu-Criveanu, Dr. Sanda Voiculescu, psychologist Liviu Damian, "Unele aspecte metodologice si social-psihologice legate de studiul centrului orasului Bucuresti" (Some methodologic, historic and sociopsychologic aspects of a study carried out on the center of Bucharest): an attempt to define this central zone from the standpoint of operational and historic urbanism, urban sociology and psychology. At the same time it sketches the extension of Bucharest's central zones with chronological landmarks in 1789, 1838, 1930, 1975. This central zone encompassed approximately 800 hectares in 1975, out of which 200 hectares represent the central core; *A.,* XXIV, 4(161), 1976, pp. 19–23 (part I) (English summary, pp. 2–3), and XXV, 6(169), 1977, pp. 47–52, (part II).

32) The research project started at the request of the Popular Council of the City of Bucharest (The city's governing body). The team included: professor Dr. Arch. Gheorghe Curinschi-Vorona (coordinator), architects: Doina Cristea, Serban Popescu-Criveanu, Dr. Alexandru Sandu, Dr. Sanda Voiculescu, Dr. Mira Dordea and Dr. Anton Moisescu; archaeologist Marioara Nicorescu; Petre Dache, Alexandru Dutu and Panait I. Panait, participated in as representatives of the Museum of History of Bucharest. A noticeable number of students gathered information in the field.

33) The preliminary conclusions of the study were discussed at a public session at the "Architect House," Bucharest, on June 8, 1976: a note, *A.,* XXIV, 5(162), 1976, pp. 6–7.

34) Architects Doina Cristea, Dr. Alexandru Sandu, Serban Popescu-Criveanu and Sanda Voiculescu, "Centre si zone istorice. Studiul de delimitare a zonei istorice a orasului Bucuresti" (A survey aimed at establishing the borders of the historic center of Bucharest), *A.,* XXV, 6(169), 1977, pp. 38–47 (English summary, pp. 2–5). Students of Ion Mincu Institute of Architecture—Monica Ciurdariu, Doru Covrig, Istvan Karcsmaros, Florin Machedon, Irina Serbeniuc, Georgeta Tanase, Maria Angela Toma, Ion Vede and Olimpiu Vultur participated in writing the draft.

35) The following 27 local areas of historic interest are documented through written records (mainly from the 16th–19th centuries) and archaeological items: Mogosoaia, Straulesti-Maicanesti, Baneasa, Giulesti, Plumbuita, Herastrau, Tei, Grivita, Chiajna, "de la Sosea," Colentina, Fundeni, Rosu, Ciurel, Grant, Obor, Marcuta, Pantelimon, Cernica,

Caldararu, Cotroceni, Ghencea, Filaret, Foisor, Dudesti, Vacaresti and Leordeni. Some are within the city, others in the suburban zone or near it.

36) On June 8, 1976 (see footnote no. 33). Other articles on Bucharest's center:

 —Psychologist Liviu Damian, "Centrul Bucurestiului: unele aspecte psihologice" (Bucharest's center: some psychological aspects), *A.*, XXI, 4(143), 1973, pp. 13–14 (English summary, p. 1); psychologist Mihai Macavescu, "Inima orasului. Cerinte fata de psihosociologie" (The city's heart . . .), ibid., pp. 12–13; Dr. Arch. Sanda Voiculescu, "Inima tirgului. Unele aspecte ale evolutiei centrului orasului Bucuresti" (The city's heart. Some aspects of the evolution of Bucharest's center), ibid., pp. 81–83; Dr. Arch. Aurelian Triscu, "Unele probleme ale sistematizarii Municipiului Bucuresti. Pe marginea plenarei Uniunii arhitectilor din octombrie 1974" (Some problems raised by Bucharest town planning. Marginal notes on the Union of Architects' Plenary Session held in October 1974), *A.*, XXIII, 1(152), 1975, pp. 6–7;

 —Architects Dr. Eugenia Greceanu, Dr. Boris Grinberg and Dr. Aurelian Triscu, "Integrarea valorilor arhitecturale in urbanismul contemporan din R.S.Romania" (Integration of architectural values in Romanian's contemporary urbanism), report presented at the Fourth Conference of the Architects of the Balkan countries held in Bucharest on September 24–29, 1973, *A.*, XXII, 1(146), 1974, pp. 9–10.

37) See p. 47, *A.*, XXV, 6(169), 1977.

38) Arch. Cristian Enachescu, "Unele aspecte ale restaurarii urbanistice a zonei 'Curtea Veche'" (Aspects from the urbanistic restoration of the Old Court), *A.*, XXI, 4(143), 1973, pp. 85–88 (English title, p. 10);

 —Arch. Nicolae Pruncu, "Probleme teoretice ale remodelarii microzonei Palatului voievodal din Curtea Veche a Bucurestilor" (The theoretical problems of microzone remodeling of the princely palace from the Old Court of Bucharest), *A.*, XXI, 4(143), 1973, pp. 88–91 (English title, p. 10);

 —Arch. Constantin Joja, "Problemele restaurarii zonei 'Curtea Veche'— Bucuresti" (The restoration of the historic center of Bucharest. The area of the Old Court, *A.*, XXI, 4(143), 1973, pp. 83–85 (English summary, pp. 9–10).

39) Arch. Dr. Virgil Bilciurescu, "Tirgoviste" (The center of Tirgoviste), *A.*, XIV, 6(103), 1966, pp. 62–67 (English summary, p. 3).

40) Arch. Dr. Virgil Bilciurescu, "Tirgoviste," *A.*, XXI, 4(143), 1973, p. 28.

41) Professor Architect Cezar Lazarescu, "Studiu pentru sistematizarea zonei centrale a orasului Pitesti" (Study for the planning of the center of Pitesti), *A.*, XIV, 6(103), 1966, pp. 50–51 and 71 (English summary, p. 2); Arch. Pompiliu Soare, "Restructurarea zonei centrale Pitesti" (Replanning the central zone in the city of Pitesti), *A.*, XXI, 2(141), 1973, p. 4 (English title, p. 1); Arch. Victor Popa, "Studii de asamblare urbanistica intre cartierele noi si zona centrala a orasului Pitesti" (Studies of the urbanistic assemblage between the new wards and the central zone of the town), idem, p. 5 (English title, p. 1).

42) Arch. Victor Popa, "Zona centrala a orasului Cimpulung-Muscel" (The central zone of the city of Cimpulung-Muscel), *A.*, XXI, 2(141), 1973, pp. 7–8 (English title, p. 1).

43) Arch. Constantin Joja, "Arhitectura civila veche din Cimpulung si Pitesti" (Old privately owned architecture in the towns of Cimpulung and Pitesti), *A.*, XXIV, 5(162), 1976, pp. 29–32 (English title, p. 1); Arch. Eugenia Greceanu, "Elemente de metodica in cercetarea centrelor istorice ale oraselor" (Elemental methods as applied to the research of historic town centers), *A.*, XXIV, 4(161), 1976, pp. 24–30 (English summary, p. 3).

44) Arch. Teodor Cocheci, "Schita de sistematizare—Craiova 1972" (Updating the planning scheme for the city of Craiova), *A.*, XXI, 3(142), 1973, pp. 4–5 (English summary, pp. 1–2).

45) Architects Jeni Brandt and Georgeta Nicolae, "Municipiul Craiova. Aspecte ale integrarii centrului istoric in remodelarea zonei centrale" (Craiova municipal town. Aspects of historic center integration into central zone replanning), *A.*, XXIV, 4(161), 1976, pp. 30–31 (English title, p. 3); Arch. Dan Budila, "Valente arhitecturale ale

16

fondului de cladiri existente in zona centrala" (Architectural valences of the buildings found existing in the central zone—Craiova), *A., XXIV*, 4(161), 1976, pp. 32–34 (English summary, p. 3); see also: "Problemele sistematizarii orasului Craiova. Plenara filialei Oltenia a Uniunii arhitectilor din RPR, 22–24 Octombrie 1964" (Problems of systematization of the town of Craiova. The plenary session of the Union of Architects' branch in Oltenia, October 22–24, 1964), *A., XIII*, l(92), 1965, pp. 38–46.

46) Arch. Dr. Virgil Bilciurescu, "Metodologia aplicata" (Applied methodology), *A., XXIV*, 4(161), 1976, pp. 36–37 (English summary, p.3); Arch. Viorel Oproescu, "Zona centrala Braila" (Central zone Braila), idem, pp. 38–43; cf. "Braila," *A., XXI*, 4(143), 1973, pp. 26–27.

47) Arch. Alexandra Andronescu, Prahova. "Probleme de sistematizare a municipiului Ploiesti" (Planning problems raised in the city of Ploiesti), *A., XXI*, 2(141), 1973, pp. 28–30 (English summary, p. 4): after 1975 the investment for new buildings will be concentrated within the central zones along the main thoroughfares (see p. 30 and English summary, p. 4).

48) Arch. Dan Stoica, "Aspecte teoretice si metodologice ale studiului Restructurarea si valorificarea centrului istoric Oras Vechi Constanta" (A study on the "Replanning and evaluation of the historic center of the old city of Constanta"), *A., XXIII*, 4(155), 1975, pp. 27–29 (English title, p. 3); Arch. Victor Popa, "Zona centrala a orasului Curtea de Arges" (The central zone of Curtea de Arges), in *Monuments Bulletin*, XLV, 2, 1976, pp. 47–51 (see esp. pp. 50–51).

49) Arch. Eusebie Latis, "Suceava" (The center of Suceava), *A., XIV*, 6(103), 1966, pp. 64–65 (English summary, p. 3). The relevance of this area was again emphasized by Theodor Lebada and Eusebie Latis, "O prezentare" (A presentation), *A., XXI*, 3(142), 1973, pp. 16–18 (English summary, p. 3–4).

 —For Dorohoi: Arch. Olga Chirila, "Restructurarea zonei centrale a orasului Dorohoi" (Replanning of the central zone of the city of Dorohoi), *A., XXI*, 3(142), 1973, p. 19 (English title and summary, p. 4).

50) Professor Dr. Arch. Ludwig T. Staadecker, "Concursul pentru sistematizarea zonei centrale a municipiului Botosani si amenajarea pietei Mihai Eminescu" (Contests for planning the central area of the town of Botosani and Mihai Eminescu Square), *A., XIX*, 4(131), 1971, pp. 50–57 (English summary, p. 3) (see also, idem, pp. 24–25).

51) Arch. Dr. Eugenia Greceanu, *Ansamblul medieval Botosani* (The medieval town of Botosani), edited by the National Museum of History, Bucharest 1981, 150 pages and 48 illustrations (including maps). See also the volume's review, *A., XXX*, 4(197), 1981, pp. 57–58.

52) Arch. Dr. Virgil Bilciurescu, "Studii pentru valorificarea centrelor istorice" (Some problems in relation to the rehabilitation of the historic areas), *A., XXI*, 4(143), 1973, pp. 20–31 (English summary, p. 4).

 A preliminary study was carried out for the Transylvanian towns of Brasov, Fagaras, Sibiu, Sighisoara and Medias: Arch. Gabriela Bertume, "Citeva probleme ale sistematizarii unor orase din regiunea Brasov" (Some problems of town planning in the Brasov region), *A., XIII*, 2(93), 1965, pp. 4–17 (English summary, p. 1). See also: Arch. Dr. Virgil Bilciurescu, "Studii pentru sistematizarea centrelor istorice ale oraselor. Brasov" (Planning of historic centers of our old towns. The center of Brasov), *A., XIV*, 6(103), 1966, pp. 52–55 (English summary, pp. 2–3); idem, "Sibiu" (The center of Sibiu), *A., XIV*, 6(103), 1966, pp. 56–69 (English summary, p. 3).

53) Idem, "Brasov" and "Sibiu", *A., XXI*, 4(143), 1973, pp. 32–36.

54) Idem, "Sebes-]Alba" (The center of Sebes-Alba), *A., XIV*, 6(103), 1966, pp. 60–61 (English summary, p. 3).

55) Arch. Viorel Oproescu, "Zona centrala Sf. Georghe" (Central zone of St. Gheorghe), *A., XXIV*, 4(161), 1976, pp. 44–48 (English title, p. 4).

56) Arch. Viorel Oproescu, "Renovare urbana Tg. Secuiesc" (Urban renewal of the Tirgu Secuesc downtown), *A.,* XXV, 6(169), 1977, pp. 58–64 (English title, p. 5).

57) "Oradea," *A.,* XXI, 4(143), 1973, pp. 30–31.

58) "Referat asupra problemelor de sistematizare a orasului Timisoara" (Planning problems in the town of Timisoara, an account of the plenary session of the Banat regional branch of the Romanian Union of Architects, November 1964), *A.,* XIII, 2(93), 1965, pp. II–VII (English summary, p. 1);

Arch. Mihai Opris, "Evolutia structurii urbane a Timisoarei" (Development of the Timisoara urban structure), *A.,* XXV, 6(169), 1977, pp. 53–56 (English title, p. 5).

59) Arch. Milos Cristea and Viorel Bulgareanu, "Arad" (A presentation), *A.,* XXI, 3(142), 1973, pp. 33–35 (English summary, pp. 5–6).

60) Arch. Karoly Rupprecht, "Satu Mare" (A presentation), *A.,* XXI, 3(142), 1973, pp. 22–25 (English summary, pp. 4–5).

The traditional Romanian architecture consists of: a) houses and other civil buildings, a few prior to 1800, the others from the 19th century and the interwar period, of old-Romanian, neoclassical, neo-Gothic, eclectic, neo-Romanian, Bauhaus and cubist styles; b) churches of Romanian style based on the Byzantine tradition; c) the network of streets including old routes and the overall urban fabric which evolved over the centuries.

The following photographs taken in October 1985 offer a glimpse of some Romanian traditional structures on seven segments of Bucharest streets. Unless individually verified, it is virtually impossible to find out how many of these buildings have survived until the present. No systematization plan of Bucharest has ever been released to the author's knowledge. The pace of demolition is marked by the written and/or oral announcements made by the municipality. Thus, people living in an area or a street find out that they must move within a few weeks or months.

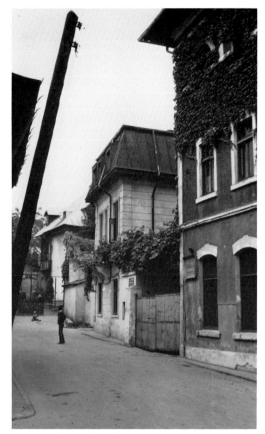

Intrarea Brigadierului Street.

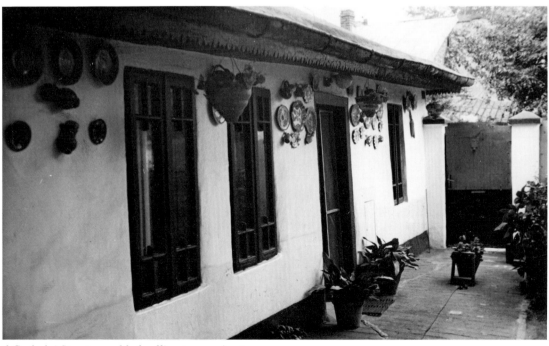

6 Cerbului Street, an old dwelling type, prior to 1800.

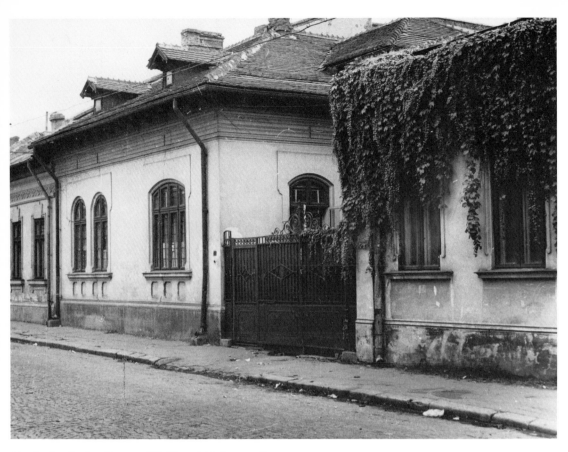

Single-family dwellings at 37, 39 and 12 Aurora Street.

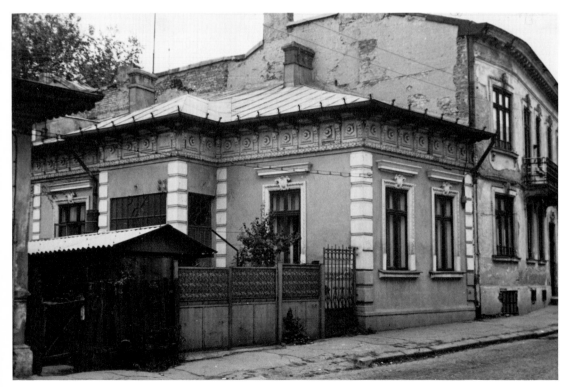

Bucharest, late-19th and early-20th century eclectic style residences and apartment buildings, the latter a superposition of single-family dwellings.

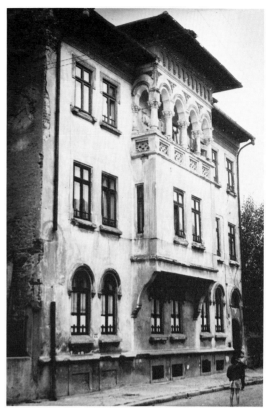

67 Aurora Street.

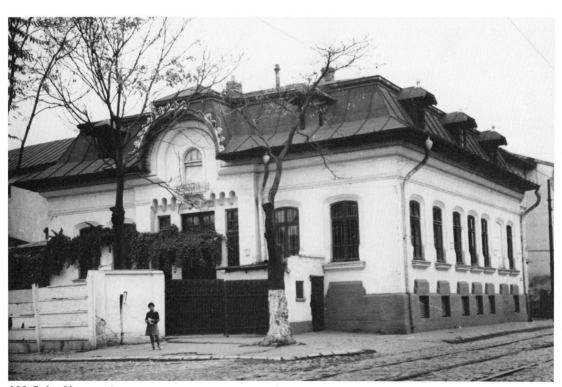

110 Calea Vacaresti.

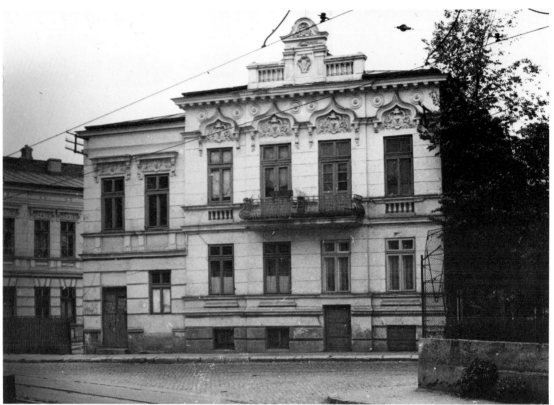

Splaiului Street at the corner of Calea Vacaresti.

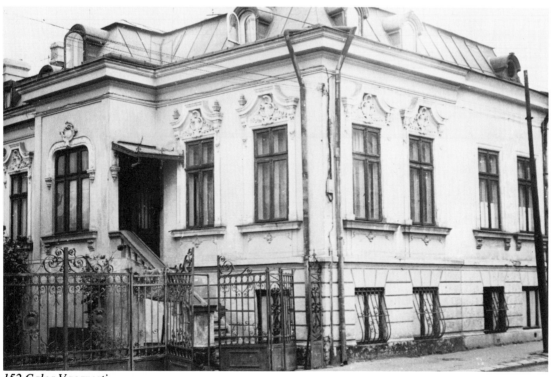

152 Calea Vacaresti.

Bucharest, neo-Romanian style, single-family houses, early 20th century.

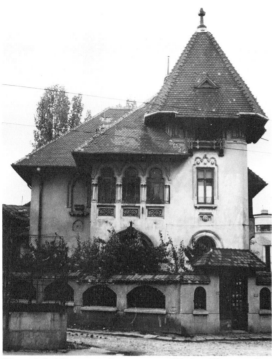

Hameiului Street at the corner of Calea Vacaresti.

*Calea Vacaresti
at the corner of Marasesti Boulevard.*

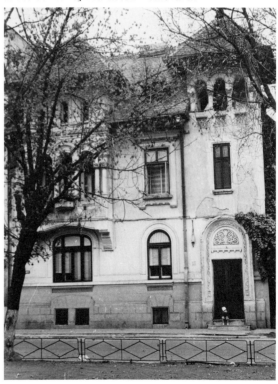

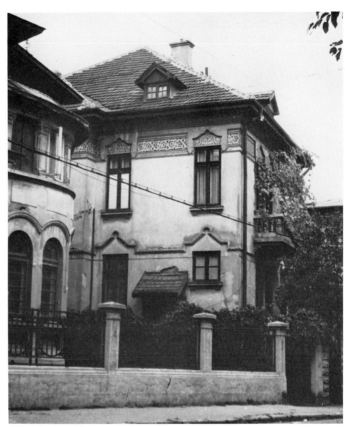

50-A Aurora Street.

65 Aurora Street, eclectic style.

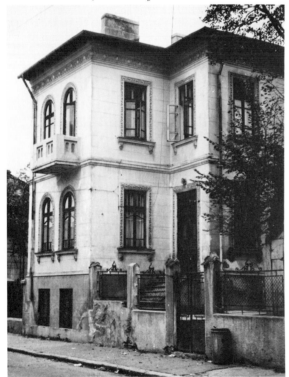

Bucharest, structures of the interwar period
with two, three or four one-family apartments.

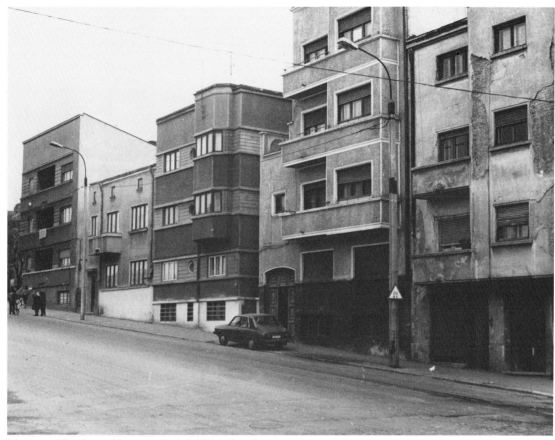

*Marasesti Boulevard between Splaiul Unirii and
Calea Vacaresti. Visible signs of dereliction on the
facade of the first building (at right of photo). The
overwhelming majority of these facades have not
been repaired for years. Such marks of decay are
put forward by the municipal authorities as cause
for demolition of the traditional urban architecture.*

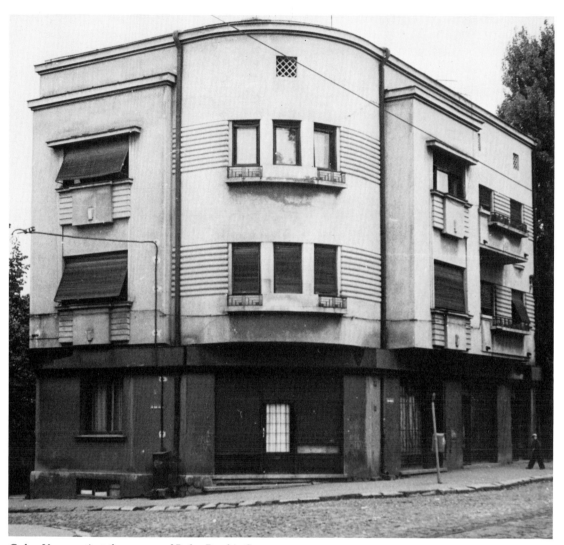

Calea Vacaresti at the corner of Baba Dochia Street.

Bucharest, urban streetscape

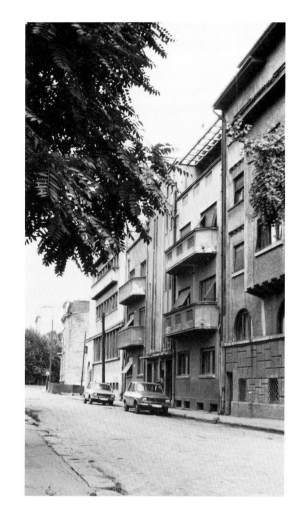

Sapientei Street with interwar dwellings; the street is close to the area where thousands of old structures have been demolished and replaced by the new center.

Aurora Street
at the corner of Splaiul Unirii (Unirii Avenue).

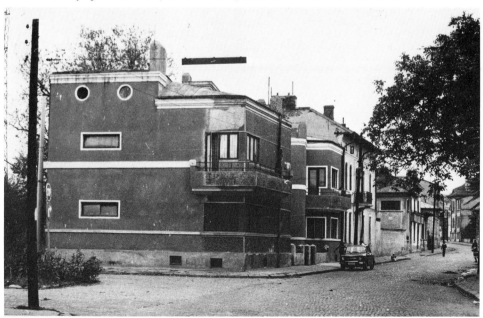

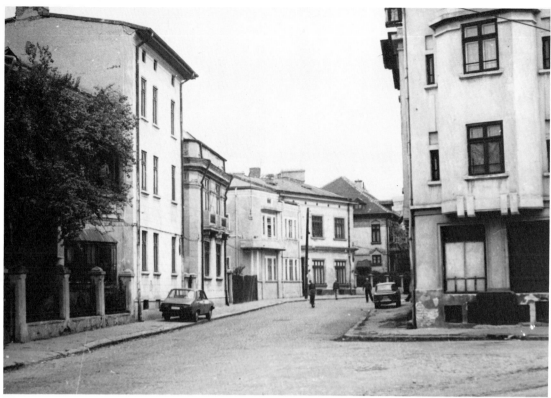

View of Aurora Street.

*Calea Vacaresti
at the corner of Marasesti Boulevard.*

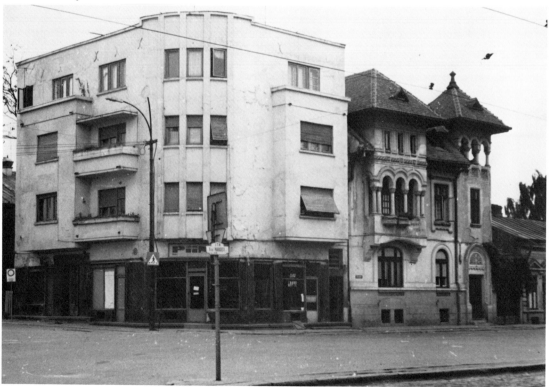

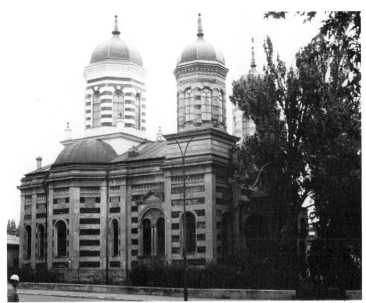

Dobroteasa Church, 101 Calea Vacaresti. The first church dated 1736 was destroyed by an earthquake and rebuilt in 1847; the present one was completed in 1887–1892.

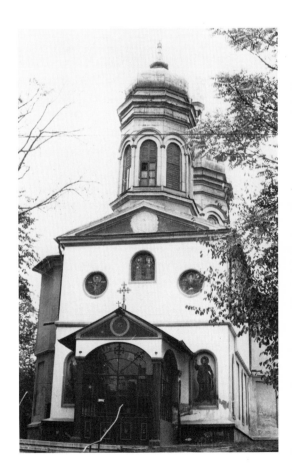

Apostle Church, 143 Calea Vacaresti, built in 1765 and restored in 1820–1830, also in 1864 and again in the post-war years.

Buildings between Brutus and Sapientei Streets in the immediate proximity of the demolished areas in central Bucharest where the new civic center is being built.

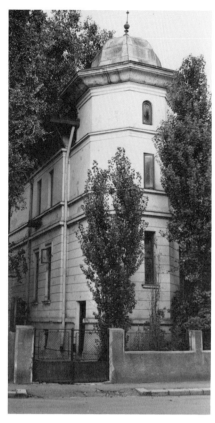

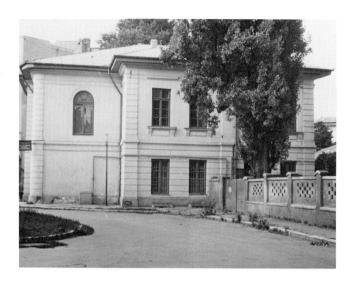

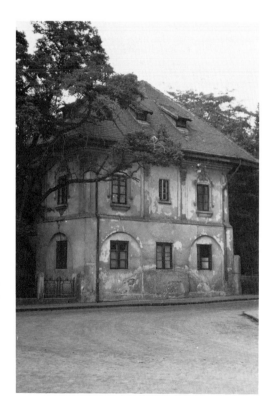

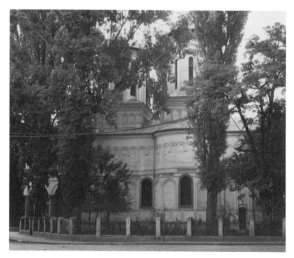

The parish house and the Church Sfintii Apostoli (Saint Apostles), 33-A Sfintii Apostoli Street. The church was erected in the second half of the 16th century, restored in 1705, 1715, partly reconstructed in 1843, repaired in 1864, 1898–1899 and in 1936; it is a listed historic monument. All structures around the church and the parish house were demolished in 1987.

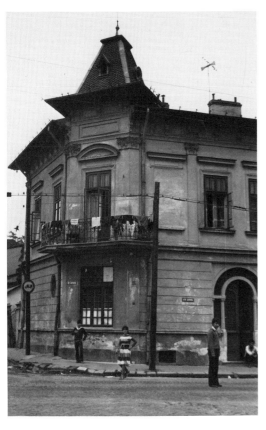

27 Aurora Street
at the corner of Cerbului Street.

Single-family house, neoclassical style on Splaiului
Street at the corner of Aurora Street.

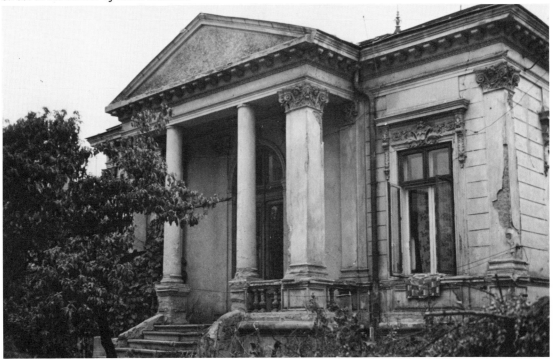

A number of traditional buildings underwent repairs in the last 20 years in Bucharest. Among the positive examples: some mansions on Ana Ipatescu Boulevard, the Central State Library and the Tribunal on Splaiul Dimbovitei. Such actions have been widely publicized by the Romanian mass media in recent years. The overwhelming majority of the traditional urban architecture has been left in a state of gradual dereliction, although little money would have been needed to keep up the existing building stock as compared to the extensive cost to pull down 85–90 percent of these structures and to replace them with apartment buildings. The decay of the buildings has been and continues to be represented by the municipal council as an "objective argument" for large-scale demolition. The following are a few examples of the dereliction process.

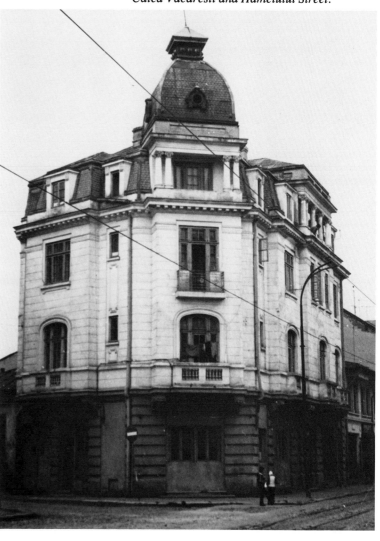

Apartment building of the early 20th century on Calea Vacaresti and Hameiului Street.

Craiova (Dolj county) is one of the major Romanian cities documented in the 16th century. By the mid-1980's, at least 75 percent of the city had been entirely rebuilt with the multistory apartment building as the basic unit. Systematization is now being applied to the central area, the last area with traditional architecture.

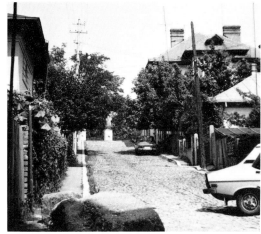

Street with single-family houses from the 1920's and 1930's.

One-family house of the late 19th century or early 1900's. In the background a 10-story tenement building. Once an infill of several high-rise buildings is completed, the one-family household is considered "out of scale," "deteriorated" and "in a state of decay" and therefore is demolished.

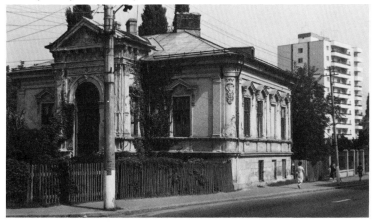

Townscape with the old urban fabric at the right and some new multistory buildings in the background.

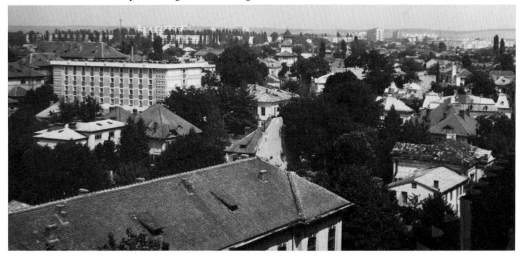

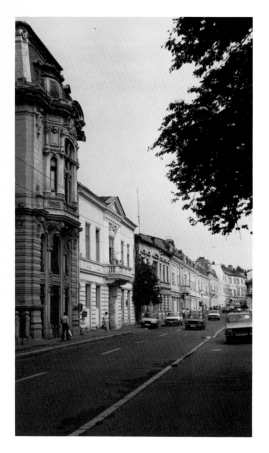

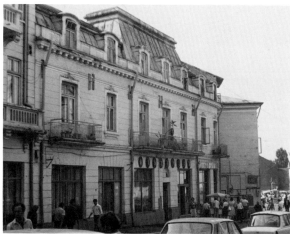

*Streets in the traditional commercial center of
Craiova, 19th and early 20th century.*

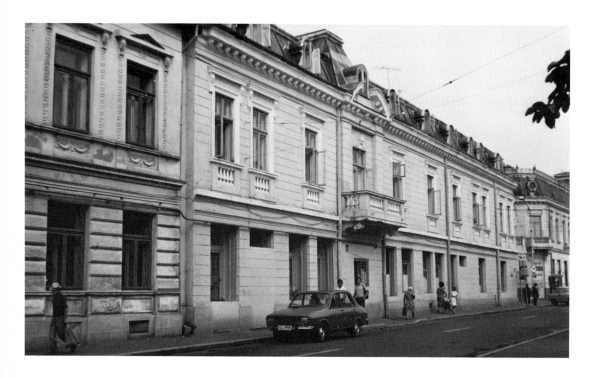

Craiova

One-family house of the 17th–18th century type.

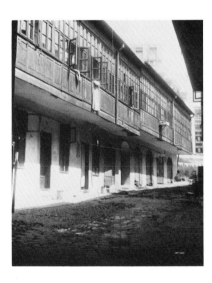

An 18th-century inn with the second floor articulated by a continuous band of windows. Close in the background the multistory building which will eventually replace all the traditional architecture.

A 19th-century, single-family house.

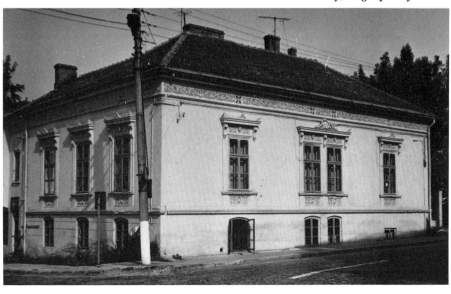

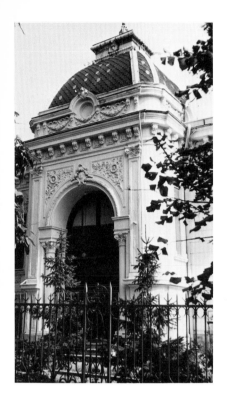

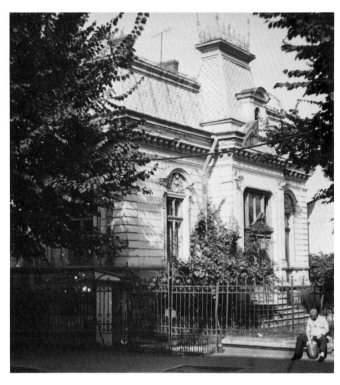

Mansions and houses of the eclectic style, 19th century and early 1900's. They are clear examples of how traditional architecture retains its value through normal maintenance and repairs.

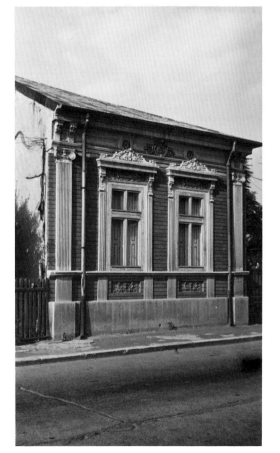

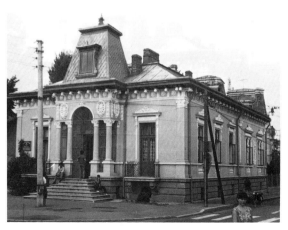

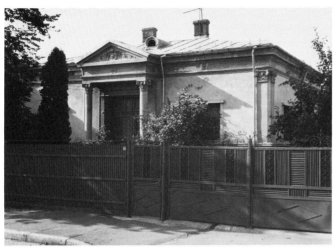

Neoclassical, single-family dwelling, early 20th century.

Mansion of the same period.

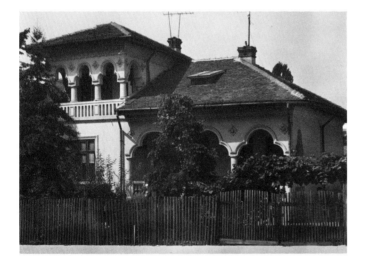

Neo-Romanian style, early 20th century or post-World War I.

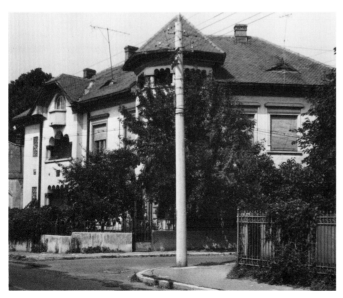

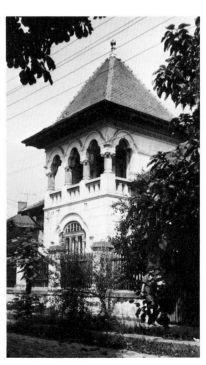

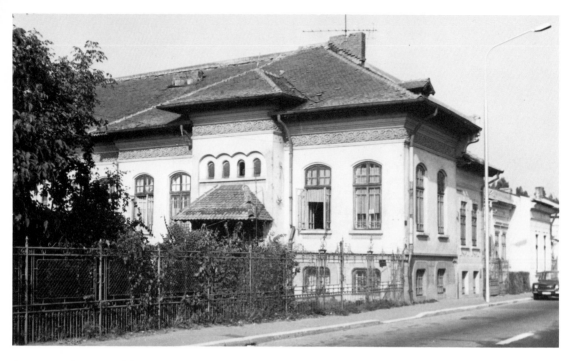

Structures from the 1920's and the early 1930's.

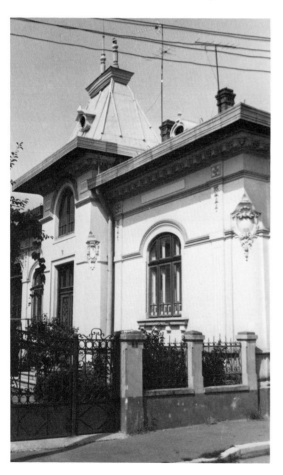

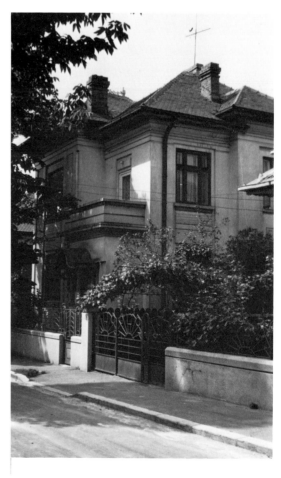

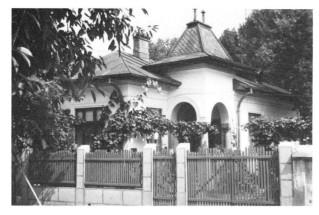

Other types of single-family houses.

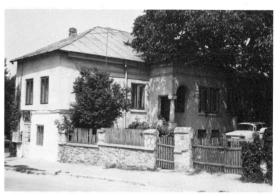

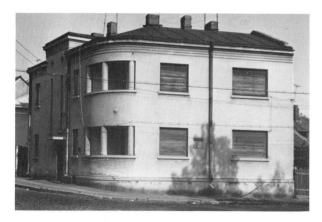

The Cubist style of the late 1930's. Located in the central zone of Craiova all these houses are destined to disappear in the systematization process.

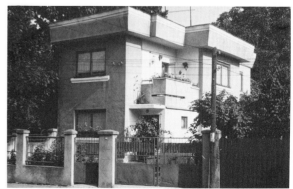

Craiova

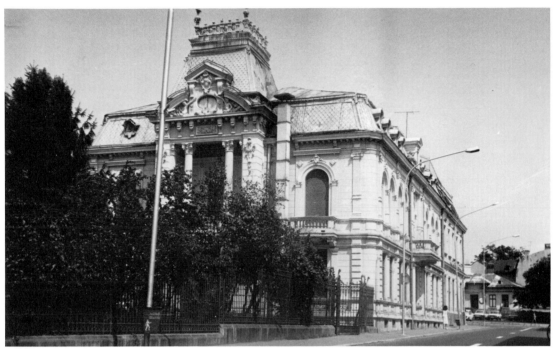

Public building, eclectic style, 19th century.

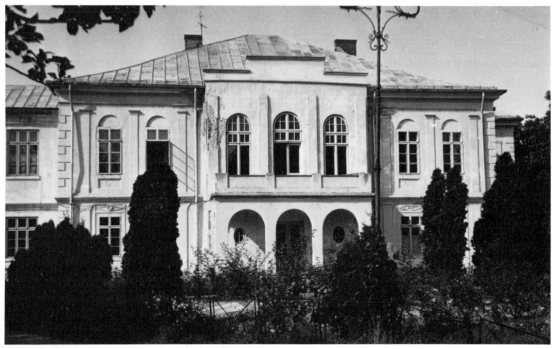

Former Glogoveanu mansion (residence of a major Craiova landlord), 17th–18th century, restored in the 19th century. The deterioration is visible on the facade. In the 1960's and 70's, the county court was located here.

In Craiova, as throughout the country, little has been done to maintain the traditional urban architectural stock in normal condition. The cost of such repairs would have been a small amount compared to the great expense of demolition.

All photographs were taken in August 1986. Since no maps and no planning schedules of the demolition have ever been released, it is not known how many houses of the central zone of Craiova are still in place in spring 1989.

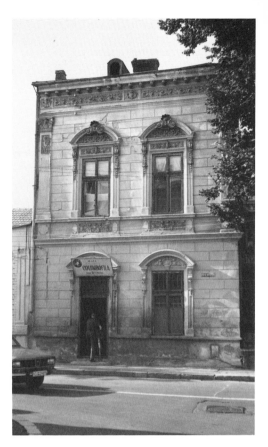

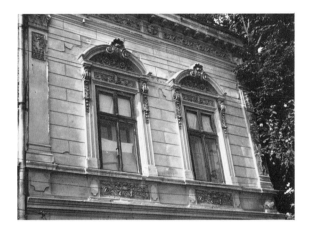

The deterioration process on a two-story building.

Single-family houses in Craiova, late 19th century, eclectic style; repairs to the facade would change the general appearance and restore the value of the premises.

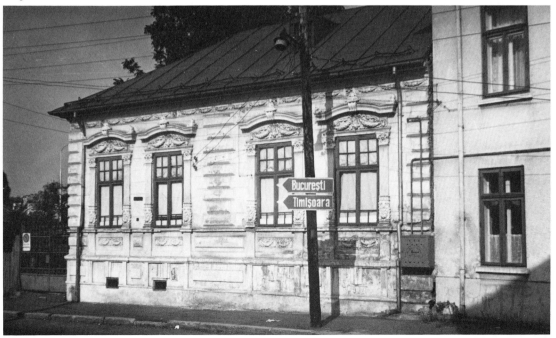

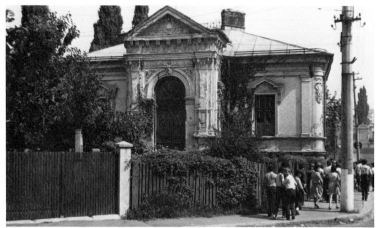

Another example of a late 19th-century, one-family house. One need not be a professional to imagine the same building after some repairs.

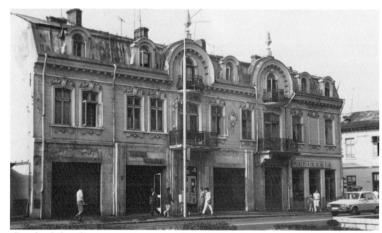

Gradual dereliction at the ground and third-floor levels; 19th century or early 1900's, eclectic style, in the center of Craiova.

These houses in the central area of Craiova were left without normal maintenance and were scheduled for razing in 1986.

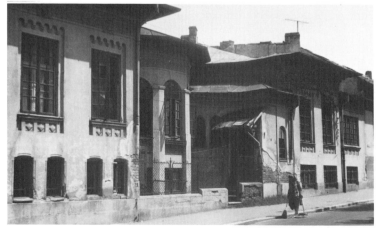

The town of Tirgoviste (Arges county) was the capital of the Principality of Wallachia in the 15th–17th centuries.

Large areas of Tirgoviste have been demolished and reconstructed with apartment buildings. All photographs were taken in September 1985.

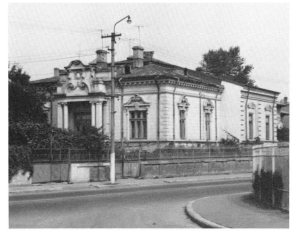

One-family house, eclectic style, late 19th century or early 1900.

A house with its basic structure dating from the 17th–18th centuries. The deterioration, visible at the second floor, could have been repaired without a major investment. Buildings in this condition are considered by the town administrations to be in an advanced state of decay and thus slated for demolition.

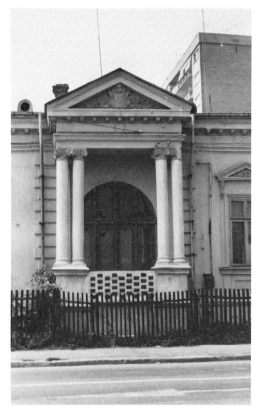

Neoclassical dwelling. In the background, the multistory apartment buildings advance and eventually replace all old structures.

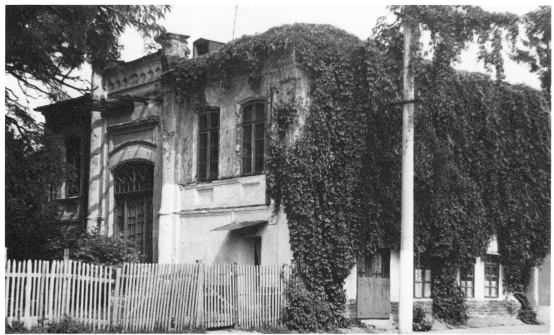

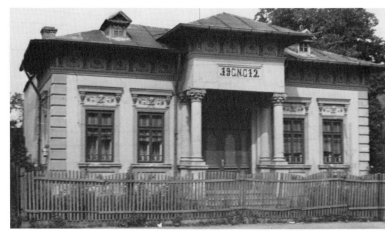

One-family house. Above the front door the initials of the first owner, "G.N.G.," and the date, 1912.

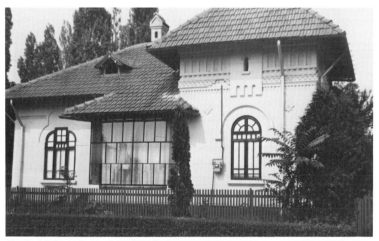

Early 20th-century, one-family house. Kept in normal condition, the traditional urban architecture maintains its value.

Market place with warehouse, early 20th century.

The tenement buildings are replacing the single-family dwellings.

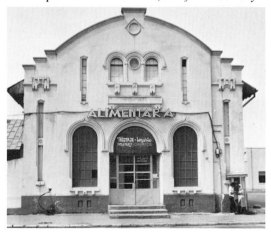

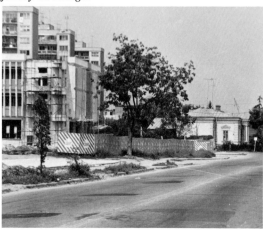

Botosani (Botosani county), documented in the 15th century, is one of the finest examples of urban architecture in the 17th, 18th and 19th centuries. More than 80 percent of the old constructions have been demolished and replaced mainly by the same multistory, standardized tenement buildings.

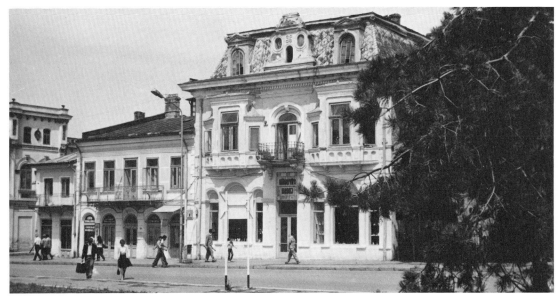

A few traditional structures have survived and were kept in place.

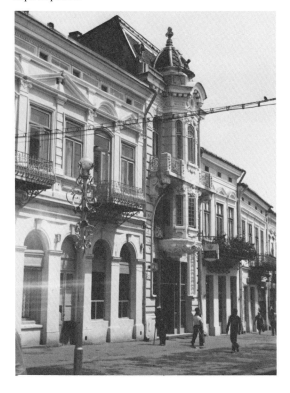

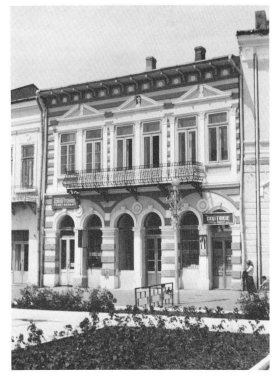

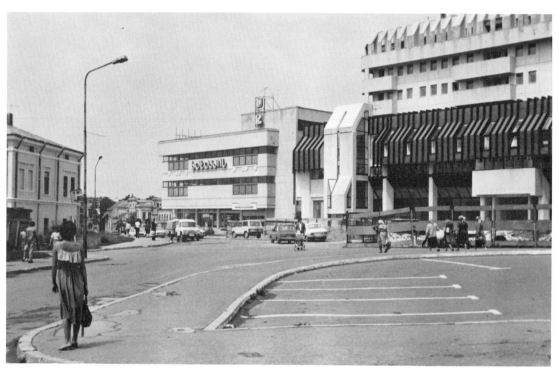

A department store built in the 1980's; at left and in the background, houses waiting for demolition (August 1985).

Piatra Neamt (Neamt county) was documented in the 15th century. Small parts have been spared by the restructuring process. All photographs were taken in July 1985.

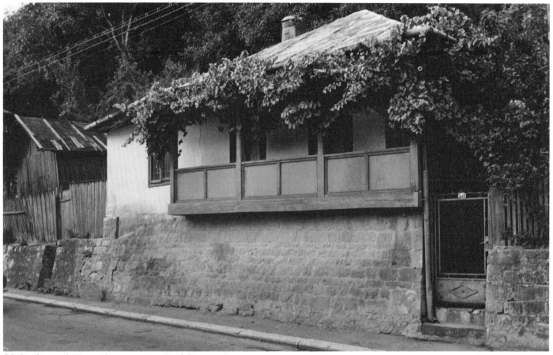

58 Stefan cel Mare Street, a typical Romanian house. The typology dates from the 17th century.

38 on the same street, 19th century. With an open terrace at the ground floor, this type is prevalent in the countryside from the 17th century forward.

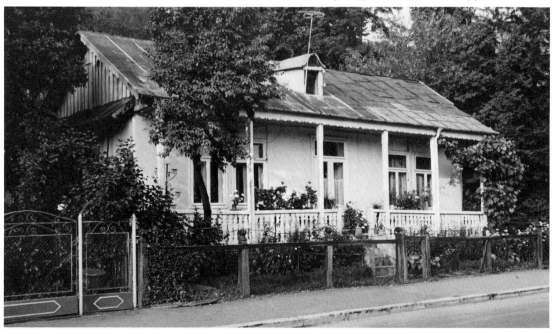

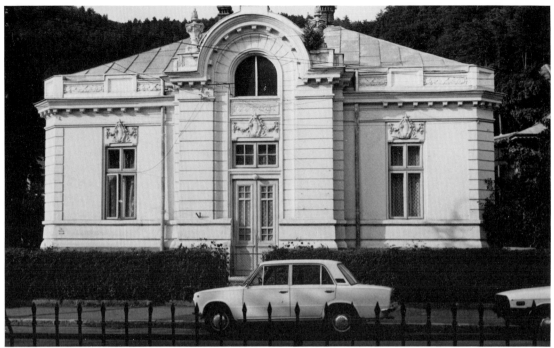

Eclectic-style mansion; a striking example of the traditional urban style.

A structure from the 1860's.

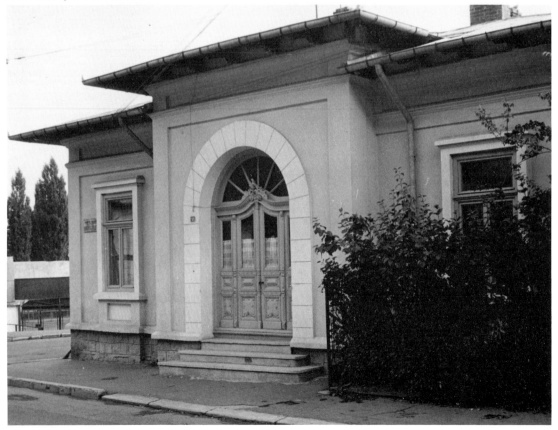

Pitesti (Arges County) is first mentioned in 1388. More than 90 percent of the traditional architecture has been demolished. Here are a few examples of the old structures. All photographs were taken in November 1985. It is not known how many of the houses on Constantin Brancoveanu and Saint Friday streets are still in place in Pitesti in 1989.

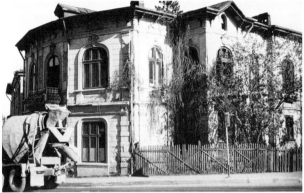

A late 19th–early 20th century mansion on Tirgul din Vale Street (Lower-Town Street).

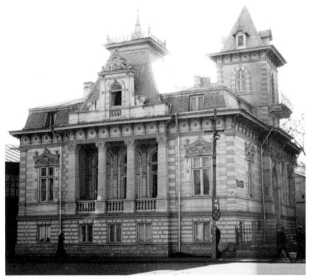

An eclectic-style mansion on the same street.

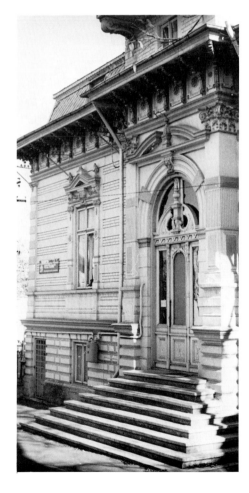

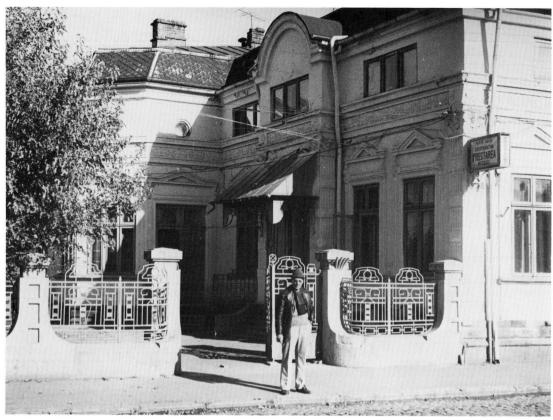

Constantin Brancoveanu Street.

On Sfinta Vineri (Saint Friday) Street. (In Bucharest the streets with names of saints were officially renamed in 1986–1987.)

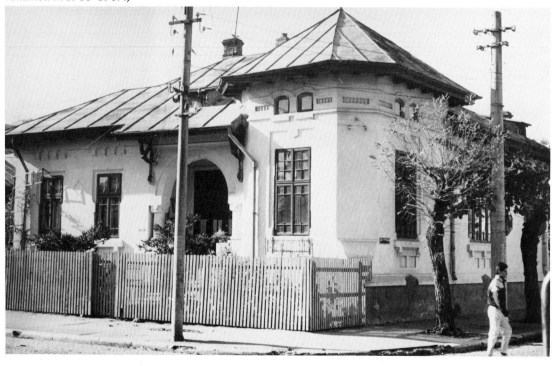

Resorts and watering places are illustrative of traditional Romanian urban architecture. With the present pace of destruction, these documents of Romania's identity and civilization will soon vanish, like the other demolished urban and rural sites, as if they had never existed.

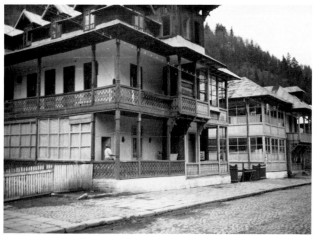

Comarnic (Prahova county).

Calimanesti (Vilcea county).

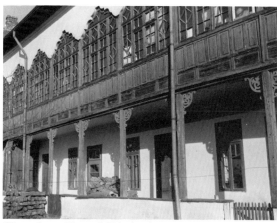

Cimpulung-Muscel (Dimbovita county).

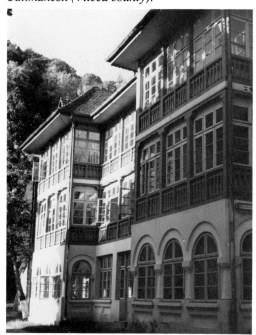

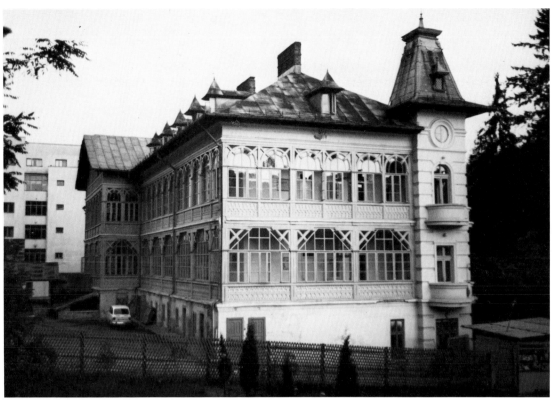

Olanesti (Vilcea county).

Govora (Vilcea county).

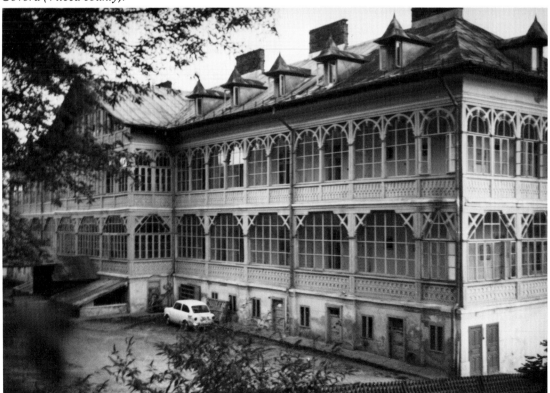

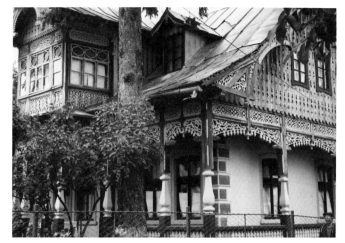

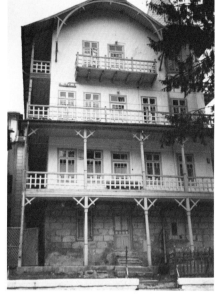

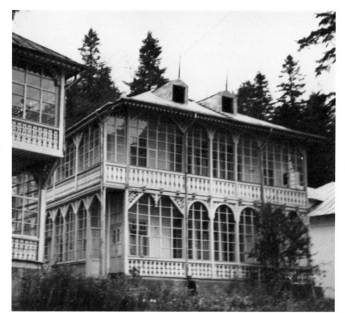

Slanic Moldova (Bacau county).

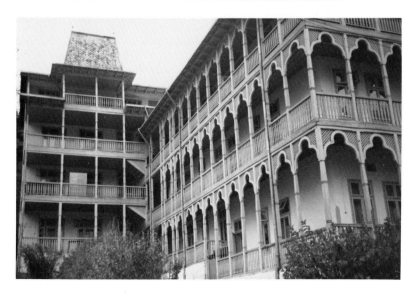

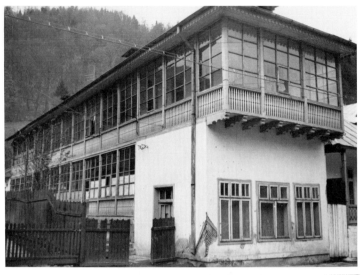

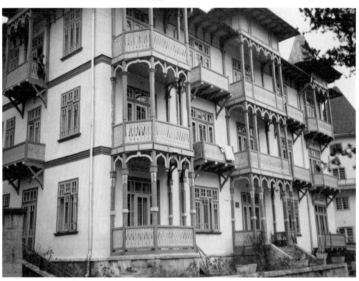

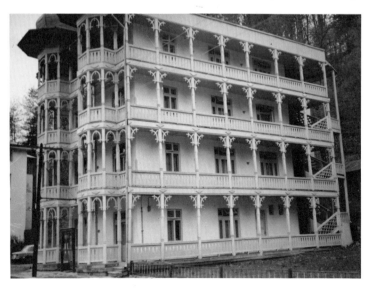

Towns in Transylvania conserving Hungarian architectural traditions.
(Photos of Hungarian architecture: Oliver A. I. Botar, Jr.)

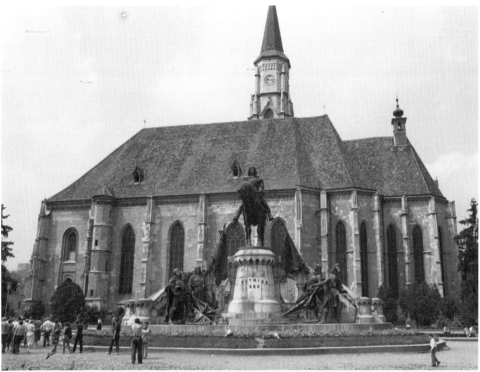

Cluj (Koloszvar, Klausenburg), Cluj county, Equestrian statue of Matthias Corvinus, King of Hungary. In the background, St. Michael's Church, Gothic, 14th–15th centuries.

Townhouses in Cluj.

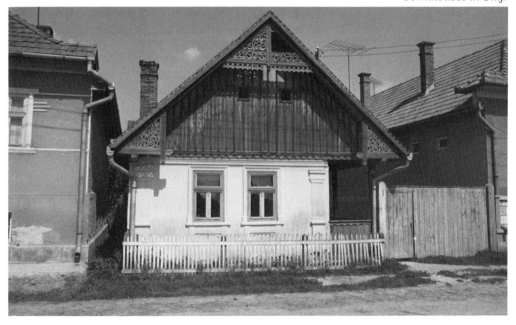

View of Cluj from Citadel Hill.

Cluj, view of the main square with structures dating from the mid-19th century.

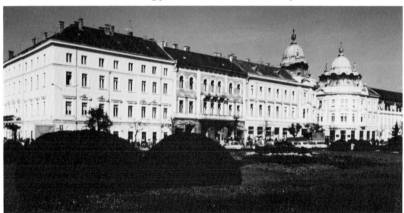

*Tirgu Mures (Marosvasarhely), Mures county.
View of old town from the tower of the Hungarian
Reformed Church.*

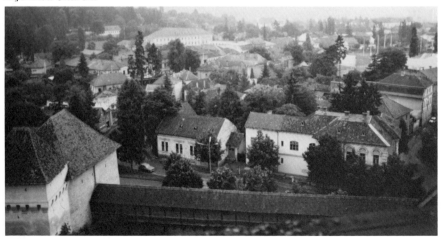

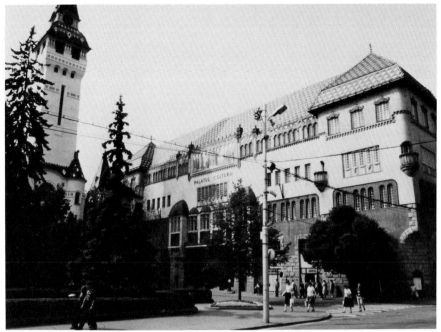

Tirgu Mures, former town hall and former music school, architects Marcell Komor and Dezso Jakab, 1907–1908.

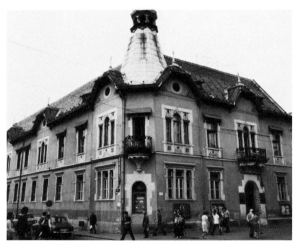

Tirgu Mures, Art Nouveau buildings on the main square.

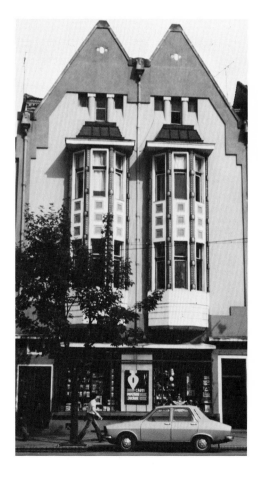

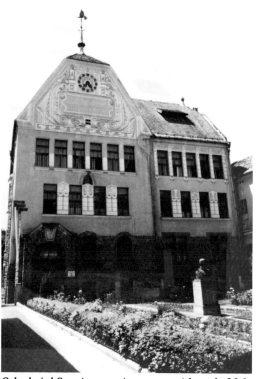

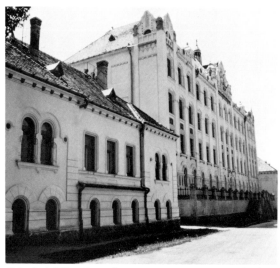

Odorheiul Secuiesc, former state gymnasium, built in 1893.

Odorheiul Secuiesc, main square with early 20th-century Hungarian urban structure.

Odorheiul Secuiesc (Szekelyudvarhely), Harghita County. Main square with Hungarian Reformed Church (1563, refitted in 1781) and county administration building (late 19th century, eclectic).

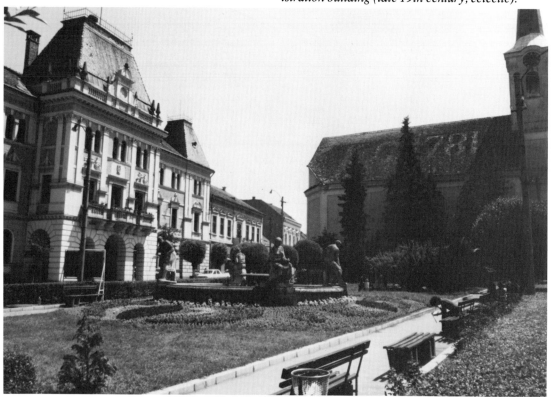

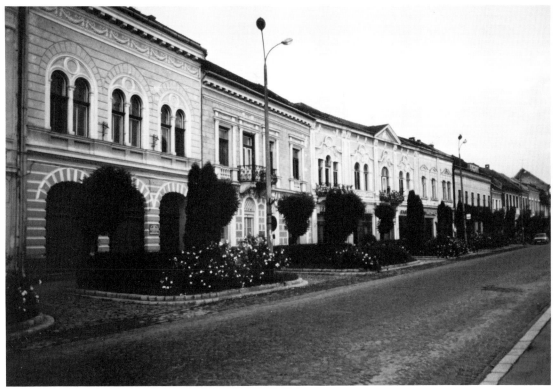

Tirgu Secuiesc (Kezdivasarhely), Covasna county.
Typical urban structures, built as guild houses in
late 18th century and early 19th century.

Sfintu Gheorghe (Sepsiszentgyorgy), Covasna
county. Szekely Museum built by Karoly Kos, 1913.

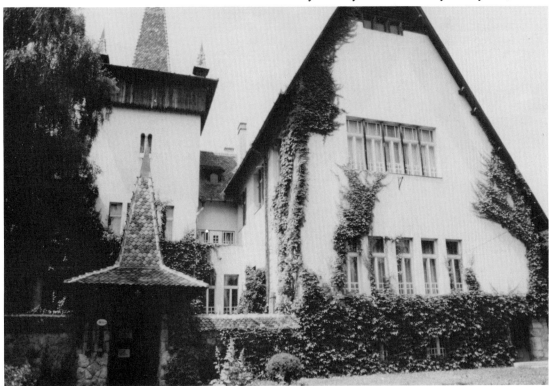

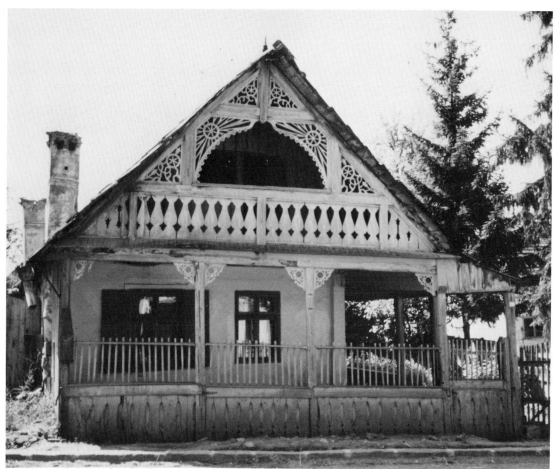

Miercurea Ciuc (Csikszereda), Harghita county.
Single family home, older interior structure with
mid-19th century modifications.

Sighisoara/Schässburg was founded in the 13th century by the German (Saxon) colonists who settled in Transylvania. The town in its entirety is highly representative of the provincial German urban architecture. Many monuments and structures are from the 16th–18th centuries, and many others date from the 19th century. Sighisoara/Schässburg should be declared a historic site. The same status must be granted to all the principal towns of Transylvania in which a centuries-long co-existence of different communities shaped a specific cultural urban environment with architectural values shared by Romanians, Hungarians and Germans. Among the towns which are to be considered historic sites in their entirety are: Timisoara, Arad, Oradea, Sighetu Marmatiei, Dej, Cluj (Koloszvar/Klausenburg), Turda, Alba-Iulia, Bistrita (Bistritz), Reghin, Medias (Mediasch), Sebes (Muhlbach), Tirgu Mures (Marosvasarhely), Sfintu Gheorghe (Csikszentgyorgy), Miercurea Ciuc (Csikzereda), Odorheiul Secuiesc (Szekelyudvarhely), Brasov (Kronstadt), Feldioara, Fagaras, Sibiu (Hermannstadt) and Lugoj.

The following photographs include monuments and townscapes of Sighisoara, in August 1985. Special programs are urgently needed to permit repair and restoration of these structures.

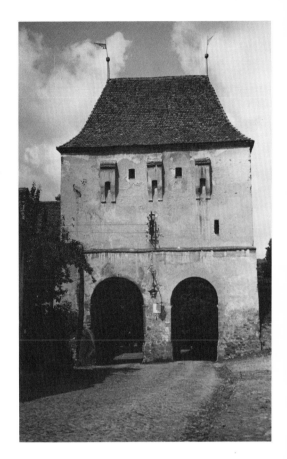

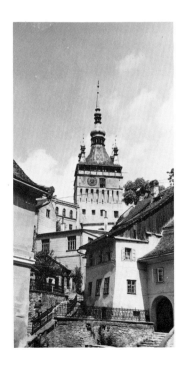

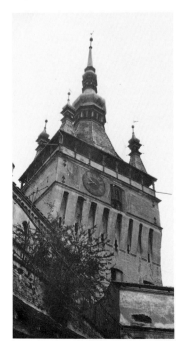

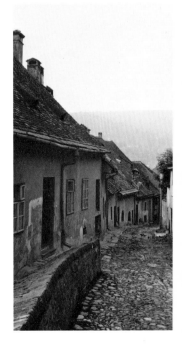

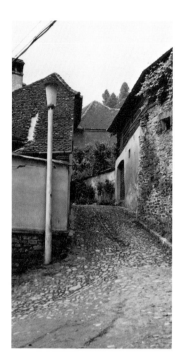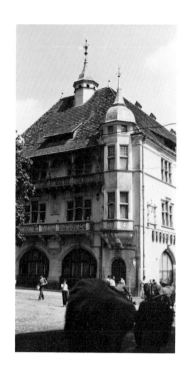

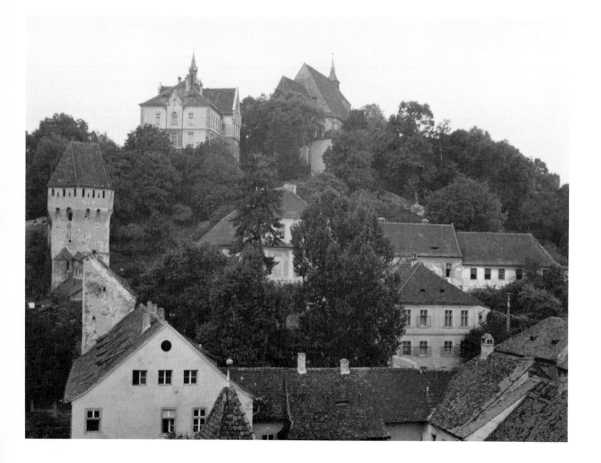

The town of Brasov/Kronstadt was founded by German (Saxon) settlers in the 13th century. With a great number of structures from the 15th century to World War II, the whole town should be declared a historic site.

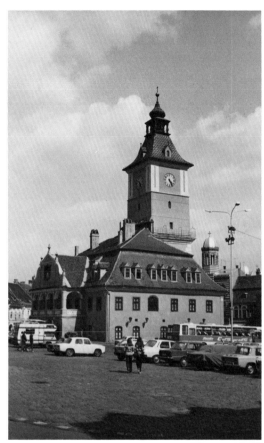

The townhall.

19th-century high school on Nicolae Iorga Street.

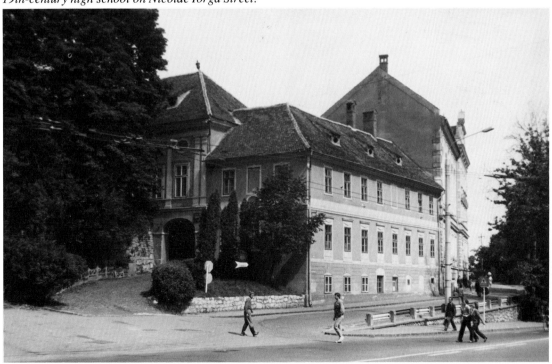

Streetscapes.

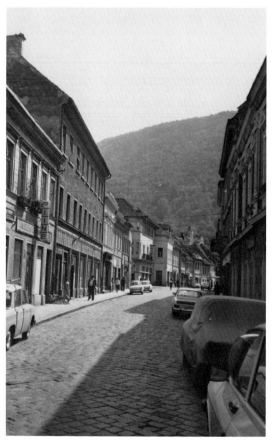

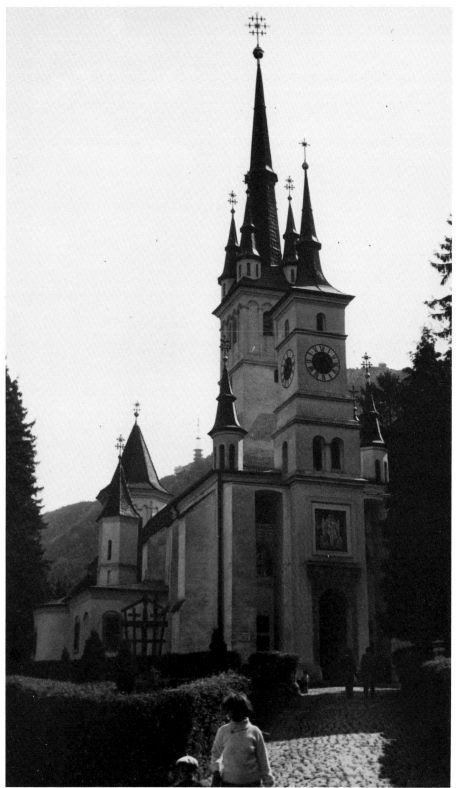

*Saint Nicolae-Schei orthodox church in the area in-
habited by the Romanian community since the
14th–15th centuries.*

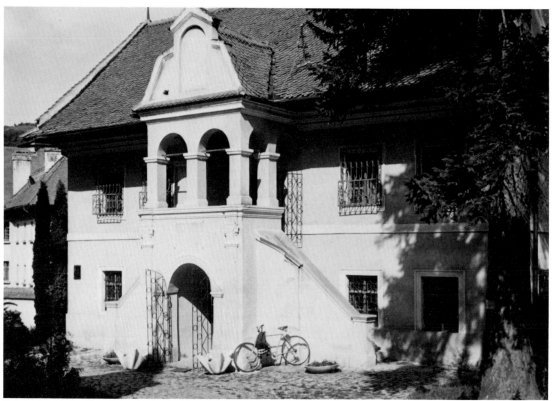

Romanian school at Saint Nicolae-Schei.

Dwellings and streetscape in the same area.

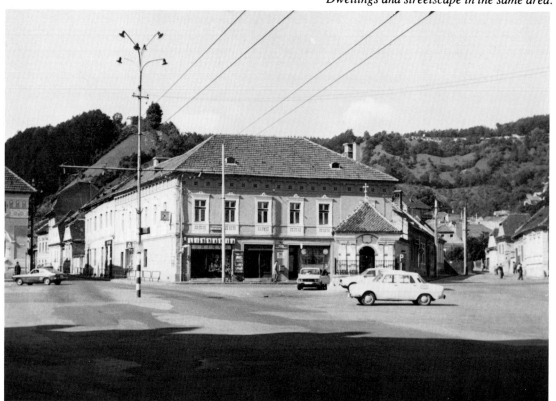

Brasov, old residential German architecture

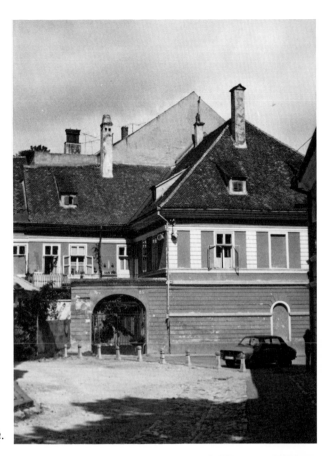

Near the Black Church.

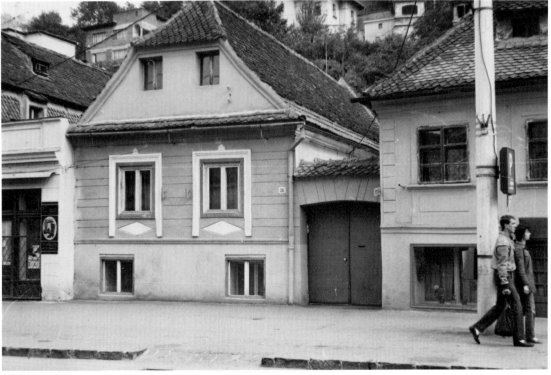

26 Lunga Street.

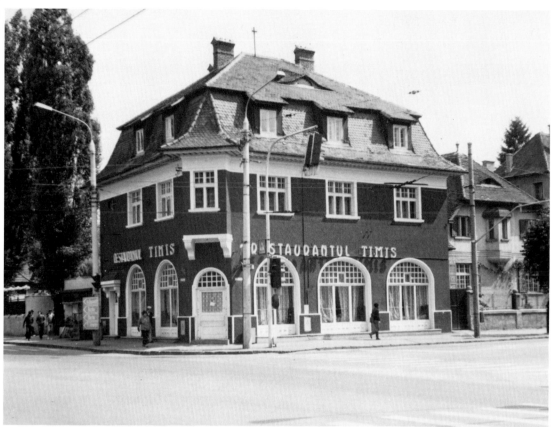

On Karl Marx Street.

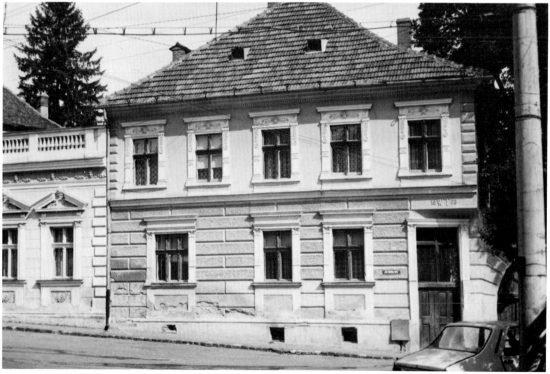

On Fintina Rosie Street, mansion built in 1908 on an earlier pattern.

Brasov, Secession and Jugendstil
architecture

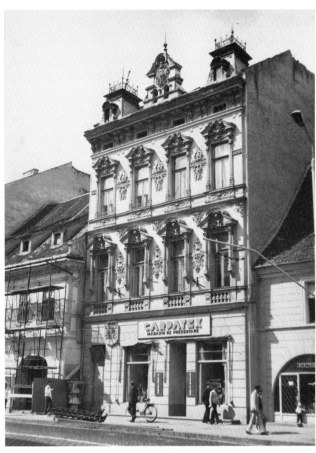

No. 17, 7 November Street.

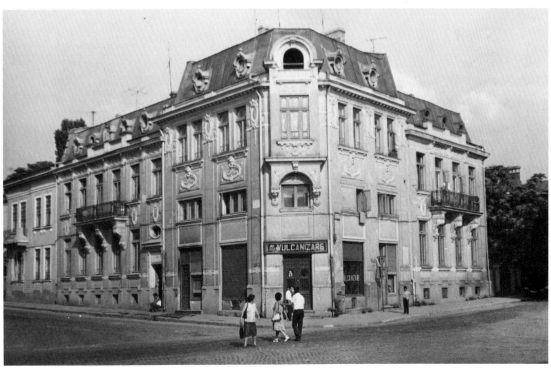

Near the Polytechnical School.

Brasov, interwar buildings of the 1920's and 1930's

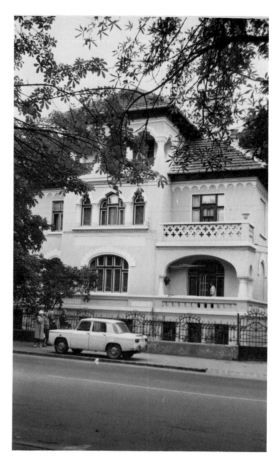

Near Andrei Saguna high school.

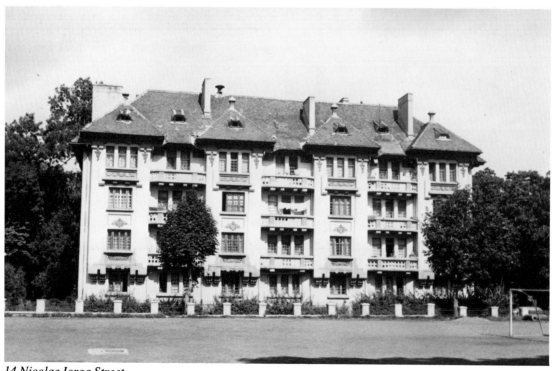

14 Nicolae Iorga Street.

Towns in Transylvania with significant German architecture. (Photos: Oliver A.I. Botar, Jr.)

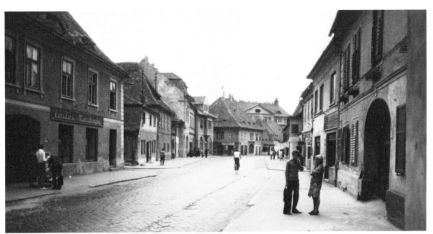

Sibiu, two views of lower town showing typical German architecture of the 17th–18th centuries, sometimes built upon earlier structures.

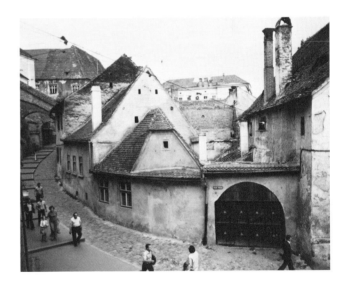

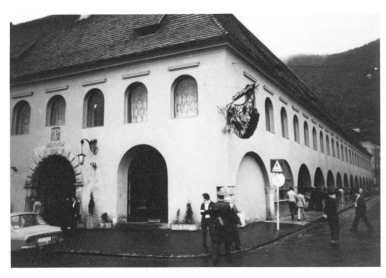

Brasov (Kronstadt), Brasov county, The Carpathian Stag Inn, built in 1545 as House of Commerce.

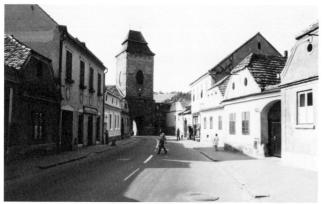

Medias (Mediasch), Sibiu county. View towards 16th-century town entrance gate and tower, with houses dating primarily from the 17th and 18th centuries.

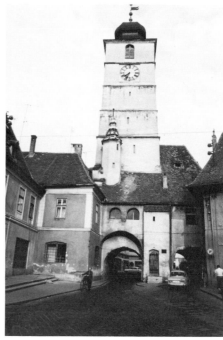

Sibiu, view toward the tower of City Hall, built in the 16th century.

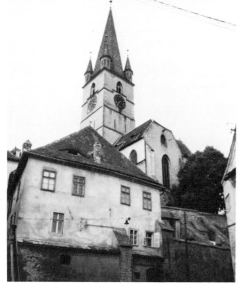

Sibiu, view toward upper town and Lutheran Bishop's Church (14th century), with structures in the foreground dating from the 17th–18th centuries.

Sibiu (Hermannstadt), Sibiu county. Main square with typical German Saxon structures from mid-17th century.

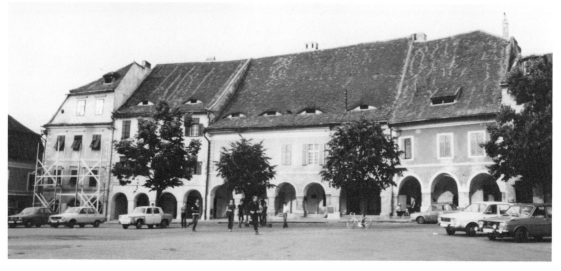

THE RURAL ARCHITECTURAL HERITAGE

THE RURAL ARCHITECTURAL HERITAGE

Guidelines.

Some guidelines were officially set forth for rural systematization: the reduction of the built perimeter, the increase of population density as a peremptory condition to raise the standard of living, a rational traffic network and urban facilities, such as running water and bathrooms. The guidelines were set to reduce gradually the differences between town and village(1). Preliminary studies were carried out in the Slatina, Calarasi and Dragasani districts. Prior to 1968, Romania had been divided into regions and districts. Professionals agreed to develop a civic center with a town hall, cinema, lecture hall, a club and a library, shopping units and multi-story buildings equipped with urban comfort(2).

What kind of habitat? Single-family, privately owned houses or three to five-story tenement buildings? This early question(3) was fundamental to the future of the villages, whether Romanian or Hungarian, German or Serbian. According to the March 15, 1966, census of 19,105,056 inhabitants, 87.8 percent were Romanians, 8.4 percent were Hungarians, 2 percent Germans and 1.8 percent belonged to other nationalities.

The peasants' answer.

The peasants' response has been an uncompromising one throughout the entire period. According to the March 15, 1966, census, there were 3,323,416 single-family privately owned houses in the countryside. (Figures of the January 1978 census are not available.) In the 1951–1985 interval, 2,120,480 houses were built "by the population with its own forces" as the Romanian *Statistical Yearbook* puts it (1,994,720 in the villages and communes and 126,360 in the suburban areas)(4). This means that almost two-thirds, or 63.8 percent, of the rural dwellings were rebuilt by the peasants

in 35 postwar years. In some places, such as Otopeni, near Bucharest, 95 percent of the inhabitants were living in new houses by 1970(5). Otopeni was one of the first places where "rural systematization" was implemented. The houses were demolished and replaced by five-story tenement constructions in 1987–1988.

All these 2,120,480 one-family houses surrounded by gardens represent private investment and labor. Although a thorough analysis of the nationwide postwar architectural activity has never been made, its trends have been outlined. Among the positive ones:

a) Increased durability of the constructions by the use of cement, bricks, tiles, industrial lumber and oil-base paints.

b) Increased comfort, such as windows five-to-six times larger than the traditional ones, more indoor space, a separate kitchen and terra-cotta stoves replacing the hearth, formerly used both for cooking and heating.

c) Larger living space: 7.9 square meters per inhabitant according to the 1966 census. Whereas the traditional house covered between 10 and 30 square meters, the average new one had 77 square meters in the 1975 census, which represents an increase of 385 percent. In 1975, houses with three or more rooms increased to 52.8 percent, vs. 38.8 percent in 1970, whereas those with 2 rooms dropped to 34.7 percent vs. 45.2 percent in 1970 and with one room to 12.55 percent, vs. 16.0 percent in 1970.

d) Continuity and development of some traditional architectural patterns, such as in new two-story houses in Oltenia and Muntenia (historic provinces between the southern Carpathians and the Danube River), in the Hateg district, in the southern parts of the Apuseni mountains, in Transylvania, or in northern Moldavia. The link to the past is visible in many one-story houses of rectangular or square plan rebuilt throughout Romania. According to a study completed in the early 60's, "the new rural dwellings which most frequently continue very old traditional patterns have been gradually adapted to superior standards of life"(6).

e) Furniture, radio and TV sets, sewing machines, gas stoves and electric irons became customary items in tens of thousands of rural households every year(7).

All these trends give indisputable evidence of the villagers' receptivity to comfort, of their willingness and ability to improve their standard of living in their own homes despite the dramatic and fundamental changes they had to face in the postwar years.

Negative tendencies have been outlined too: few bathrooms; the near impossibility of creating an infrastructure for running water and sewerage (alternative solutions suited to the one-family rural household have not been discussed to date); the influence of low-standard suburban patterns, such as harsh colors on the facades and the abandonment of some of the main principles of traditional housing types(8).

The professionals stepped in with their own answer to the basic issue—one-family privately owned dwellings or state-owned apartments in collective buildings? The latter have been envisaged for state employees in the rural civic centers, whereas the villagers would continue to live in their private homes and gardens(9).

Planned reduction in the number of villages.

By 1973, sketches of systematization were drawn up for 125 communities in Ilfov county: villages considered by the administration as being "without prospects for de-

velopment" would be regrouped to open up approximately 7,300 hectares (approximately 1,804 acres) for agriculture. The housing would include stove-heated apartment buildings and single-family, privately owned houses stemming from the existing local types(10). Sixty-five sketches were completed for Dolj county(11), whereas the Mures county proposals led to differentiated projects with civic centers and private dwellings(12).

At this early stage, when the concepts of resettlement and regrouping were referred to in general terms, two experimental studies went directly to the point for the Calarasi and Slatina districts (1967).

	Calarasi	Slatina
Existing villages	45	120
Number of villages per 100 square kilometers	2.9	9.6
Average number of inhabitants per village	1,800	785
Villages with less than 1,000 inhabitants	13	90
Number of people living in the above-mentioned villages (percent of the district's rural population)	29%	75%
Rural centers to remain in place after systematization	20	27

The planned reduction in the number of villages (55.5 percent in Calarasi district and 77.5 percent in Slatina) was motivated by the following: the small size of the existing localities, the loss of agricultural land by households stretching along the roads, a concentration of investments into units with the best economic conditions. What about the inhabitants? For 29 percent (Calarasi) and 75 percent (Slatina) of the rural population, the regrouping will take longer. No details on future housing conditions were given(13). This prospect was a total reversal and a direct rejection of the option exercised by the peasants, who by their private initiative and financing had raised 2,128,480 new one-family houses (see above pp. 1–2). Some articles acknowledge this reality: "The peasant prefers living in an individual house with his courtyard and household," a condition reinforced by the agricultural cooperative statute(14), which continues the earlier situation where the peasant owned his land.

"Systematization means a long-time process until the inhabitants will be persuaded of the great advantages offered by the new center: schools, shops, running water, in short, good conditions of life. . . . In our studies we have determined places for some major communal buildings but people don't want to move to the new locations given to them"(15). This is why in almost every systematization study of the late 60's and early 70's, the one-family house is the basic unit, whereas collective buildings were projected in the center of the new communes. This is why "flexible systematization" was suggested with no rigid patterns, with no multiplication of identical buildings, organized in order to give "a certain freedom of choice" to everyone(16).

The small village.

The small-size village is the rural architectural heritage. The average village has 880 inhabitants and the average commune has 2,000(17). Of the 13,123 villages, 232 are linked to towns and 12,891 are grouped into 2,705 communes(18).

Number of inhabitants per village	No. of villages	%
Up to 500 inhabitants	5,673	44.0%
Between 501 and 999 inhabitants	3,465	26.9%
Between 1,000 and 1,999	2,409	18.7%
Between 2,000 and 4,000	1,041	8.1%
More than 4,000 inhabitants	303	2.3%
Total	12,891	100.0%

11,547 villages or 89.6 percent are small with less than 1,999 inhabitants. For the entire country the average size is, as cited, 880 dwellers. (Figures have not been released for the Hungarian, German or Serbian villages, but they fit within these percentages.)

The small-size village is the normal size for Romania's peasantry. The one-family house and the little rural community are the two essential patterns of the peasant's individualism. To live in a privately owned house surrounded by a garden and in a community in which everyone knows everyone else is the outcome of centuries of evolution and is a mode of existence centered on the individual. This is a social reality in which the individual is the main factor. This is why 70.9 percent of Romania's villages have less than 999 residents and 18.7 percent have between 1,000 and 1,999 residents. To contend that small size means backwardness is to reverse a main stream of Romanian rural history. Modernity and civilization can be achieved by adapting the one-family house to contemporary technical standards.

The value, the importance and the significance of popular architecture is universally acknowledged. This rural heritage —houses, households and sites of specific fabric—is the very synthesis of a people's history and expresses the national identity. To destroy this rural heritage and to replace it with standardized construction means not only to destroy a centuries-long evolution but at the same time to change the essence of a nation through a kind of social engineering never seen and never before accomplished at this scale in Europe's long history.

NOTES: CHAPTER 2

1) Arch. Ioan L. Baucher, "Unele principii in legatura cu sistematizarea satelor" (Some problems of village planning), in *A., XV*, 1(104), 1967, pp. 6–7 (English summary, p. 1); Architects Peter Derer, Mircea Stanculescu, "Sistematizarea localitatilor rurale" (Opinions on village systematization), in *A., XVI*, 5(114), 1968, pp. 9–10; idem, "Locuinta factor primordial in procesul de sistematizare rurala" (The dwelling, main component of rural planning), in *A., XXV*, 5(168), 1977, p. 57 (English summary, p. 3).

2) Arch. Ioan L. Baucher, "Tendinte in arhitectura si sistematizarea noua a satelor" (New trends in village architecture and planning), *A., XIX*, 5(132), 1971, p. 39. This image of village civic centers was taken for granted among professionals, administrators and activists in the 60's and 70's.

3) Architects Peter Derer and Mircea Stanculescu, Op.cit.

4) *Anuarul Statistic al Republicii Socialiste Romania (Statistical Yearbook of the Socialist Republic of Romania),* 1987 edition, Directia Centrala de Statistica (Central Directorate of Statistics), Bucharest, p. 63, table 43.

 For the March 1966 Census, see Arch. Mircea Stancu, "Arhitectura mestesugareasca contemporana a cladirilor de locuit" (Handicraft methods used by contemporary architecture in the building of dwellings), *A., XVIII*, 6(127), 1970, pp. 61–65, footnote 4 (English summary, p. 5).

5) See *A., XVIII*, 2(123), 1970, pp. 36–37.

6) Professor Arch. Dumitru Vernescu, "Prolegomene," *A., XVIII*, 2(123), 1970, pp. 37–38; Professor Arch. Horia Teodoru, "Trebuie studiata noua arhitectura a satelor," ibid., p. 54. Both emphasize the need to know in detail this nationwide experiment caused by the peasants' private initiative.

 Two studies examine some features of the new rural architecture and its links with traditional patterns: Paul Henri Stahl, "Case noi taranesti" (New peasant houses), *Studii si cercetari de istoria artei (SCIA)*, XI, 1964, Bucharest, pp. 15–33 (Russian and French summaries); Paul Petrescu and Paul H. Stahl, "Decorul in arhitectura populara romaneasca," *SCIA*, VII, 1, 1960. pp. 75–109 (Russian and French summaries). Paul H. Stahl is "Directeur d'Etudes" at the Ecole des Hautes Etudes en Sciences Sociales (Paris) and Director of the Department of European Sociology and Ethnology, University Rene Descartes—Sorbonne (Paris). Paul Petrescu conducts research in West Germany. Since the early 60's, Paul Petrescu and Paul Stahl have been prominent researchers in Romanian popular art, ethnography and ethnology.

7) Arch. Mircea Stancu, op.cit., pp. 63 (see note 4); see also pp. 64–65; Dumitru Vernescu, op.cit., p. 38, 40; Arch. Ion Popescu, "Noile functii ale casei rurale" (New functions of the peasant's house), *A., XVIII*, 2(123), 1970, pp. 47–48; Arch. Gheorghe Polizu, "Materiale traditionale—materiale noi," idem, pp. 44–47 (discusses new materials used in rural constructions); Arch. Mircea Talasman, "Confort in locuinta rurala" (Comfort in rural dwellings) idem, pp. 50–51; Architects Peter Derer and Mircea Stanculescu, "Sistematizarea localitatilor rurale" (The systematization of villages), *A., XVI*, 5(114), 1968, p. 10; Arch. Dumitru Iancu, "Aspecte ale noii arhitecturi rurale" (Aspects of new rural architecture), *A., XIX*, 5(132), 1971, pp. 40–41: the one-family house with two stories represents the starting point for development in the next two decades (English summary, p. 2); Arch. Ioan L. Baucher, "Locuinta—factor primodial in procesul de sistematizare rurala" (The dwelling, main component of rural planning), *A., XXV*, 5(168) 1977, p. 57 (English summary, p. 3).

8) Arch. Mircea Stancu, op.cit., p. 63; Arch. Ignace Serban, "Problema principala: sistematizarea satelor" (The main problem: rural systematization), *A., XVIII*, 2(123), 1970, pp. 52–53; Professor Arch. Dumitru Vernescu, op.cit., p. 40; Arch. Dumitru Iancu, op.cit., p. 41; Arch. Ioan Baucher (see note no. 2).

9) Arch. Petre Derer and Mircea Stanculescu, op.cit., p. 10; Arch. Aurelian Triscu,
 "Arhitectura sateasca" (Rural architecture), *A.*, XVI, 5(114), 1968, p. 12; Arch. Aristide
 Streja, "Locuinte individuale rurale pentru investitii din fondurile proprii ale populatiei"
 (Private dwellings in the countryside to be built by means of private investments), *A.*,
 XIII, 5(96), 1965, pp. 46–47; see the whole set of projects, *A.*, XVIII, 2(123), 1970. pp.
 33–54: "Trei concursuri pentru locuinte satesti" (Three contests for rural dwellings); all
 the awarded projects refer to the one-family private house; Professor Arch. Ghika-
 Budesti, "Trebuie sa ne adaptam noilor nevoi functionale" (We should adapt ourselves
 to new functional needs), *A.*, XVIII, 2(123), 1970., pp. 53–54. See also, Arch. Ioan
 Baucher, "Unele principii in legatura cu sistematizarea satelor" (Some problems of vil-
 lage planning), *A.*, XV, 1(104), 1967, pp. 4–29 (English summary, p. 1; especially p. 8);
 Arch. Ofelia Stratulat," Studii asupra gospodariei si locuintei rurale" (Studies on the
 rural household and dwelling), *A.*, XVII, 2(117), 1969, pp. 8–13.
 Various projects for one-family houses in Arch. Cezar Niculiu's "Locuinta
 satului din Baragan in contextul dezvoltarii judetului Ialomita" (The rural house in
 Baragan in Ialomita county), *A.*, XXII, 3(147), 1974, pp. 55–57: semi-detached one-fam-
 ily houses with two or three stories (p. 56); "the peasant needs a house with land sur-
 rounding it" (ibid.).
 Various projects of one-family houses have been drawn in Brasov, Dimbovita,
 Sibiu, Prahova and other counties: Arch. Ioan L. Baucher, "Locuinta, factor principal in
 procesul de sistematizare rurala" (The dwelling, main component of rural planning), *A.*,
 XXV, 5(168), 1977, pp. 58–59.
10) Architects Dinu Antonescu, Nicolae Leca and Gabriela Contescu, "Activitatea de azi si
 de miine a arhitectilor din judetul Ilfov" (The present and future activity of the architects
 of Ilfov district), *A.*, XXI, 2(141), 1973, pp. 44–46 (English summary, p. 5); see also
 Arch. Ion Geicu, "Prognoza retelei de localitati a judetului Ilfov in perspectiva anului
 2000" (Prognosis on the settlement network of Ilfov district), ibid., p. 47; Engineer Dan
 Constantinescu, "Sistematizarea localitatii Bolintinul din Vale" (The systematization of
 the village of Bolintinul din Vale), ibid., p. 47; the houses will range from the one-fam-
 ily type to five-story buildings.
 Arch. Angela Scheletti, "Schita de sistematizare pentru viitorul oras turistic
 Snagov" (Planning scheme for the future Snagov touring town), *A.*, XXI, 2(141), 1973,
 p. 50 (English title, p. 6). The commune Snagov composed of seven villages will be-
 come a tourist polycentric town by regrouping two former villages. The civic center will
 be provided with collective multistory dwellings; private houses will remain in the other
 areas. Earlier sketches of systematization in 20 villages in the Bucharest region: Arch.
 Aurelian Triscu, "Reteaua de localitati rurale in regiunea Bucuresti" (Planning study of
 the community network in the Bucharest region), *A.*, XV, 1(104), 1967, pp. 10–13 (En-
 glish summary, p. 2); the author stresses the importance of the vernacular one-family
 house.
 Development variations for the 12 communes (35 villages) in the suburban area
 of Bucharest are discussed in Arch. Iancu Dumitru's, "Dezvoltarea comunelor suburb-
 ane municipiului Bucuresti," *A.*, XVIII, 1(122), 1970, pp. 40–41.
11) Arch. Teodor Cocheci, "Dolj" (A presentation), *A.*, XXI, 3(142), 1973, pp. 2–3 (English
 summary, p. 1).
12) Arch. Ileana Nits, "Unele observatii dupa o prima etapa a campaniei de sistematizari
 rurale" (Some remarks following the first stage of rural planning action), *A.*, XXI,
 2(141), 1973, pp. 16–17 (English summary, p. 2).
13) Arch. Mircea Possa, "Doua studii experimentale pentru sistematizarea raioanelor
 Calarasi si Slatina" (Two experimental studies for the planning of Calarasi and Slatina
 districts), *A.*, XV, 1(104), 1967, pp. 14–17 (English summary, p. 2).
14) Architects Petre Derer and Mircea Stanculescu, "Sistematizarea localitatilor rurale" (The
 systematization of rural communities), *A.*, XVI, 5(114), 1968, p. 10.

15) Arch. Rado Coloman, "In unele sate se mai construieste spontan si neorganizat" (Spontaneous and nonsystematical construction sites in some villages), *A.,* XV, 1(104), 1967, p. 25 (see English summary, p. 3). Cf. arch. Ileana Nits (see above, note no. 12).

16) Arch. Aurelian Triscu, "Arhitectura sateasca" (Rural architecture), *A.,* XVI, 5(114), 1968, p. 12.

17) Dr. Arch. Alexandru Budisteanu, "Sistematizarea si modernizarea—procese cu efecte de amploare pentru inflorirea satelor patriei" (Systematization and modernization—processes with long-lasting effects for the development of the country's villages), *Revista economica,* 24, 1988, Bucharest, pp. 3–4 and 6. The author is the head of the Systematization Center.

18) The average is 5 villages per commune. 188 communes have only 1 village, 1291 communes have between 2–4 villages, 1107 communes have between 5–10 villages and 119 communes have more than 10 villages, ibid., p. 4.

Rural Architecture in Romania

Traditional rural architecture expresses a logical correlation between constructed space and natural environment, between intimacy and monumentality. The single-family dwelling and the small rural community are the essential elements of peasant identity. Within a community in which everyone knows one another, the privately owned house surrounded by a garden represents a mode of existence centered on the individual. It is the result of development and progress over the centuries.

To imply, as do the official government statements, that the small-scale village with its single-family dwellings symbolizes backwardness reverses the course of rural history in Romania. The outright destruction of some 7,000–8,000 villages and the reconstruction of the remaining 5,000–6,000 has been portrayed officially as an improvement in the peasant standard of living. The government's goal is to homogenize Romanian society as a whole. But modernity and improved living standards are easily achieved by adapting the single-family house to contemporary technical standards, rather than by moving people into concrete, multistory tenement buildings. The result of rural systematization will be the forced transformation of millions of peasants into state tenants. The individual cultural identity of the Romanians and every minority—Hungarian, German, Serbian and Ukrainian—will be crippled and changed forever.

The importance, significance and value of popular architecture is universally acknowledged. The individual houses and the sites that comprise the rural heritage synthesize the history of a people. They express the Romanian identity, as well as that of the Hungarian, German, Serbian and Ukrainian peasant communities that have existed with the Romanians for centuries.

Official figures released in March 1988 and again in June project the reduction in the number of villages from the present 13,123 to a maximum of 5,000–6,000. Thus, approximately 7,000–8,000 rural centers will vanish from the map. Those villages remaining will be 90–95 percent demolished and built anew, following the program that has already begun around Bucharest and in other areas.

Beginning in the late 1970's, dedicated professionals in Romania—among them architects, historians and art historians—maintained that the basic single-family, privately owned house must remain the central unit of the contemporary rural village. To equate enhanced quality of life with the standardized apartment building denies the very history of the evolution of rural and urban life.
(Photos: Giurescu Documentation)

Examples of traditional Romanian rural dwellings (village name followed by the county, in parentheses).

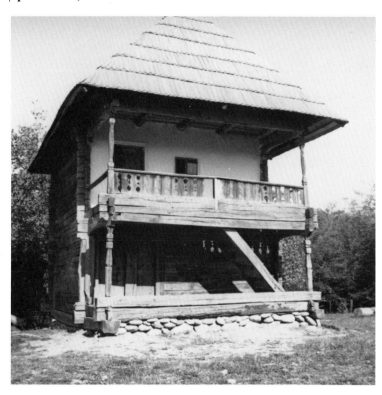

Curtisoara (Gorj)

Provita (Prahova)

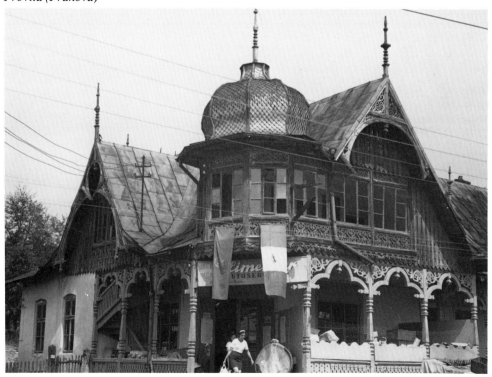

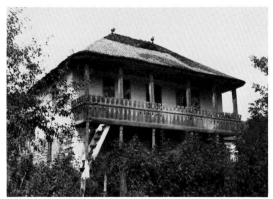

Posesti (Prahova)

Golesti (Arges)

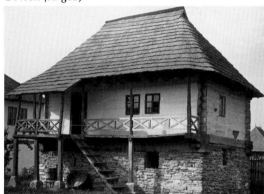

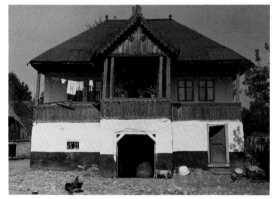

Ogretin (Prahova)

Urechesti (Gorj)

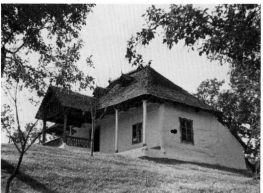

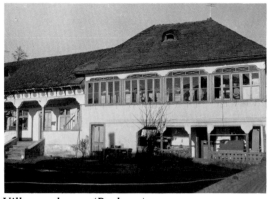

Village unknown (Prahova)

Chiojd (Buzau)

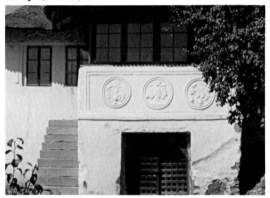

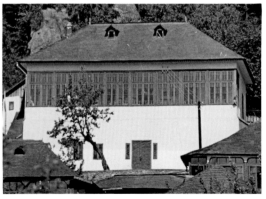

Namaesti (Arges)

Namaesti (Arges)

Rural-style dwellings in towns.

During the 17th and 18th centuries, rural residential architectural styles were adapted in Romanian towns. Some examples still exist.
(Photos: Giurescu Documentation)

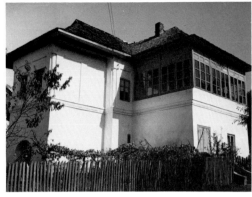

Rimnicul Vilcea (Vilcea)

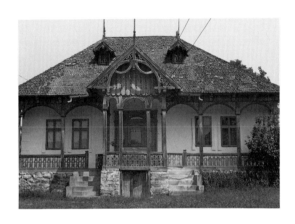

*Breaza (Prahova),
above, right and below.*

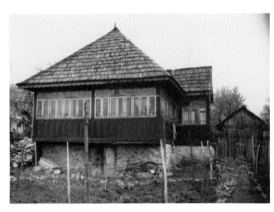

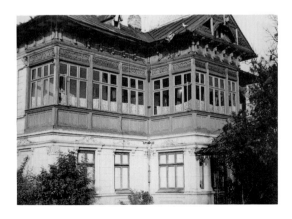

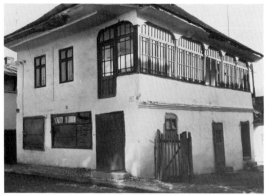

Cimpulung (Arges)

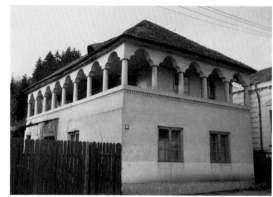

Pucioasa (Dimbovita)

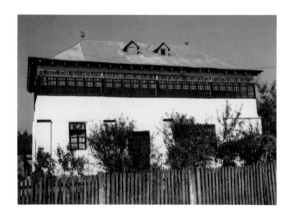

*Tirgul Jiu (Gorj),
above and right.*

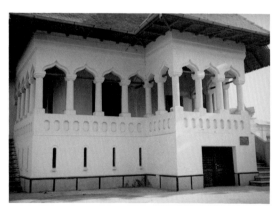

Hungarian Rural Architecture
(Photos: Gabor Boros)

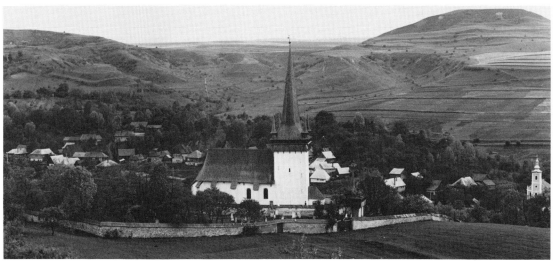

Hungarian village of Valeni (Magyarvalko), Cluj county. Inhabitants live in single-family, privately owned houses. In the foreground, 13th-century church; at the right, a smaller Baroque church.

Peasant house, exhibiting traditional floral ornaments carved into the wooden doorway. Tetisu (Ketesd), Salaj county.

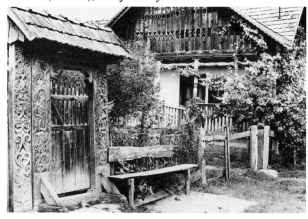

Szekeley house and Hungarian Reformed church in the village of Bisericani (Szentelek), Harghita county.

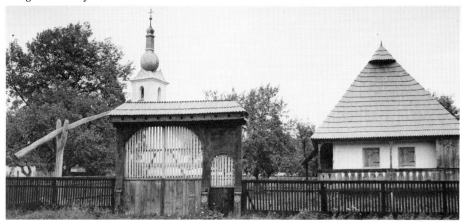

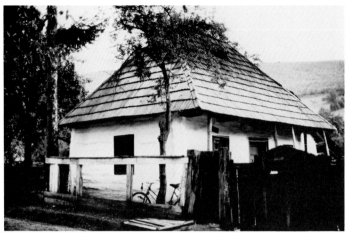

Hungarian peasant house with shingle roof, Zagon (Zagon), Covasna county.

Peasant house with thatch roof, birthplace of Ady Endre (1877–1919), the prominent Hungarian poet. Ady Endre (Ady Endre Falu), Satu Mare county.

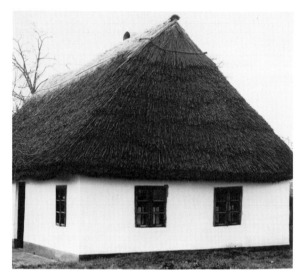

The Chapel of Jesus and peasant houses on the outskirts of the town of Odorheiul Secuiesc (Szekelyudvarhely), Harghita county.

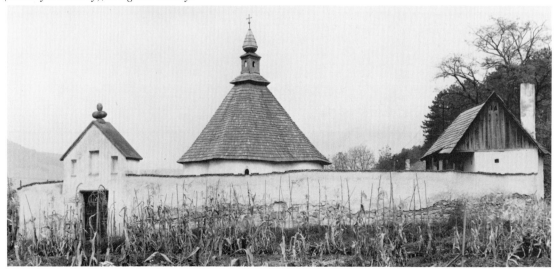

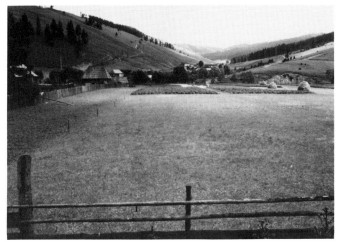

Village of Lunca de Jos (Gyimeskozeplak), Harghita county. (Photos, above and below, left: Oliver A.I. Botar, Jr.)

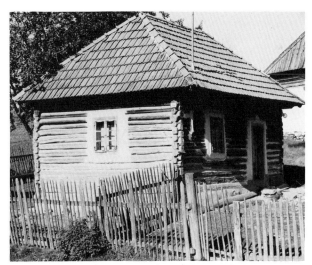

Hungarian wooden peasant house, Lunca de Jos (Gyimeskozeplak), Harghita county. (Photo: Gabor Boros)

Village of Satu Mare (Marefalva), Harghita county. Peasant houses along the main street.

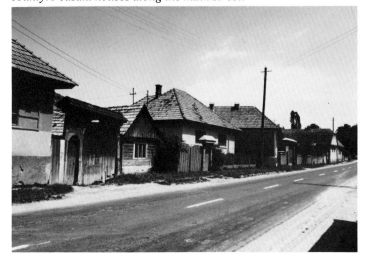

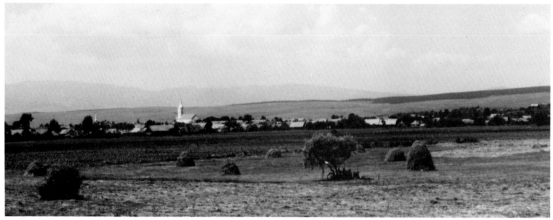

Village of Frumoasa (Csiksepviz), Harghita county.

Village of Capilna (Kapolnas), Harghita county.
Decorative entryway.
(Photos: Oliver A. I. Botar, Jr.)

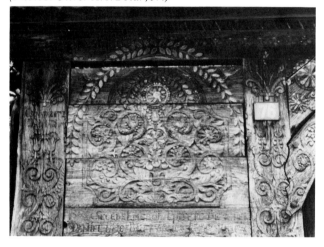

Village of Satu Mare (Marefalva), Harghita county. Traditional carved gate in front of a single-family house.

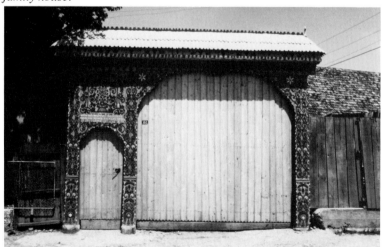

German rural architecture.
(Photos: Oliver A.I. Botar, Jr.)

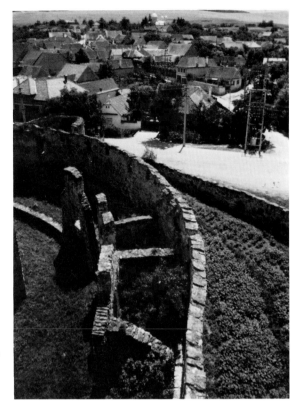

Village view of Cilnic (Kelling), Alba county. One of the oldest rural sites in Transylvania (documented in the 13th century), taken from the fortified church and citadel.

Cristian (Grossau), Sibiu county. German houses along the main village street.

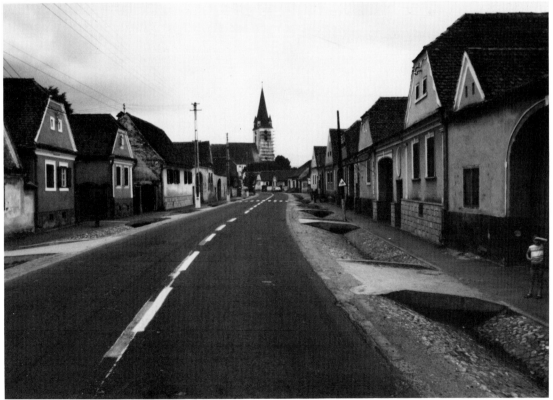

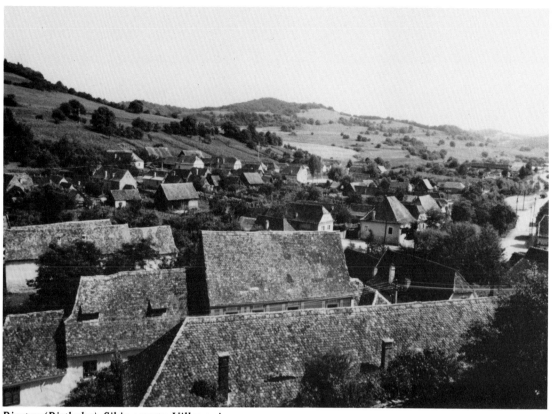

Biertan (Birthalm), Sibiu county. Village views
from the Reformed Church.

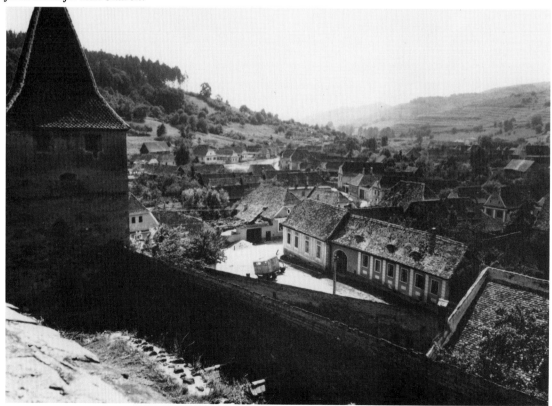

CONSERVATION AND RESTORATION IN THE POSTWAR YEARS

CONSERVATION AND RESTORATION IN THE POSTWAR YEARS

There was a slow start. Despite many difficulties, 15 major Roman and Byzantine citadels had been listed as historic monuments at the end of the war on April 25, 1945 (1). In the following three years, repairs were made at several churches, castles and memorial houses(2). In 1948 the Commission for Historic Monuments was closed down. Founded in 1892, this Commission in the post-World War I years had developed systematic nationwide research and restoration activities with special branches for Transylvania, Bukovina and Bessarabia. In 1951 a Scientific Commission for Museums, Historic and Art Monuments was created(3). Its first task was the inventory of monuments. Later on, the government issued a decree for the preservation and management of cultural monuments(4). The concept included archaeological sites, architectural, art and historic monuments and their "protection zones" (article 1; see also the "Regulation" annexed, article 1a, b and c).

In the next year, 4,345 cultural monuments were approved and listed(5). The Directorate for Historic Monuments, with departments for inventory, research, planning, preservation and restoration was organized in 1959(6). A review for museums and monuments, *Revista Muzeelor (Museums Review),* Bucharest, appeared in 1964, followed by the quarterly *Buletinul Monumentelor Istorice (Bulletin of Historic Mon-*

uments) (1971), marking the continuity with the academic periodical well known in the interwar period. The Commission for Historic and Art Monuments was reestablished in 1971(7). The Romanian ICOMOS Committee started its work on July 1, 1970(8).

The Directorate for Historic Monuments expanded its activities throughout the country. In the 60's and 70's it became an efficient organization with dedicated people, mainly architects, engineers, art historians and other professionals. A large and skilled team of building craftsmen was patiently and painstakingly brought together. One hundred and four complex restoration sites were opened in the 1954–1974 interval(9). Among the sophisticated projects and achievements are(10), in Transylvania and Banat the bastion of Timisoara (Austrian); the citadel of Cilnic; the Hungarian Roman Catholic cathedral of Alba-Iulia; Ion Zidaru's house in Bistrita; Saint Michael parish church in Cluj (Hungarian); Hirscher house in Brasov (German); the city hall in Sibiu (German), the evangelical church at Medias; the evangelical church at Sebes and the Prejmer citadel (all three German). In Wallachia: the monastery of Horezu; the Patriarchal church in Bucharest; the Curtea Veche (Old Court) in Bucharest; the Manuc Inn in Bucharest; the palace at Potlogi; the bishop's palace in Buzau; the Court in Tirgoviste. In Moldavia: the monasteries of Putna, Bistrita (Neamt), Dragomirna, Sucevita, Cetatuia, Dobrovat; the fortress of Suceava and the Suceava Inn in the town of Suceava. In Dobrogea, the site at Basarabi. Since a detailed report on the restorations completed in the 1954–1977 interval has not been published, important restoration sites may be missing from the above-mentioned list.

Surveys of annual activities were occasionally released. Thirty-one restorations were completed at the end of 1974(11). Another twenty-one were added in 1976(12). Every issue of the The *Monuments Bulletin* between 1970–1977 included approximately 15 to 20 articles and notes on research and on construction sites(13). The Commission for Historic Monuments and the Directorate for National Cultural Patrimony held monthly meetings and annual sessions to discuss various topics toward the mid-70's(14). Dozens of fully restored monuments enlarged and enhanced the Romanian architectural heritage and, at the same time, the historic heritage of the German and Hungarian communities. Architects, engineers, art historians, archaeologists, historians and others cooperated. Archival research preceded the field work. The guiding principles were: to recover the original state, if possible, and the significant phases of a monument's evolution; to remove the trivial or redundant additions to the site; and to avoid hypothetical reconstructions. Various ingenious technical solutions and procedures were discovered and expanded by the engineers of the teams(15).

A new consciousness slowly developed. The mass media stepped in, thanks to the commitment of a few devoted journalists, broadcasters and writers. The 1955 list with 4,345 cultural monuments (see above) was reexamined. Further proposals raised this number to 6,456 in 1974, to 8,922 in 1977 and to 10,072 in 1978(16). They never received official approval and the situation remained among the great expectations of dedicated professionals. Three decades ago, 5,518 rural hydraulic installations were still working. These included 4,475 corn grinding mills, 30 oil presses, 446 felting machines for the thickening of cloth and 424 saw-mills(17). It is unknown how many are in place now. Folk art museums opened throughout the country in the 60's and early 70's(18). Monographs, articles, studies, brochures and

albums focused on popular art and architecture, on diverse items of ethnography and ethnology. There was increasing interest and awareness of the values stemming from the one-family rural household which embodies a way of thinking, a mode of life, and represents a major component of the national identity(19).

Romania's mural painting heritage included 635 monuments of which 30 were of Byzantine style, 14th and 15th centuries; 80 were Romanian paintings in Byzantine tradition, 14th–17th centuries; 500 were Romanian paintings (in the Byzantine tradition), 18th century; 25 were in the Gothic style of the German and Hungarian communities of Transylvania(20). Specialists from Romania and the International Center for the Study of the Preservation and Restoration of Cultural Property (ICCROM), Rome, worked together on certain projects(21). The restoration of mural paintings and its techniques were advanced with significant results(22). Contributions to the restoration work of popular architecture and folk art should be mentioned, too(23).

The concept of historic heritage extended to both urban and rural architectural areas with their fabric. A Plenary Session of Romania's Union of Architects validated this concept (July 19, 1973): "Through its personality and traditional components, the center or the historic set maintains a cultural continuity and a human scale, to attain variety in the sites that develop in new technical and economic conditions. The monuments and the architectural areas should be integrated into the social and economic life and become active constituents of contemporary life, keeping their housing, commercial, cultural, educational and touristic functions. . . . The urban fabric, the size, the height, the green areas, the architectural scale of the whole, the protected zones around the monuments, a careful evaluation of infill without damaging the existing balance—all this must be taken into account in order to make the most of these centers"(24).

An official comment released at a meeting attended by architects and urban planners at the Central Committee of the Romanian Communist Party on February 24, 1975, raised new hopes. It stated that the specialists should concentrate on keeping the city's specific features as developed throughout the ages and on making the most of the existing buildings and of the road network. The city should be examined street by street and house by house; "demolitions, waste of space and a change of the city's architectural fabric should be avoided to the utmost extent." It was furthermore recommended "that the new constructions should harmonize with the existing ones"(25). Some guidelines were drawn up at a popular rally in the capital on March 6, 1975(26) and in the town of Tirgu Mures in September following the visit of the leadership to Calarasi, Iancului and Dudesti (three areas of Bucharest which were demolished to a great extent in 1987–1988).

A central state commission, the Directorate for the National Patrimony with offices in Bucharest and in the counties, was set up(27) to implement the provisions of a 1974 "Law for the protection of the National Cultural Heritage"(28). The newly organized Directorate was commissioned to examine projects for territorial systematization, including towns and other centers(29). For a balanced definition of the urban architectural heritage, the Directorate organized joint sessions with the participation of the Architects' and Fine Arts' Unions. The first effective results came out in cooperation with the urban planners of Bucharest, Brasov, Sibiu and Tirgu Jiu(30). The protection and restoration of some segments of Mosilor and Calarasi Avenues in Bucharest were agreed upon. Later in the early 80's, the "Calea Mosilor,"

from the intersection with Republicii Boulevard to Mihai Bravu Blvd, was almost completely leveled and reconstructed with tenements. The demolition included facades on Calea Mosilor, between Republicii Blvd and Mihai Eminescu street, characteristic of the Romanian urban architecture, which the Directorate for the National Cultural Patrimony had decided to conserve and to renovate in 1976. The Calea Calarasi eastward from Traian Plaza has been razed to a great extent; it is not known how much of Calea Calarasi closer to the city's center was still in place in fall 1988.

Eighteenth and nineteenth-century buildings and the medieval network of streets were identified in the towns of Pitesti and Roman, based on archival and field research(31). The same was done to a certain extent for Bucharest and other towns(32).

A law for "systematization, planning and road constructions in urban and rural centers" was enacted in November 1975. The need to protect the urban and rural fabric was expressly stated: The whole traffic system should be designed to retain and to make the most of the existing street network and constructions, "to maintain the architectural and urbanistic fabric . . . to respect the particular features . . ." and to avoid demolition. It was forbidden to raze built areas for new plazas or gardens. The opening, the enlarging or the closing of streets in the old parts of the towns were subject to prior presidential approval(33). The same provisions were repeatedly voiced at the Grand National Assembly when the law was unanimously approved(34). For almost two years, February 1975 to February 1977, the conservationists' message seemed somehow to have been understood. Romania's participation in ICOMOS and ICCROM was firmly established. A symposium was held July 2–7, 1977, on "Conservation and restoration of mural paintings" organized by the Romanian ICOMOS Committee and the Directorate for National Cultural Patrimony. There was discussion of the problems and achievements of Romanian specialists in the field, especially in Suceava, in the northern state of Bucovina. The symposium was attended by representatives from Belgium, Czechoslovakia, France, the German Democratic Republic, Hungary, Poland, Portugal, United Kingdom, Yugoslavia, UNESCO and ICCROM. Visits and discussions were organized at principal sites and at monuments with major mural paintings, such as Sucevita, Voronet, Moldovita, Humor, Arbore and Dragomirna; at churches where little was left of paintings—Probota, Sfintul Dumitru (St. Demeter) and Sfintul Ioan (St. John), both in Suceava; and at some prominent museums of Romanian art of the 14th–17th centuries, in Putna, Moldovita, Sucevita and Dragomirna. The papers submitted to the symposium along with an exhibition of specific projects with photographs and data showed the important results of a coherent national restoration and conservation policy in cooperation with the specialized international bodies and in accordance with pre-established guidelines(35). The proceedings of the symposium were published(36).

If maintained and continued, such trends would have saved significant parts of the country's architectural and artistic heritage(37). The movement for protection and restoration was severely damaged by the March 4, 1977, earthquake, which hit many towns and left 1,570 people dead. This occurred primarily in Bucharest. It was a quake that smashed the hopes and expectations that more protection be granted to the architectural heritage. An opposing policy was soon put in motion, which aimed to replace the traditional urban and rural architecture almost in its entirety. The implementation of this new concept, of this reverse trend, was speeded up in recent years.

NOTES: CHAPTER 3

1) Decree no. 1384

2) Work was started at the following Orthodox churches in May 1946 (county name in parentheses): Berinta and Carpinis (Satu Mare); Bob, Baciu and Apahida (Cluj); Sintimbru (Hunedoara); Bicsad (Harghita); Valea Bradului (Ciuc); Beznea (Salaj); Ighiel (Alba), at the Protestant church at Sic.

In 1948, at the churches of Saraca (Banat); Densus (Hunedoara), Vad (Maramures); Iclodul Mare (Mures); at the Hunedoara (Hunyad) castle (Hunedoara); at the Fagaras citadel; at the Coronation Palace in Alba Iulia.

In 1949, the memorial house I.C.Frimu at Birzesti (Vaslui county) and the church at Petrindu were listed historic monuments. Some repairs were started at the memorial houses Ion Creanga, town of Iasi, and I.C.Frimu (see above). At the same time demolition work planned by the new popular authorities at the Banffy castle at Bontida (Bonchida), at the Feldioara castle, at the Mureseni Gate and the City Hall of Brasov, at the Ghimbav castle was stopped before it was started: see Opris, *Heritage,* pp. 176–178, English summary, pp. 211–213).

3) Decision of the Grand National Assembly in Bucharest on March 15, 1951. An additional decree (no. 46) was issued the same year for the conservation of historic monuments: Opris, *Heritage,* pp. 178–179.

4) No. 661 on April 22, 1955, and the annexed "Regulation on the protection and management of cultural monuments." (Five chapters, 29 articles, Romanian text.)

5) *Lista monumentelor de cultura de pe teritoriul RPR (Cultural monuments list of the Romanian Popular Republic),* published by the Academy of the Romanian Popular Republic, The Scientific Commission for Museums, Historic and Art Monuments, Bucharest, 1956, XV, +195 pp.

6) Decree no. 781/1959

7) Decree no. 301/1971

8) Opris, *Heritage,* p. 182

9) Idem, p. 180

10) Idem, p. 197, footnote 49

11) *Monuments Review,* XLIV, no. 1/1975, Bucharest, pp. 94–95

12) Ibid., XLVI, no. 1/1977, p. 94–95

13) For example: Ibid., no. 1/1975 with 20 titles; no. 1/1976, 15 titles; no. 2/1976, 20 titles; no. 1/1977, 19 titles; no. 2/1977, 20 titles, etc.

14) A summary of the 1975 annual session included 16 papers focusing on urban architectural heritage, Transylvanian wooden architecture, churches and houses of the 16th–19th centuries, Moldavian fortresses, etc.; Ibid., XLV, no. 1/1976, Bucharest, p. 93.

15) Opris, *Heritage,* p. 181 and footnotes 53–59 (page 198). See, for example, the work of engineers Ion Munteanu, Dumitru Pirscoveanu, Gh. Paunescu, Elena Pagu, Eugen Ionescu, A. Dragulin, and D. Hasnas.

16) Opris, *Heritage,* p. 198, footnote 71.

17) Cornel Irimie, "Ancheta statistica in legatura cu reteaua de instalatii tehnice populare actionate de ape pe teritoriul Romaniei" (Statistical survey of water-powered technical installations on Romanian territory), in *Cibinum* 1967–1968, Sibiu. See also Opris, *Heritage,* p. 182 and note 64 (p. 198).

18) *Anuarul Statistic al Republicii Socialiste Romania (Statistical Yearbook of the Socialist Republic of Romania),* 1978 edition, Directia Centrala de Statistica (Central Directorate of Statistics), Bucharest.

19) See also Dr. Arch. Eugenia Greceanu, "Aspecte juridice privind conservarea monumentelor si ansamblurilor istorice," *A.,* XXIX, 2–3(189–190), Bucharest, 1981, pp. 85–86 (On some juridical components of monument and historic centers preservation).

20) The figures have been established by Vasile Dragut, cf. Opris, *Heritage,* p. 198, footnote 50.

21) Paul Philippot and Paolo Mora, "Raport asupra santierului pilot organizat in Moldova de Centrul International de studii pentru conservarea si restaurarea bunurilor culturale si Directia Monumentelor Istorice din RSR," in *Monuments Bulletin,* XLI, 2/1972, Bucharest (Report on experimental restoration work organized in Moldavia by the International Center for the Study of the Preservation and Restoration of Cultural Property (ICCROM) and by the Romanian Directorate for Historic Monuments).

22) Engineer Ion Istudor, "Un fenomen de denaturare a culorilor in pictura murala de la Voronet" (Color changes in the mural paintings of Voronet), in *Revista muzeelor (Museums' Review),* 1, 1965, Bucharest, pp. 65–66; Ion Istudor, "Cercetari de laborator privind conservarea monumentelor rupestre de la Basarabi" (Laboratory research on the conservation of Basarabi monuments), ibid., no. 6,1866, Bucharest, pp. 500–504; Ion Istudor, "Unele probleme privind curatirea, desinfectia si fixarea picturilor murale aparute cu prilejul restaurarii bisericii fostei manastiri Humor" (Some aspects of the cleaning, disinfection and fixing of mural painting of the Humor church), in *Monuments Bulletin,* XLII, 3/1973, Bucharest, pp. 54–58; Ion Neagoe, "Consideratii asupra operatiilor de consolidare" (Considerations on the consolidation of the Humor church), ibid., pp. 58–60; Nicolae Sava, Daniel Dumitrache, Oliviu Boldura, "Restaurarea cupolei pronaosului" (The restoration of the narthex dome, Humor), ibid., pp. 61–63; Jeno Bartos, "Probleme de chituire aparute in cursul lucrarilor" (Problems of the puttying process at the Humor church), ibid. pp. 66–70; Viorel Grimalschi, Stefania Grimalschi, "Probleme de curatire a picturii si de consolidare a peliculei de culoare exfoliate" (The cleaning and consolidation of the exfoliated paint layer, Humor), ibid., pp. 70–73; Al. Efremov, "Restaurarea picturii privita prin prisma istoricului de arta" (Restoration of the Humor painting—the art historian approach), ibid., pp. 76–79; Tatiana Pogonat, "Citeva consideratii asupra mortarelor folosite in restaurarea monumentelor istorice si de arta" (Some considerations on plasters utilized in the restoration of historic and art monuments), in *Monuments Review,* XLIV, 1/1975, Bucharest, pp. 90–91; Tatiana Pogonat, "Restaurarea picturilor murale din paraclisul manastirii Bistrita-Neamt" (Restoration of mural paintings in the pareklesion of the Bistrita-Neamt monastery), ibid., XLV, 1/1976, Bucharest, pp. 86–89; Ion Istudor, I. Lazar, I. Ionita and Lucia Dumitru, "Unele consideratii asupra fenomenului de eflorescenta a picturilor murale" (Considerations on the efflorescence phenomenon of mural paintings), ibid., XLV, 2/1976, Bucharest, pp. 87–89; Dan Mohanu, "Pictura murala a bisericii manastirii Dobrovat si urgente in restaurare" (Mural painting from the church of the Dobrovat monastery and its urgent restoration needs), ibid., XLVI, 2/1977, pp. 82–86. Later new results were released: Al. Ghillis, Materiale sintetice romanesti folosite in practica conservarii si restaurarii picturii in tempera" (Romanian materials used in the conservation and restoration of tempera painting), in *Museums Review,* 7/1983, Bucharest, pp. 39–44; Al. Ghillis, "Fenomenele fizice ale consolidarii straturilor picturale degradate" (Physical phenomena of the consolidation of deteriorated paint layers) ibid., 2/1984, Bucharest, pp. 27–33; Al. Ghillis, "Natural sau sintetic; optiuni in restaurarea moderna a picturii" (Natural or synthetic: options in modern painting restoration), ibid., 7/1984, Bucharest, pp. 21–24; Al. Ghillis, "Evaluarea unor sisteme adezive utilizate in consolidarea structurii picturilor degradate" (The evaluation of some adhesive systems in the consolidation of deteriorated paint structures), I, II, III, ibid., 1/1985, pp. 48–57; 2/1985, pp. 36–46 and no. 4/1985, pp. 32–41.

23) Barbu Aurel Pandele, "Conservarea lemnului din constructiile din muzeele etnografice in aer liber" (Wood conservation in ethnographical museums), ibid., 4 /1968, Bucharest, pp. 325–327; Dr. E. Vintila, "Protectia antiseptica si ignifuga a acoperisurilor din sita sau sindrila la obiectivele muzeografice in aer liber" (Antiseptic and fireproof protection of the shingle roofs), ibid., 3/1967, Bucharest, pp. 236–239; C. Bucsa, Gh. Ban, "As-

pecte metodologice privind actiunile de combatere a biodegradarii bunurilor culturale din lemn aflate in teren" (Methods to prevent the bio-deterioration of wooden objects . . .), ibid., 3/1980, Bucharest, pp. 56–69; C. Bucsa, "Metode de conservare si restaurare a lemnului" (Wood conservation and restoration methods), ibid., 10/1981, Bucharest, pp. 56–60.

24) Cited in *A.*, XXVIII, no., 3(184), 1980, Bucharest, pp. 58–59, by Arch. Dr. Eugenia Greceanu.

25) *Scinteia*, XLIV, 10, 112, February 25, 1975.

26) *Scinteia*, XLIV, 10, 113, February 26, 1975, and *Scinteia*, March 7, 1975.

27) Decree no. 13, January 17, 1975, published in *Official Bulletin*, XI, 15, part I, January 23, 1975, pp. 1–5.

28) Law no. 63, October 30, 1974, published in the *Official Bulletin*, X, 137, part I, November 2, 1974, pp. 9–12. According to the law (articles 2a and b), the concept of heritages incorporates "architectural and memorial monuments." The Central State Commission for National Cultural Patrimony had a department for the conservation and restoration of historic and art monuments (article 6b of Decreee no. 13, see above, footnote no. 27).

29) Decree no. 13, January 17, 1975, article 8g (see footnote no. 27).

30) Vasile Dragut, "Centrele istorice si monumentele de arhitectura, documente complexe ale societatii umane" (Historic centers and architectural monuments, complex documents of human society), in *A.*, XXIV, 4(961), 1976, pp. 9–10 (English summary, pp. 1–2). See also the Symposium held at the Architects' House in Bucharest, on February 24, 1976: "The conservation of urban and rural historic centers," with an introduction by Vasile Dragut and three papers presented by Georgeta Stoica, Arch. Eugenia Greceanu and Arch. Eugen Neculcea, in *A.*, XXIV, 3(160), 1976, pp. 6–7 (an account of the symposium, English summary, p. 3); Arch. Eugenia Greceanu "Ansamblul urban medieval Pitesti" (The medieval town of Pitesti), edited by the National Museum of History, Bucharest, 1982, 164 p. (French summary, pp. 154–162). A similar monograph was completed and published by Eugenia Greceanu for the town of Botosani.

31) Arch. Eugenia Greceanu, "La structure urbaine medievale de la ville de Roman" (The urban medieval structure of Roman), in *Revue Roumaine d'Histoire*, XV, 1976, 1; idem, "Elemente de metodica in cercetarea centrelor istorice ale oraselor" (Elements of methods applied to the research of historic town centers), *A.*, XXIV, 4(161), 1976.

32) To the articles already mentioned in Chapter 1 should be added: Eugenia Greceanu, "Realizari privind protectia unor centre istorice din sudul Transilvaniei" (Progress toward the protection of historic centers in Southern Transylvania), in *Monuments Bulletin*, 1/1973, pp. 41–48; Engineer V. Munteanu, "Noi orientari si recente realizari in restaurarea monumentelor istorice si de arta" (New trends and recent projects in the restoration of historic and art monuments), ibid., pp. 72–73.

33) Law no. 37, November 20, 1975, published in *Official Bulletin*, XI, 123, part I, November 26, 1975, Bucharest, pp. 1–14 (see the preamble, articles 3 and 38). These provisions were maintained when law no. 37 was reprinted in *Official Bulletin*, XIV, 82, part I, September 6, 1978, Bucharest, pp. 5–6.

34) *Official Bulletin*, XI, 5, part II, November 21, 1975, pp. 2–4 and 6, November 22, pp. 1–8.

35) An account of the Colloquium's activities, by Tereza Sinigalia, in *Monuments Review*, XLVI, 2/1977, Bucharest, pp. 93–94.

36) Colloque sur la conservation et la restauration des peintures murales (Suceava, Roumanie, Juillet 1977), volume published by the Romanian ICOMOS Committee.

37) Highly skilled architects, dedicated to their tasks, have made important contributions to the restoration of historic monuments and to the knowledge of traditional urban sites: Stefan Bals, a representative of the interwar generation, symbol of knowledge and professional devotion; Nicolae Diaconu, Otto Czekelius, Herman Fabini, Eugenia Greceanu, Florin Ionescu, Constantin Joja, Gheorghe Leahu, Rodica Manciulescu, Paul

Emil Miclescu, Ana Maria Orasanu, N. Pruncu and Gh. Sion; also Mariana Angelescu, V. Antonescu, Liliana Bilciulescu, Ioana Grigorescu and Cristian Moisescu. To these names must be added those of architects who repeatedly pleaded for the protection and renovation of the historic centers, such as: Virgil Bilciulescu, Dan Budila, Dr. Ioan Ciobotaru, Doina Cristea, Arch. Ascanio Damian, psychologist Liviu Damian, Arch. Dr. Peter Derer, Prof. Dr. Arch. Grigore Ionescu, Arch. Eusebie Latis, Viorel Oproescu, Mihai Opris, Serban Popescu-Criveanu, Dr. Alexandru Sandu, Gh. Sebestyen, Dr. Aurelian Triscu and Dr. Sanda Voiculescu. See also other names in part IV, notes 24 to 77.

Art historians and historians from the interwar generation who made direct contributions in the conservation and restoration of historic monuments after 1945: G. M. Cantacuzino, Constantin Daicoviciu, V. Canarache and CS. Nicolaescu Plopsor. In the postwar generation: Vasile Dragut, "a sensitive and articulate philosopher of historic preservation" (Paul N. Perrot, Director, Virginia Museum of Fine Arts, in a letter to Bonnie Burnham, Executive Director, World Monuments Fund, August 2, 1988); Hadrian Daicoviciu, Corina Nicolescu, Ioan Opris and others.

For popular art and architecture, ethnography and ethnology (in the postwar years): Lucia Apolzan, Tancred Banateanu, Ernest Bernea, Valeriu Butura, Ion Chelcea, Nicolae Dunare, Gheorghe Focsa, Traian Herseni, Cornel Irimie, Karoly Kos, Radu Maier, Ion Muslea, Tache Papahagi, Paul Petrescu, Paul Stahl, Georgeta Stoica, Ion Vladutiu, Romulus Vuia, Romulus Vulcanescu, Boris Zderciuc and others. (See bibliography, Romulus Vulcanescu, *Dictionar de etnologie* (Dictionary of Ethnology), Editura Albatros (Albatros Publishing House), 1979, sub voce.

Restoration in Romania

4,345 cultural monuments were listed by the Romanian government in 1956. Proposals to increase the number, first to 6,456, then to 8,922 and finally to 10,072 (in 1978), were not approved by the government.

The Commission for Historic Monuments, which had departments for inventory, research, planning, preservation and restoration, was organized in 1959. In the 1960's and 1970's it functioned efficiently with a dedicated staff of architects, engineers, technicians, art historians and skilled building craftsmen. From 1954–1974, 104 restoration projects were undertaken.

From November 1977 to February 1978, the Commission and all its restoration sites were dissolved by state decree. The following photographs illustrate some of the monuments restored prior to 1977.

Church of Saint Nicolas (completed by 1352); Curtea de Arges, Arges county.

Cozia Monastery (1387–1388), church; near Calimanesti, Vilcea county.

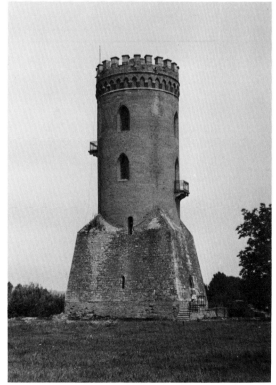

Chindia tower (14th and 15th centuries) at the princely court; Tirgoviste, Dimbovita county.

Romanian architectural monuments
(Photos: Dinu C. Giurescu)

Church of the Holy Cross (1487); village of Patrauti, Suceava county.

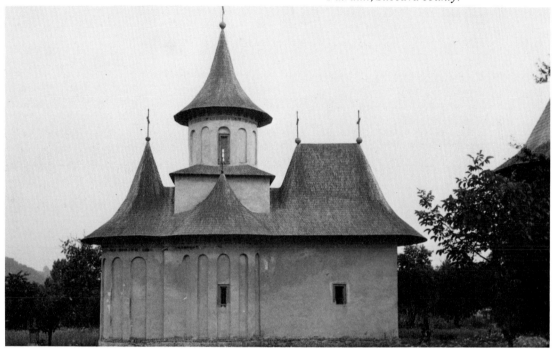

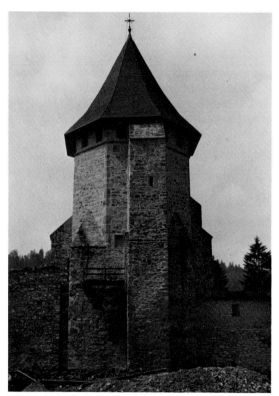

Tower (1481) at the fortified monastery of Putna (15th century); village of Putna, Suceava county.

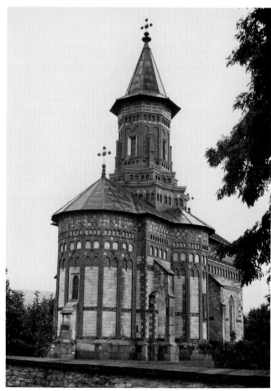

Church of Saint George (1492); Hirlau, Iasi county.

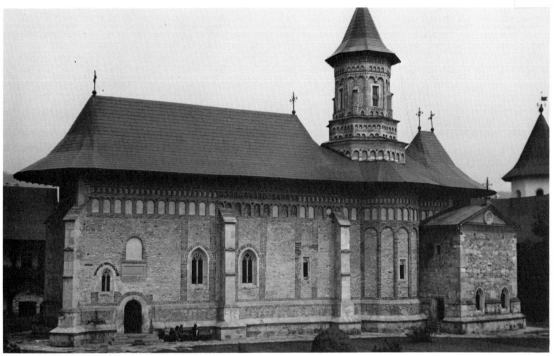

Monastery of Neamt, view of the main church (1497); village of Vinatori-Neamt, Neamt county.

Church of St. John (1497–1498); town of Piatra Neamt, Neamt county.

Church of St. John (1503), known as the Arbore Church, view of the western facade; village of Arbore, Suceava county.

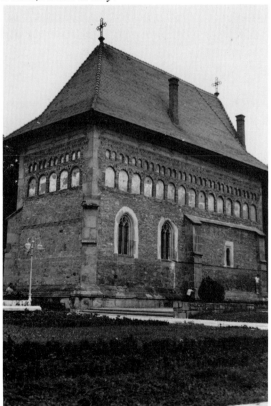

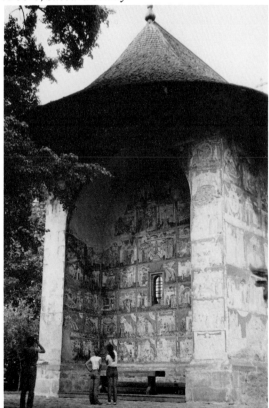

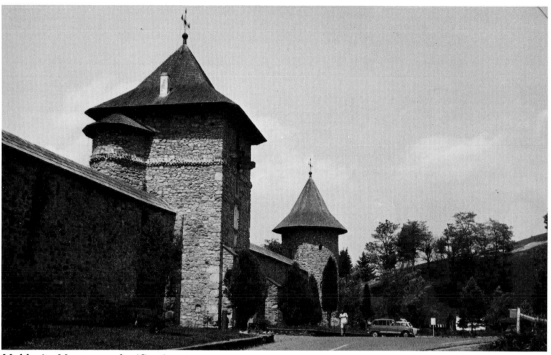

Moldovita Monastery, fortifications.

Moldovita Monastery, view of the eastern apse of the church (1532); village of Vatra Moldovitei, Suceava county.

Humor Church, view of the eastern apse (1530–1535); village of Manastirea Humorului, Suceava county.

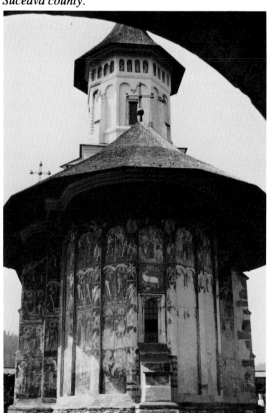

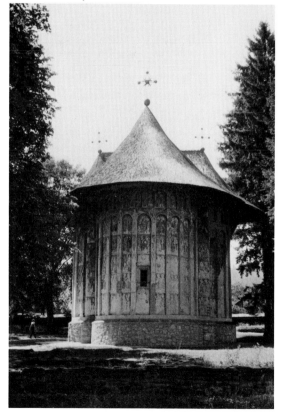

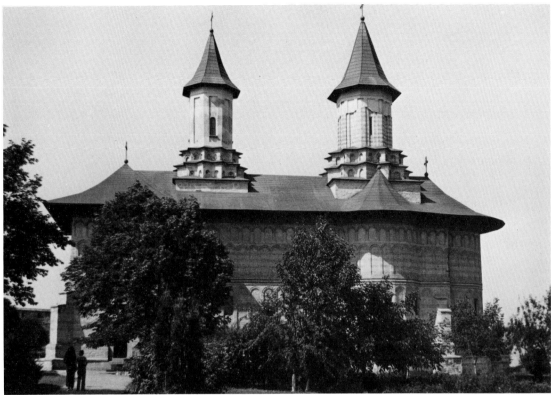

Galata Monastery, view of the main church (1579–1584); city of Iasi, Iasi county.

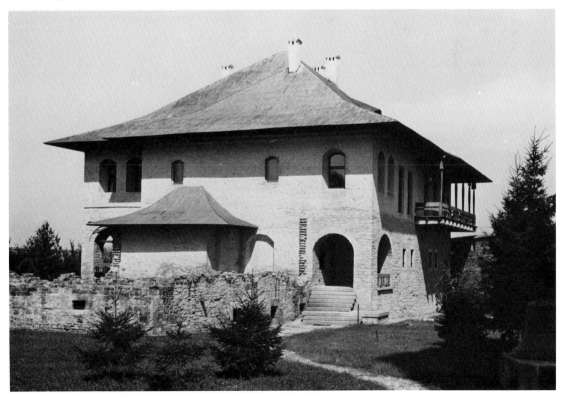

Princely residence at Galata Monastery.

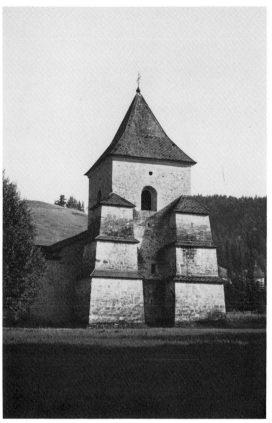

Sucevita Monastery, fortifications.

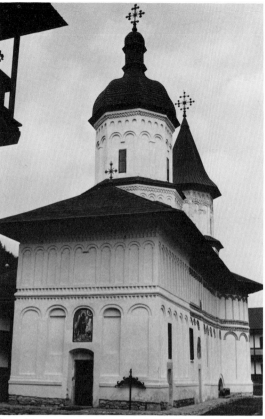

Secu Monastery, main church (1602); village of Vinatori-Neamt, Neamt county.

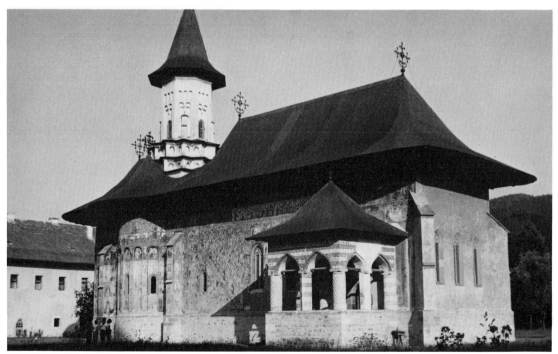

Sucevita Monastery (1581–1601), the main church with mural paintings; village of Sucevita, Suceava county.

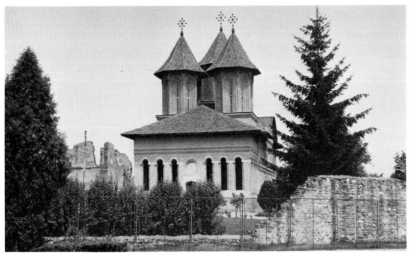

Princely church (1585), town of Tirgoviste,
Dimbovita county.

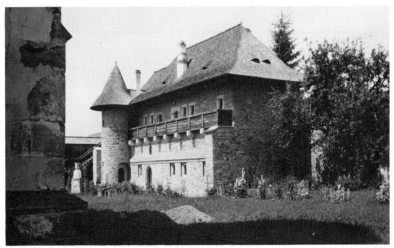

Bishop's residence at Moldovita Monastery (1612);
village of Vatra Moldovitei, Suceava county.

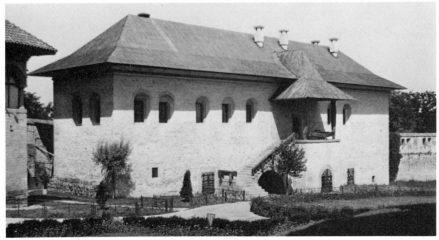

Cetatuia Monastery (1669–1672), princely residence;
city of Iasi, Iasi county.

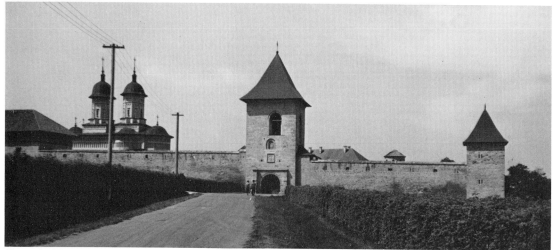

Cetatuia Monastery, fortifications.

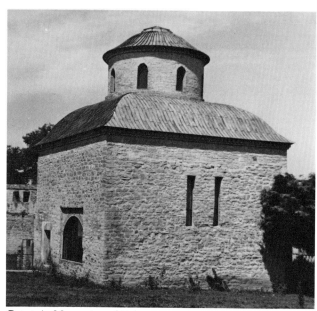

Cetatuia Monastery, kitchen.

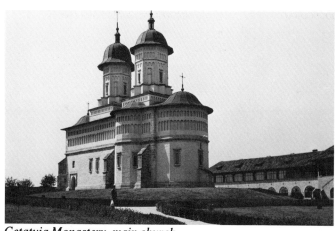

Cetatuia Monastery, main church.

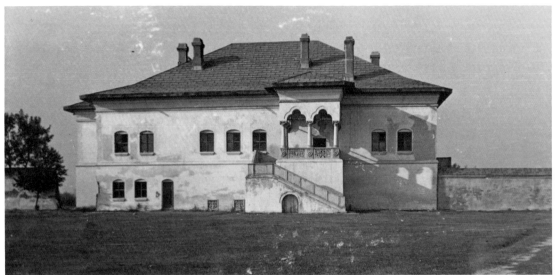

Residence (1698) of Constantin Brancoveanu, ruling
prince of Wallachia from 1688–1714; village
of Potlogi, Dimbovita county.

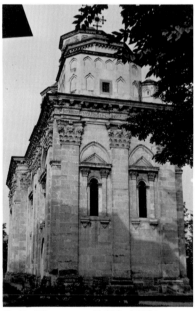

Urban dwelling (17th century); city of Iasi, Iasi county.

Golia Monastery (1650–1653),
church; city of Iasi, Iasi county.

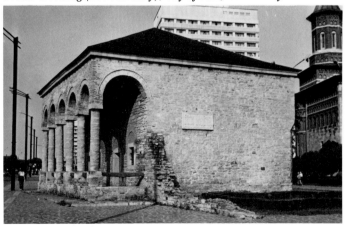

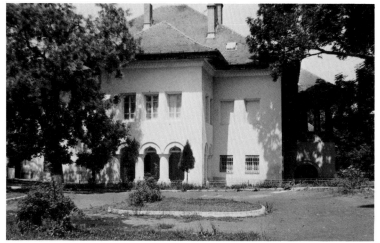

Cantacuzino-Pascanu residence (late 17th century); town of Pascani, Iasi county.

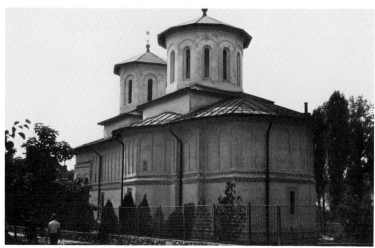

Church of Saint Nicolae Belivaca (1794); city of Craiova, Dolj county.

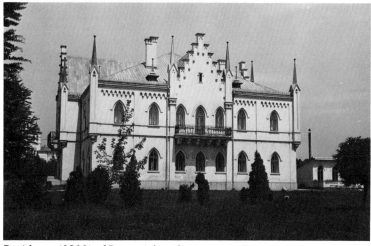

Residence (1811) of Romania's ruling prince Alexandru Ioan Cuza (1859–1866); village of Ruginoasa, Iasi county.

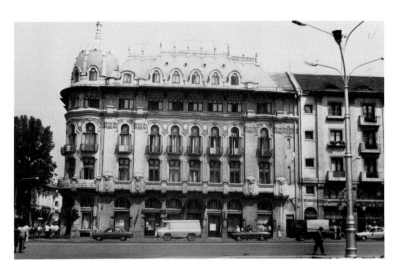

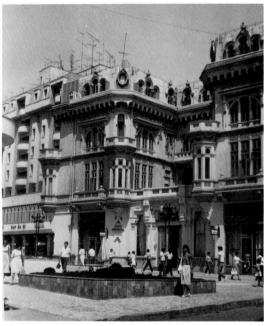

Large urban buildings dating to the late 19th and early 20th centuries that have been maintained among the new structures of the 1970's and 1980's; city of Craiova, Dolj county.

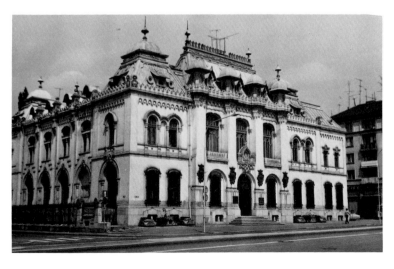

The northern half of the capital city, from the ring boulevards (Banu Manta, N. Titulescu, Ilie Pintilie, Stefan cel Mare, Mihai Bravu) to the demolished central districts (in yellow on the map) is a large area including a whole range of districts highly representative of Romanian traditional architecture. Thousands of valuable structures are still in place in the southern half of Bucharest also, as, for example, between Boulevard G. Cosbuc, Dimitire Cantemir, Serban Voda and Soseaua Viilor.

This plan is based on the author's knowledge of the field at the end of 1987.

Karthographie u. alle Rechte, Falk-Verlag GmbH
Hamburg

Legend

Yellow	Demolished areas
Green	Areas under demolition
Blue	Demolition along boulevards and major thoroughfares
• • • Red	Ring-boulevards of the central zone of Bucharest

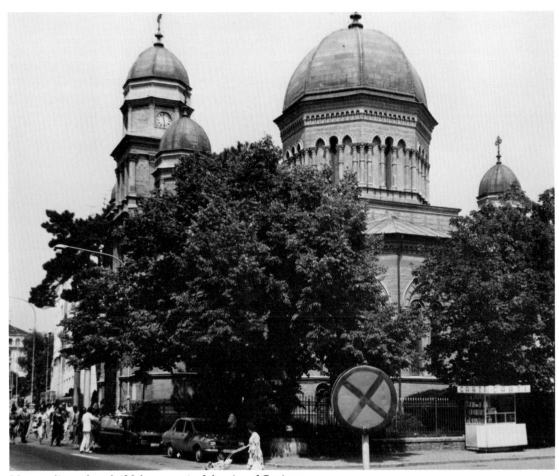

Metropolitan church (20th century) of the city of Craiova.

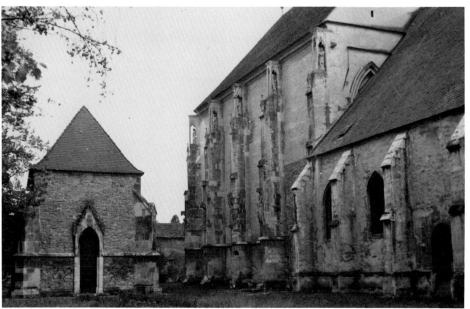

*Lutheran church (13th–14th century); town of
Sebes (Muhlbach), Alba county.*

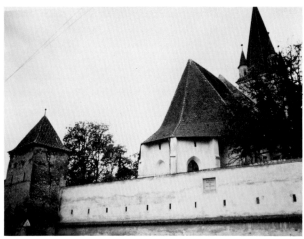

*View of Cristian (Grossau), Sibiu county. The
church was reconstructed in 1486–1498; the fortifi-
cations were built in the 16th century. (Photo:
Oliver A. I. Botar, Jr.)*

*The Black Church (1384–1477), the largest
Gothic German monument in Romania;
town of Brasov (Kronstadt), Brasov county.*

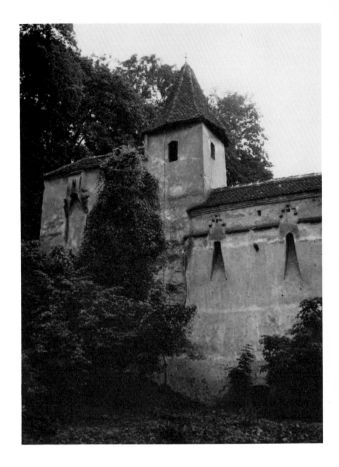

Fortifications (15th–16th century) of the town of Brasov (Kronstadt), Brasov county.

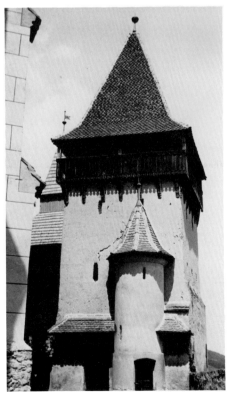

16th-century fortifications of the Lutheran church (1492–1516); village of Biertan (Birthalm), Sibiu county.

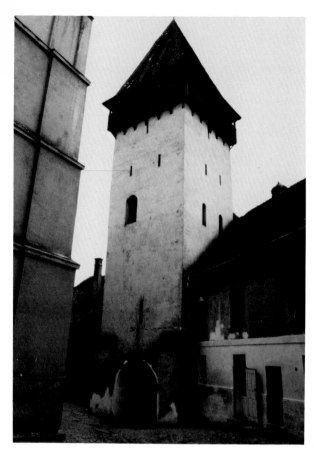

Tower (15th–16th century); town of Medias (Mediasch), Sibiu county. (Photo: Oliver A. I. Botar, Jr.)

Peasant fortress (15th–16th century); village of Calnic (Kelling), Alba county.

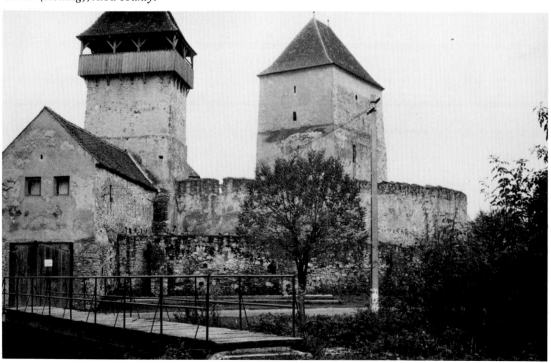

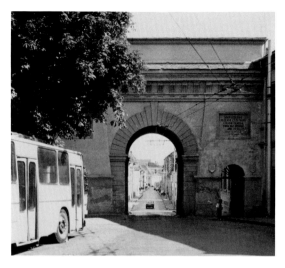

18th-century gate, with a view to the 7th November Street; town of Brasov (Kronstadt), Brasov county.

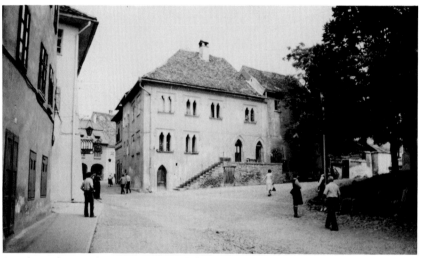

Secular urban architecture (16th–18th centuries) in the town of Sighisoara (Schassburg), Mures county. (Photos: Oliver A. I. Botar, Jr.)

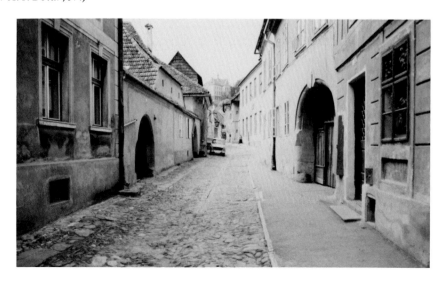

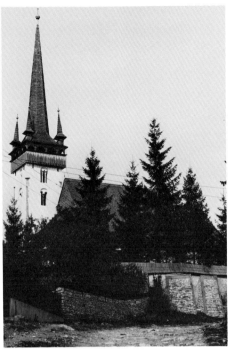

*Hungarian Reformed Church
(13th century); village of Manastireni
(Magyargyeromonostur), Cluj county.
(Photo: Gabor Boros)*

St. Michael's Cathedral, main portal.

*Roman Catholic Cathedral of Saint Michael
(1250–1291); town of Alba Iulia (Gyulafehervar),
Alba county. (Photos below and right: Oliver A. I.
Botar, Jr.)*

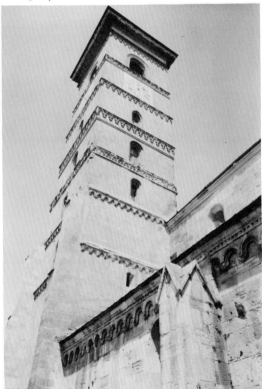

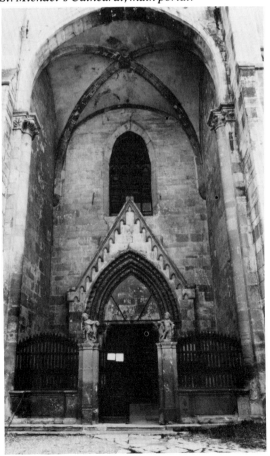

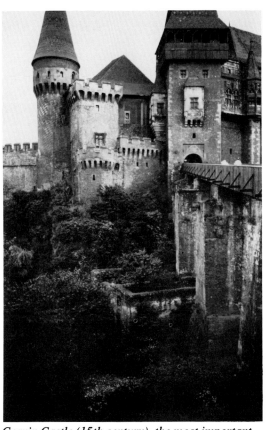

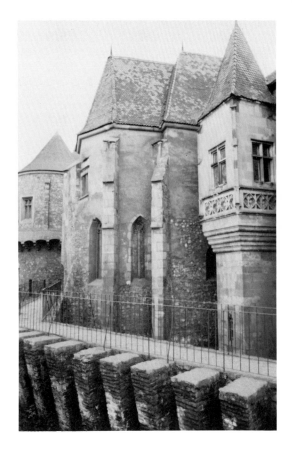

Corvin Castle (15th century), the most important secular Gothic monument in Transylvania; town of Hunedoara (Vajdahunyad), Hunedoara county. (Photos, above and right: Oliver A. I. Botar, Jr.)

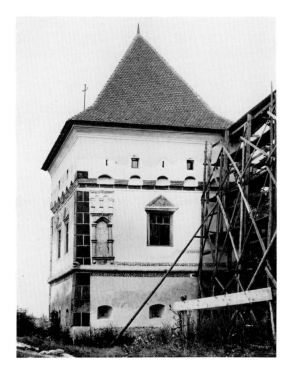

Restoration work initiated in the 1970's at the Castle of Lasarea (Szarhegy) (1531–1631/32); village of Lazarea (Szarhegy), Harghita county. (Photo: Gabor Boros)

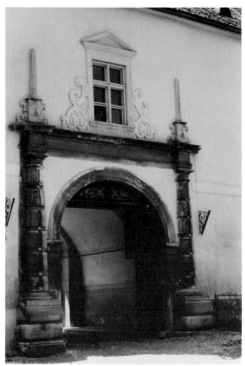

Main gate to the Bishop's Palace (built over several phases from the 15th to the 18th centuries), Roman Catholic Cathedral; town of Alba Iulia (Gyulafehervar), Alba county. (Photos: Oliver A. I. Botar, Jr.)

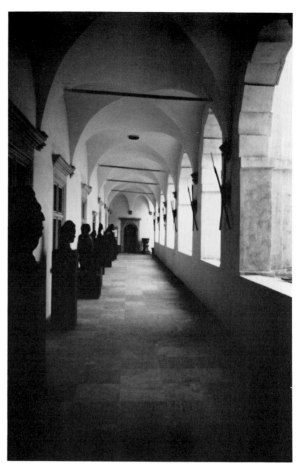

Fagaras (Fogaras) Castle, rebuilt in the 15th–17th centuries; town of Fagaras (Fogaras), Brasov county.

Fagaras (Fogaras) Castle, second floor gallery.

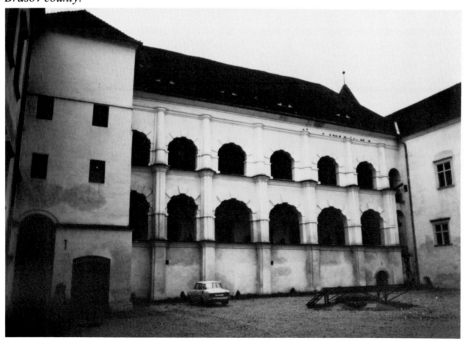

Wooden belfry (18th century), cemetery of the village of Ceauasul de Cimpie (Mezocsavas), Mures county. (Photo: Gabor Boros)

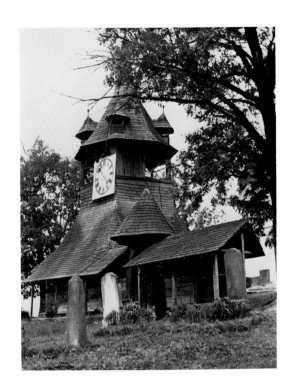

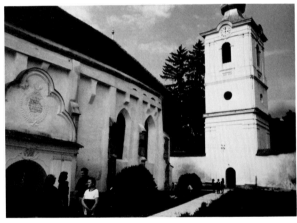

Hungarian Reformed Church (15th century, completed in 1656); village of Zabala (Zabola), Covasna county. (Photos, left and below: Oliver A. I. Botar, Jr.)

Banffy Palace (1773–1785), built by J. E. Blaumann; city of Cluj (Kolozsvar, Klausenburg), Cluj county.

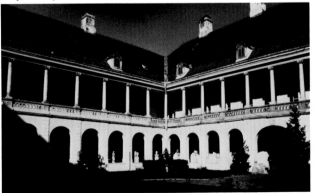

Armenian Monuments

The restoration of the monasterial complex began in the mid 1970's, but was interrupted at the end of 1977 with the dismantling of the Commission for Historic Monuments.

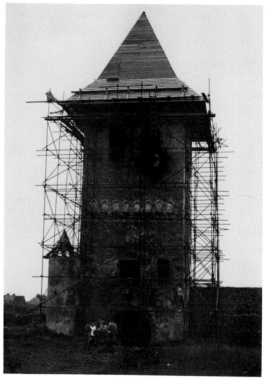

Tower of Zamca Monastery.

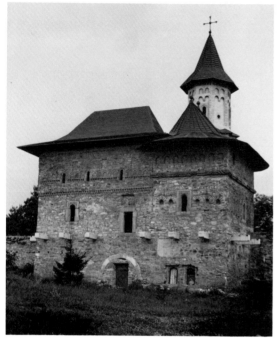

Zamca Monastery, the little church.

Zamca Monastery (1551–1612), main church; town of Suceava, Suceava county.

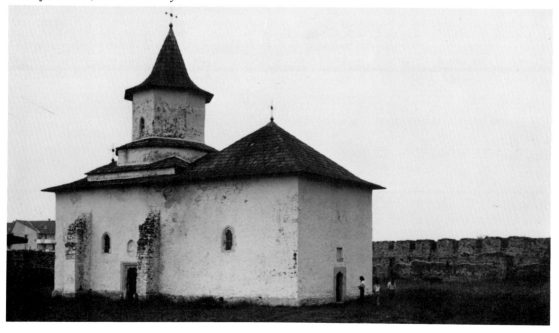

Residence from the late 19th century, with repainted facade, St. Friday Street; town of Pitesti, Arges County. This is but one example of how historic architecture can be integrated within the modern urban fabric. A four-story modern apartment building appears in the background. In Pitesti, more than 90 percent of the old structures have already been demolished.

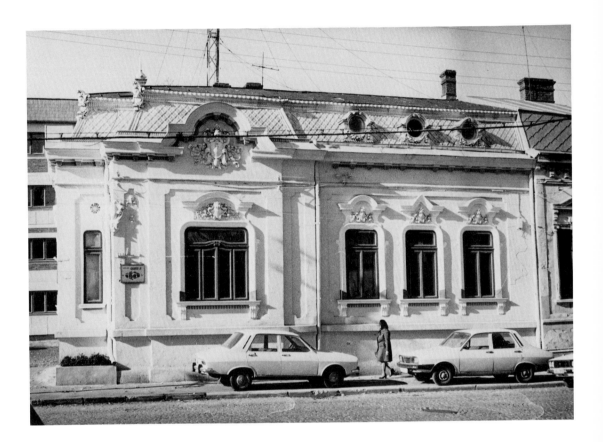

NATIONWIDE URBAN AND RURAL DESTRUCTION AND RESETTLEMENT

NATIONWIDE URBAN AND RURAL DESTRUCTION AND RESETTLEMENT

Aftermath of the 1977 earthquake.

In the aftermath of the March 1977 earthquake conflicting developments took place. On the one hand, there was an impressive concentration of forces, skills and technical means to remove the huge quantity of rubble, to repair shattered buildings and to construct new ones. By the end of 1977 reconstruction work had noticeably progressed throughout the country(1).

On the other hand, the need to clear destroyed areas gave local administrators and urban planners the opportunity to carry out hurriedly the demolition of all buildings regarded as badly damaged. People favoring and advocating a radical urban reconstruction considered the March 1977 earthquake a pretext and an illustration to make their opinions prevail. It was asserted that the old architecture was extremely damaged, thus opening the way for new apartment buildings, most of which, with some exceptions, had withstood the shock.

Houses and streets in a "state of imminent collapse" was the wording often used to justify the leveling of thousands of houses. There is no information on how

such essential decisions were made and put into effect. The change of tide soon became visible.

At the end of March rumors spread on the probable demolition of the Enei Church (1724) in Bucharest, a listed historic monument. The building had been somewhat damaged by the quake. Additional cracks were inflicted by a crane removing the rubble of a nearby building that had fallen on March 4. Even so, the repairs were estimated within the normal range with no special technical or financial problems involved. It has not been possible to find out why, how and by whom the demolition order was issued.

In mid-April, the advisory board of the Directorate of the National Cultural Patrimony discussed the issue and in a written report stressed the significance of Enei Church and its need for immediate restoration. It was stated that there were no technical or financial impediments to start the work. At the beginning of May the monument was demolished. The advisory board of the Directorate could not convene again without prior approval of its agenda by the Council for Culture and Socialist Education. In the summer and fall of 1977 attention was concentrated on repairs to be started at various monuments. As far as anyone can remember, there was no analysis at the Directorate advisory board level of the global state of urban architecture in the aftermath of the March 1977 earthquake.

In April–May 1977 a second demolition of special importance was decided and hurriedly carried out in the central zone of Bucharest, on Calea Victoriei and Sevastopol Street: a typical example of neo-Gothic style, designed by Grigore Cerchez, built in the last decades of the 19th century, a listed historic monument which had housed Romania's Union of Fine Arts(2). The advisory board of the Directorate was not consulted on this issue nor on any other demolition completed in several Romanian towns by local authorities following the March 1977 events.

This was the beginning of the new phase in which the concept of a radical urban reconstruction became prevalent. From 1978–1980 on, up to 90 percent of the traditional architecture was gradually razed in many towns and replaced by new structures of a completely different scale and style, often in a totally changed urban setting.

The law for urban and rural systematization.

This trend toward urban reconstruction was embodied in the 1974 "Law for the territorial, urban and rural systematization" with its pivotal concept of systematization(3).

Its objectives were: "the judicious organization of the entire country's territory (counties, communes, urban and rural localities);" the determination of appropriate guidelines for construction density and height, for population density, for the creation of recreation areas and of technical and sanitary installations, of roads and transportation, for the preservation and improvement of the natural environment; for enhancing historic and artistic monuments and sites; for increasing the efficiency of economic and social investments and of working and living standards of the entire population as well. On the surface it looked good.

Nevertheless, some of the 1974 law's provisions are more explicit. Constructed areas were to be reduced to a necessary minimum for an optimal use of the land, which represents an important national asset; the reduction of agricultural areas was forbidden (articles 1 and 3); the network of roads was to be simplified and ra-

tionalized (article 3). Perimeters were to be traced for every locality and approved by law. Sketches of systematization would be drawn up for towns and villages (article 4).

The harmonious development of the towns included a rational placement of economic units, dwelling and recreational areas, of the social-cultural units, an improvement of traffic circulation and the reduction of the built surfaces (Chapter II, article 6). As a rule, apartment dwellings were to be five stories high but no less than two, with compact street facades (article 8). The new constructions would primarily extend from the centers of the towns to the marginal zones (article 9).

New dwellings would be constructed in the present constructed areas and harmonized to the existing ones in order to achieve optimal density.

The rural systematization foresaw the relocation of households in small and scattered villages considered to lack prospects for development (article 14). The remaining villages were to be organized alongside functional zones, i.e. production units, dwellings, social and cultural buildings, streets, etc. The town hall, school, medical unit, shops and a movie theatre would be placed in the village center (article 13). Dwellings would start from this civic center to the outside parts, in order to build a compact structure, an intensive use of the built surface and the introduction of running water and electricity. The housing lots were not to exceed 200–250 square meters and the dwellings usually were to be two stories high (articles 17 and 20)(4).

Party and state central commissions and local commissions for the territorial urban and rural systematization were established at the same time(5). Their primary task was to set up a national plan for systematization and to implement it(6).

For almost two years these principles were not considered in all their implications and practical consequences. The discussions and studies on historic town centers continued, as stated above. In some rural areas the 1974 law resulted in the two-story individual house replacing the former with one floor. These rural areas were mainly in the plains; in the hilly and mountainous zones the two-story house represents the common traditional type. At that time it appeared that the systematization provisions under the law were being interpreted to ensure the coexistence of traditional urban and rural sites alongside the contemporary ones.

Implementation of Urban and Rural Destruction and Resettlement.

On November 25, 1977, the State Council issued decree No. 442, "Decree for the organization and the functions of the Council for Culture and Socialist Education"(7). Article 25 stated the immediate dissolution of the Directorate for the National Cultural Patrimony and of all its construction sites(8). Henceforth, restoration projects would be discussed by a Central State Commission for National Patrimony with a limited consultative role in the territorial systematization planning when matters of the cultural heritage were involved(9). This commission was a unit of the Council for Culture and Socialist Education.

The dissolution was completed within three months. Architects, engineers, art historians and hundreds of specialized craftsmen were scattered throughout the country. Architectural conservation and restoration as a nationwide centralized activ-

ity was brought to a halt. It continued rather sporadically through the initiatives of the Orthodox church and of some civil authorities(10). Official figures have not been released for the 1978–1987 interval but a recent list of restorations and repairs for 1978–1985(11) includes 67 monuments in almost eight years. One has to take into account that repairs—not restorations—implemented after the March 1977 earthquake are included in this total.

This figure should be compared to that of the Directorate for National Cultural Heritage (dismantled on December 1, 1977) which in two years, 1974 and 1976 (see above, chapter 3), restored 52 monuments.

Another decree outlined the organization and duties for guidance, control and advisory work of the Central Party and State Commission for the territorial urban and rural systematization (March 2, 1978)(12).

The main responsibility of this new political and administrative body and of its local branches was to implement the party and state policy by setting forth a national plan for territorial, urban and rural systematization. A Bucharest Commission of Architecture and Systematization was set up with similar responsibilities(13).

The implementation of the urban destruction and reconstruction started with the five-year plan, 1976–1980(14).

Another decree, issued on December 28, 1979, announced compensation to be paid to private owners if their houses, courtyards or estates were expropriated by the state for various reasons. The annex establishing the amount of compensation was not released(15). The construction materials resulting from the demolition could be sold to the former owner (article 9).

The prospect of demolition on a larger scale was unveiled in a May 1981 decree. It was decided to identify and keep all the reusable materials, objects, installations and elements as well as everything of artistic, historic, documentary, memorial or technical-scientific interest from demolished buildings. A record was to be kept of areas, streets, group of constructions or simple buildings to be demolished. The record was to include films, photographs, social and economic data and notes on memorial events. Plans of facades, images of ornamental elements, general views of individual mansions and of their surroundings was to be added in special cases. County commissions and commissions at the Bucharest municipality level would monitor and verify these operations(16).

From the early 80's the concept of systematization became an integral part of annual and five-year plans(17). Decisions for the implementation of the 1985 and 1987 plans were made by the legislative chamber of the popular councils (every commune, town or county is governed by a popular council). The plans included provisions of the national plan for territorial, urban and rural systematization: further reduction of built borders in urban and rural areas; clustering of isolated villages and households into larger communes; dwellings with two to four floors to be constructed in these communes(18).

The law for the 1986–1990 national plan of economic and social development (19) has similar provisions, adding that the implementation of the rural systematization will be stepped up(20). The concept itself has now acquired an extended connotation since the law refers to the economic and social systematization of the territory(21). Urban and rural planning and reconstruction should therefore result in social engineering.

A plenary session of the Central Committee, convened June 23–24, 1986, decided on further measures to increase the agricultural surfaces through the reduction of built areas. Rules for a rational dimensioning of localities, according to their size, number of inhabitants, economic position and functions were to be concommitantly enforced. Such measures were aimed at standardizing working and living conditions between towns and villages and to complete the systematization and organization of communes and villages around the year 2000(22).

The political willingness and determination to carry on and to complete the programs of systematization around the year 2000 were again expressed at the National Party conference in December 1987. The ultimate target was to accelerate the process of homogenization of the Romanian socialist society, to reduce the main differences between village and town, and to achieve a single society of the working people (23).

Voices in favor of the urban and rural architectural heritage.

In the late 70's and 80's there were some direct attempts to delay destruction of the architectural heritage. Urban development was once again examined in an issue of the review *Arhitectura,* with special references to traditional centers(24). The Union of Architects engaged in animated discussions on April 12, 1979, on projects for the restructuring of Bucharest's central area, but no details were released(25). A new debate at the directorate level of the same union focused on the present problems of systematization and construction: the destruction of the architectural heritage would represent a serious blow to the national culture and would discredit the architects in the eyes of the international community, even if they were acting in compliance with orders (January 29–30, 1981)(26).

A special panel on "Urban renovation and contemporary problems" was held May 25–27, 1979, at the Transylvanian Museum of History (Cluj). Twenty-four architects and historians from Cluj, Bucharest, Sibiu, Timisoara and Pitesti outlined various components of traditional centers, the need for an inventory of the constituent buildings and their protection and integration into daily life(27).

Nineteenth-century urban architecture was the theme of a session held December 11–12, 1979, in Bucharest and attended by 34 architects, art historians, museum curators and historians. The papers presented referred to the towns of Bucharest, Cluj, Sibiu, Arad, Timisoara, Sf. Gheorghe, Tirgu Secuiesc, Baraolt, Craiova, Tirgoviste, Cimpulung, Bacau, Vaslui, Iasi and Botosani and the counties of Bacau, Dimbovita and Arges(28). Centers from the historic provinces, except Dobrogea, were included. One unanimous conclusion emerged—the significance and the importance of this 19th-century heritage and, implicitly, the need to preserve it, now that the reconstruction program had accelerated. The papers were printed in a special issue of the *Monuments Review*(29). The specific case of the capital city in a broader European perspective was discussed on June 16, 1980, at another session organized by the Bucharest Museum of History(30). Reasons to keep all significant areas of traditional architecture were explicitly stated(31).

An exhibition of 450 photographs, "Bucharest in Images," held during the summer of 1982, focused mainly on the interwar period(32). "This should strengthen

our aim to protect and restore the capital city's heritage . . . not only listed historic monuments . . . but entire areas, streets and large zones. . . ." These buildings are a statement of "what our town is, its history and individuality," wrote the present author in 1982(33).

Another exhibition, "Traditions of Urban Building," and three seminars on the subject were organized by the Ion Mincu Institute of Architecture in Bucharest June 29–July 20, 1982. The displayed projects and student theses covered restorations in Bucharest, Sinaia, Tirgul Jiu, Slatina, Turnu Magurele, Timisoara, Sibiu, Alba Iulia (Gyulafehervar), Satu Mare and Botosani. In the seminars architects, art historians, professors and museum curators discussed the present state of architectural heritage and how to protect it, and the training of needed specialists(34).

The third annual symposium for the protection of the architectural heritage was held in Cimpulung-Muscel December 11–14, 1981. (The first symposium had been held in 1979 in Bucharest and the second in 1980.) It was attended by 49 professionals: architects, art historians, archaeologists, historians, restorers and specialists in aerial photography, who submitted 43 papers to three panels: the study of monuments, conservation and restoration, and the integration of conservation areas and historic centers. Special importance was given to Bucharest, Timisoara, Cluj, Gherla, Tirgu Mures, Arad and Tirgoviste. A separate meeting focused on the architectural heritage of Arges county(35).

Some articles continued to express the concern of dedicated professionals. For example, a critical analysis of the laws and decrees issued between 1955 and 1975 for the protection and restoration of monuments and urban and rural sites(36). The article shows that there was no explicit reference to historic centers and areas in the 1974 systemization law. In fact the law clears the way for the demolition of vernacular rural architecture in dispersed villages. Proposed changes to the 1974 draft law set forth by the Directorate for National Historic Monuments were not taken into account. Delegates sent by the Directorate of the National Cultural Patrimony, which was dismantled on December 1, 1977, as stated above, to discuss urban reconstruction could not change approved projects(37). This included the 1978 decision to raze the last part of the historic commercial area of Suceava (capital city of the state of Moldavia, 14th to 16th centuries)(38). Photographs of demolished or threatened buildings as well as precise proposals to adapt the legislation to urgent conservation and restoration needs were included in the above-mentioned critical analysis.

Other articles drew attention to what could still be saved of the urban heritage, for example, in Craiova(39): the Maxim Gorki (former Madona Dudu and Precestei), 30 December (former Lipscani), Oltea (former Copertari) and Romania Muncitoare Streets; in Tirgoviste(40); in Giurgiu: the Railway and Orient Plazas and the Dacia Street(41); Arad(42); Deva(43); Timisoara(44); Bistrita-Sugalete(45); Radauti(46); and Bucharest, of course(47).

At the present rate of demolition, more than 443,000 houses of the 19th and early 20th-century will disappear within the next few years. An estimate of the early 80's warned that by 1990 only 17,600 buildings constructed prior to 1900 would remain in the whole country(48). This means an average of 325 for every town of more than 50,000 inhabitants.

In a 1983 interview the author said: "To demolish the urban architectural building stock means to erase entire pages of history from people's minds and hearts; youngsters will soon live in towns where almost nothing would remind them of past

Romanian civilization"(49). Local authorities are seeking any pretext to tear down entire areas(50). The same urban planners implant out-of-scale constructions in the middle of traditional zones and then press to get rid of the old environment, as happened in Suceava, Ploiesti, Tirgoviste, Pitesti, Rimnicu Vilcea and Buzau(51). A decision to stop the demolition should be taken immediately. The same interview focused on 18th, 19th and 20th-century architecture (up to 1939) in Bucharest, Craiova and Botosani(52).

A plan of the Pitesti central zone is highly revealing: nine historic buildings were left in place from a total of more than 100. Indeed, some of these structures could not have been maintained; nevertheless, there is a great difference between a policy of rational infill and one of more than 90 percent destruction. Some streets still in place in Lower Pitesti (Tirgul din Vale) should be protected. The editorial board of *Arges* magazine, where this request was printed, invited architects, urban planners, engineers and artists to express their views on the issue(53). An appeal to conserve Lower Pitesti with appropriate infill architecture was raised again in December 1985. "To abandon the traditional Romanian urban and rural architecture signifies to give up our own identity. This should never be thought of nor done unless we want to jeopardize our own future as a nation"(54).

Still to be decided is the fate of many mansions, such as 74 Splaiul Independentei (Independence Avenue) in Bucharest, built in 1907 by architect Leopold Schindl(55); similarly the Yellow Inn on Banu Manta and I May Boulevards and Dr. Felix Street, in Bucharest(56). After some delay The Yellow Inn was bulldozed in 1985, triggering the following comment printed in a Romanian literary almanac: "On my way home I saw through the bus window an old building being pulled down at the corner of Banu Manta Boulevard and Doctor Felix Street. It had been known as the Yellow Inn and was one of the oldest inns in Bucharest. It had stood there for the last two centuries where I could see it until a few days ago. . . .

The Yellow Inn had its own history and legend, and did not deserve to perish under the bulldozers of the new times. For we ought not to level any trace of the past with the bulldozer, and the more so since the adversities of our history have already destroyed too much. The present and the future need the testimony of bygone years"(57).

In 1984, when large-scale demolition rolled over central Bucharest, a special issue of *Arhitectura* was dedicated to "the Heritage"(58). The preservation of traditional architecture meets the requirements of the Venice Charter adopted in May 1964 and of the European Charter of the Architectural Heritage adopted in September 1975. These constructions incorporate a collective memory, they are documents of Romanian civilization and should be retained for the benefit of contemporary society(59). In recent years many mansions, streets, sites and zones have been neglected, have deteriorated and have been downgraded. Nevertheless, they all embody material and spiritual values that need to be rediscovered; they can be adapted to various needs of our present life; many of them offer standards of comfort lacking in prefabricated contemporary apartments(60). Why have so many superficial evaluations of the existing building stock been so hurriedly formulated? Why have even the results of often meager archaeological research been avoided? How is it possible to plan and develop urban centers without the slightest consideration given to historic zones thoroughly identified and delineated by well-documented studies? Why are there so many exceptions to the 1974 Heritage Law itself?(61). There is an excellent demon-

stration of how to revitalize a characteristic zone of Bucharest around Calea Mosilor, (including 40 listed historic monuments), which deteriorated mainly in the postwar years (62). "I have good memories of the former Directorate of Historic and Art Monuments," says a veteran of the restorations, in an interview published in this issue of *Arhitectura*. This Directorate, organized in 1960, expanded into four large planning workshops, a study group with its archives, a department coordinating the entire network of construction sites throughout the country, a photo laboratory including photographic archives and another laboratory to test mortars and other materials(63). This description was given more than six years after the best restoration force Romania had ever had was dismantled. In Brasov, where Romanians, Hungarians and Germans have always lived in the same town, there is a specific "cultural morphology" reflected in the whole urban fabric, says another well-known senior architect. In his opinion there should be a historic conservation area within the town and no intrusion permitted: "I don't agree with this style which standardizes everything. During my whole lifetime I strove to protect Brasov's traditional architecture against the assault of the international style"(64).

"Pitiless urbanism" is the title of an article on Calimanesti, where a new post office, a seven-story building and several others with five flats were constructed in the town center(65). Two guidelines seemed to have been adopted by the urban planners when introducing the above mentioned new structures: 1. the deepest ignorance of the urban fabric slowly and solidly traced by the residents according to the topographical and climatic data, but at the same time the total nescience of the existing surrounding buildings; 2. the opinion that every single historic construction must be pulled down to clear the way for new ones. Similar guidelines have been followed in Caciulata, the twin town of Calimanesti. "I have the bitter feeling that Calimanesti is nearing the last years of its own identity under the calm and imminent threat of industrial urbanism. I am longing for the 400–500 meters of the street between the Center and the town hall with early 20th-century one-family houses separated from the sidewalk by a tiny flowered garden enclosed by a low fence. I will return to Calimanesti," concludes the article, "and in all naivete. . . . I will imagine that I will disappear into eternity the day when this tiny segment of the street no longer exists, when, in other words, the warm hospitable heart of Calimanesti will stop." Leaving aside the sentimentality, the author's perception of the former town illustrates the genuine traditional Romanian urban lifestyle.

As regards the heritage of old Buzau (a town documented in 1431), a scholarly study was released recently with the following remark: "Succeeding details of systematization, mainly of the central area, are repeated without any regard to the existing architectural stock, to the network of streets. Opportunities created by the demolition to carry out a minimum of archaeological or architectural research in order to supplement the meager information now at our disposal are ignored"(66).

Voices also continued to be raised in favor of rural settlements in the post-1977 years. There are generally medium and large-size villages of compact type in the plains; the resettlement of some dispersed sites should not have negative effects in these areas, according to one specialist(67). He added that for the hilly and mountainous zones where more than 75 percent of all villages are located and where small and even smaller settlements of dispersed type are dominant, a general reduction of their number has totally different economic and social dimensions(68). In the mountains where agriculture is not collectivized, the disappearance of these villages would

result in negative economic effects. The transformation of the socialist village should not be achieved through "discontinuity," but on the contrary, "through the integration . . . of old traditional structures in the organization of the rural lifestyle"(69). In other words, this means the protection and the continuity of the smaller villages and their modernization. According to the analyses of professionals, maintenance of the present situation in the rural zones of Suceava county with 396 villages and eight towns "represents a rational solution. . . . the idea of an imposed grouping of the dwellings into a compact center seems to be unaffordable in these areas for the time being, for it would bring about the weakening of the economic factor"(70).

This pleading expressed by specialists was followed by others. Lots of 250 square meters for the house and the garden are too small; an increase to a minimum of 400–500 square meters would be necessary to allow a minimum of productive activity, such as vegetables, poultry, etc.(71).

Extensive scholarly studies, as well as articles, continued to focus on the vernacular rural architecture in the post-1977 years(72). The older houses are often striking in their modernity and serve as appropriate models for contemporary dwellings(73).

A commonly held professional viewpoint was clearly outlined in the articles: the one-family household had to remain the basic unit of the contemporary Romanian village. As one person recently noted, "Through attentive interpretation, knowledge and analysis of the architectural-constructive, functional-organizational and technical ingenuity of the traditional Romanian village, toward the definition of the modern, expressive and fundamentally superior features of the new settlements. . . ." (74). If the wording is tortuous, the meaning remains explicit indeed: a better contemporary rural standard has to rely upon and to start from the traditional sites. This message rejoins another opinion previously expressed: rural planning should be based upon the "one-family household surrounded by a garden and orchard. To equate quality of life with the apartment building, means to follow the path of least resistance and to turn, paradoxically, one's back on the future. This future should be propitious to the small and medium-size urban and rural centers (side by side with the big cities, naturally)"(75).

The Romanian traditional architectural thinking expresses an intrinsic correlation between the constructed space and its natural environment; a logical binomial balance between intimacy and monumentality; a geometric rectilinear style; an alternating interplay between filled and void spaces on the facades. "Coming from a remote past, the specific traits of Romanian traditional architectural thinking are more topical than the most recent solutions of the present architecture. I see and want these specific traits to continue forever," concludes a defender of this essential heritage(76).

Memorandums have been sent to various authorities. Their number and content cannot be traced since they were never made public. One of them was addressed to the Central Committee which in turn sent it to the Committee for the Popular Councils. The latter gave a noncommittal answer(77).

Present state of urban and rural architectural heritage.

All attempts made in the late 70's and early 80's to stop the destruction of the traditional heritage produced little results.

Up to 1989 at least 29 towns have been razed and 85 to 90 percent reconstructed,[1] namely: Suceava, Botosani, Pascani, Iasi, Roman, Piatra-Neamt, Bacau, Vaslui, Husi, Birlad, Tecuci, Focsani, Galati; Rimnicul-Sarat, Buzau, Mizil, Ploiesti, Pitesti, Slatina, Craiova, Rimnicul Vilcea, Giurgiu, Slobozia, Calarasi, Medgidia, Tulcea, Constanta, Mangalia and Baia Mare (Nagybanya)(78). The traditional architecture and urban fabric have been leveled and replaced by the collective dwelling with multiple apartments and by a different street network. Another urban world has emerged opposite the earlier one with almost no connection to the past, but with isolated historic monuments and a few other buildings kept and sometimes even hidden within the new structures. Rapid demolition is underway in additional 37 towns.

This new concept and trend were emphasized in many articles hailing the achievements throughout the country (79). Some of the planners promoted the new settlements, excluding any reference to the former town that they leveled(80). In 1980 the planned new civic center of Bucharest was heralded as a unique epoch-making achievement, the most important project of systematization, construction and architecture ever implemented on Romania's territory(81). The mass media increased its praise of the improvement of living standards which would result from the new architecture. Now and then photographs of old, poor, decayed houses were released side by side with the tall new constructions. By 1980, too, it was estimated that 3,000 villages with few inhabitants, "a negative demographic evolution" and a "reduced economic basis" should be dismantled in a "lengthy process"(82).

There is no choice left for the citizens living in privately owned houses once demolition has been decided. The former owner must move into a state-owned flat and become a tenant. The new living space is rented according to legal provisions: a studio for one person or a couple without children, irrespective of the size of the expropriated and destroyed house or apartment. The compensation for the lost property, paid after delays, usually represents less than 30 percent of the real value(83). In the rural areas, a house with its dependencies and a garden is replaced by a rented apartment of one, two or three rooms according to the family size. The amount of compensation paid in rural areas is not yet known. Once the inhabitants have moved and the houses have been bulldozed, the urban area or the village itself, its site and environment, simply vanish from the maps and from memory as if they had never existed.

By 1984 the radical demolition and reconstruction had started in a central residential area of Bucharest bordered by the Dimbovita River (to the north),[2] Avenue George Cosbuc and Calea Rahovei (to the east), Sabinelor Street (to the south) and Izvor Street and 13 Septembrie Avenue (to the west, see map). Everything was leveled to the ground: mansions, villas, one and two-story houses almost all surrounded by gardens, small constructions of three or four apartments, public buildings,

[1]Estimated average, with less (75–80%) in some cases, or more (over 90%). First are enumerated the towns in Eastern Romania (former province of Moldavia), then in the Southern parts (Wallachia and Dobrogea) and in Transylvania (Baia Mare).

[2]From the B. P. Hasdeu Street to Piata Unirii.

churches, historical monuments (the Mihai Voda Church and a bell tower were moved in 1986 and are the only monuments to have survived the razing), statues and a whole area highly characteristic for Romania's architectural heritage, the Uranus-Hill, which for centuries had been one of the city's landmarks.

The economic value of this entire built zone, the large and comfortable housing space it offered since the district proved resistant to the 1977 earthquake—its significance for the country's history and civilization—were not heeded at all.

One year later, in 1985, the destruction advanced to Piata Unirii, alongside the Dimbovita River (to the southeast), Boulevard Marasesti (to the south), Calea Dudesti and part of Mircea Voda Street (to the east) and Calea Calarasi (to the north)—everything was leveled to the ground, including several churches (see below for the demolished churches and historic monuments.)

Massive destruction followed in 1986 on the eastern side of the historic central zone (see map), between Dristor, Theodor Sperantia, Locotenent A. Bodea and Rodiei Streets[3]; also, between Tepes Voda (Vlad the Impaler), Agricultori, Dristor Streets and Mihai Bravu Avenue; from Calea Dudesti (south) alongside Traian Street up to Calea Calarasilor (to the north, see map), advancing eastward to Popa Nan Street, which has not yet been reached. The destruction is rolling down Calea Calarasilor, Dudesti and Alexandru Moruzi Street: it is not known how far it has advanced on both sides of these roads. New structures (8 to 10 stories) have already been completed,[4] along the Avenues Stefan cel Mare and Mihai Bravu bordering the city's historic zone to the north, east and southeast (see above, chapter 1); along the Calea Mosilor, Colentina Avenue, Masina de Piine Street, Calea Dorobantilor,[5] Ilie Pintilie Avenue, Nicolae Titulescu Av., 1 Mai, Banu Manta and Calea Grivitei Avenues, Turda Street (all in northern Bucharest); along Boulevard Dimitrie Cantemir and Calea Rahovei (in the southern and the southwestern part of the city) and Armata Poporului Boulevard (the west side). Some of these new buildings on Stefan cel Mare, Mihai Bravu, Dimitrie Cantemir, Grivitei and Armata Poporului were built in the late 60's and throughout the 70's.

In 1987 other parts within the central zone were torn down. Of approximately 150 buildings in place between Stirbei Voda, Berzei, Virgiliu Streets and Calea Plevnei only four houses and a school building survived the August to October 1987 campaign of demolition. Buzesti Street (up to Piata Victoriei) and all the buildings close to the Ministry of Foreign Affairs (between Ilie Pintilie Boulevard, and Ana Ipatescu and Clopotarii Vechi Streets) were similarly targeted and pulled down.

Outside the historic zone (see above, chapter 1) extensive demolition has been carried out on both sides of Calea 13 Septembrie up to Drumul Sarii and Panduri Avenues (southwest Bucharest), whereas the large districts around Drumul Taberei, Emil Bodnaras and Ho Si Min Streets and Armata Poporului Avenue were reconstructed in the 60's and 70's.

The 1986–1987 systematization drive extended also from Grozavesti Avenue over Econom Cezarescu Street toward the new Polytechnic Complex and between Giulesti and Cringasi Avenues. The number of demolished houses is considered a state secret. Individuals and advocacy groups have traced the destruction of churches and other monuments (listed by the year of demolition and, in parentheses, the

[3]These locations are approximate since the demolitions are advancing at a rapid pace.
[4]Some parts of Mihai Bravu Avenue are under construction.
[5]Between Stefan cel Mare and Dorobanti Plaza.

month or day when the building was pulled down; unless otherwise noted, the churches were Eastern Orthodox).

1977:
 1. The 1724 Enei Church, historic monument (April–May).
 2. Cerchez mansion of neo-Gothic style at the corner of Calea Victoriei and Sevastopol Streets, a historic monument (April–May).

Prior to 1984:
 3. The buildings surrounding the 1726 Schitul Maicilor Church, a listed historic monument. The church itself was moved more than 600 yards.

1984:
 4. Alba Postavari Church, 16th-century, rebuilt in 1855–1857 (March 18).
 5. Spirea Veche Church, mid-18th century, reconstructed in 1915 (April–27).
 6. Izvorul Tamaduirii Church, 18th-century (August 4).
 7. Gherghiceni Church (December 18).
 8. The 1679 Cotroceni Church, a historic monument (late spring-summer).
 9. The 1914 Soare house, built by architect Petre Antonescu and representative of the neo-Romanian style.
 10–13. Mirea, Ciortan, Dobrescu, Bellio houses, characteristic of the residential urban style. Thousands of unnamed mansions and houses representative of Romanian traditional urban architecture were torn down in Bucharest in 1984–1988.
 14. The Yellow Inn, built in the first decades of the 19th-century.
 15. Ruins of the 1775 Curtea Arsa (Burnt Court) a princely residence dating to 1775, with large cellars, a listed historic monument.

1985:
 16. Brincovenesc Hospital Complex, built in 1835–1837 (December 1984 and January–February 1985).
 17. The 1750 Pantelimon church, renovated in 1813, historic monument (July).
 18. Saint Mina's chapel at the Forensic Institute, built in the early 20th-century (September).
 19. Saint Nicolae Sirbi church, 17th-century, several times restored or renovated (September).

1986:
 20. Saint Nicolae-Jitnita, built in 1711–1718, restored in 1851 and afterwards (18–23 August).
 21. Seventh-Day Adventist church (August).
 22. The Vacaresti monasterial complex including the main church, a chapel, a princely residence (built in 1716–1722), a large vaulted gallery, an 18th-century type kitchen and other subsidiary buildings, "the most outstanding achievement of 18th-century Romanian architecture" (Vasile Dragut), all listed historic monuments. Restoration was started in 1974–1975 and continued for more than two years until the Directorate for National Cultural Patrimony was dismantled. (The destruction of the main church started in December 1984 and was completed for all the buildings in the winter 1986–1987).
 23. A Sephardic Synagogue was demolished in Bucharest in July 1986(84).

24. The post-1945 Oltea Doamna Church (Saint Paraschiva Church) (November).

25. Sf. Vineri Herasca (Holy Friday) Church, built in 1644–1645, rebuilt in 1839 (June 19).

26. The 17th-century Olteni Church, rebuilt in 1722 and 1863–1865 (June).

27. The 17th-century Saint Spiridon Vechi (Spiridon the Elder) Church, restored in 1746–1748. A historic monument, well preserved (August 26).

28. The 1809 Bradu Staicu Church (October 7).

29. The 1804 Saint Treime-Dudesti (Trinity) Church (October 9).

It is not known whether Acvila Church, 37 Sirenelor Street, built in the 19th century and the Dobroteasa Church (1736), 101 Calea Vacaresti, rebuilt twice in 1847 and 1892, are still in place or not.

Other monuments have been moved and often entirely hidden among new buildings.

1. Sfintul Ion Mosi (St. John-the-May-Fair), built prior to 1808 (rebuilt in 1868–1870, repaired in 1898, 1907, 1925 and 1942), previously on 305 Calea Mosilor, screened by new buildings in the early 80's.

2. Schitul Maicilor (The Nun's Convent), listed as a historic monument (23 Schitul Maicilor Street). The church was rebuilt in 1726, restored in 1896, after the 1940 earthquake and in 1955–1958. The church was moved 245 meters through a complex operation which in itself represented an important technical achievement(85). The monument is now screened off, whereas all its dependencies and the whole street have been demolished.

3. Olari (Potter's) Church, listed as a historic monument (180 Calea Mosilor), built prior to 1758, restored in 1836 and 1863, repaired in 1914, 1939 and 1943. Moved 58 meters and screened from view.

4. The synodical library of the Antim Monastery, moved 14 meters in 1985. The Antim Monastery (29 Antim Street) built in 1713–1715, restored in 1795, 1857 and 1947–1950, is now screened from view.

5. Sfintul Ilie-Rahova (St. Elia's church) (21 Calea Rahovei), built prior to 1747, rebuilt in 1838. It was moved 51 meters and screened from view.

6. Mihai Voda Monastery (Prince Michael's monastery) (2 Strada Arhivelor), built between 1589–1591, repaired in 1827, 1838, 1876, 1897, 1900, fully restored in 1928–1935. The church itself and all its dependencies (where the State Archives were located) were listed historic monuments (86). The church and the bell tower were moved 227 meters in 1985 and are now completely screened off by a tall building. All the dependencies, as well as the entire nearby area were demolished in 1984–1985.

7. Sfintul Ion-Piata (St. John of the Market) (on 1848 Boulevard at Piata Unirii), built in 1756, restored in 1790, 1818, 1878, 1890, 1935 and 1948. Moved a few yards and completely surrounded by the new apartment blocks.

8. The 20th-century Capra (Sf. Gheorge Nou) (The Saint George the New—Capra Church), on 159 Pantelimon Boulevard, moved and surrounded by new tall constructions in 1986.

9. The c. 1760 Cuibul cu Barza (The Stork's Nest Church), 97 Stirbei Voda Street, listed as a historic monument, repaired in 1853, 1877, 1898, and in 1985–

1987. Moved 13 meters (in 1987). The parish house and all the houses on Stirbei Voda Street, from the crossroad with Berzei Street to Calea Plevnei, were demolished in 1987(87).

Reactions to the demolition of Romania's urban and rural architectural heritage.

On December 14, 1984, a first letter signed by three known Romanian scholars was sent to the Press and Propaganda Section of the Romanian Communist Party Central Committee in order to stop the demolition that had just been started at the Vacaresti monastery. The church, the bell tower, the princely mansion, a chapel flanked by a large columned gallery, the monks' cells, the abbot's residence, two kitchens[6] and the surrounding walls forming the Vacaresti monastery (built in 1716–1718 and 1719–1722) were all listed as historic monuments(88). A state prison between 1864 and early 1970, the Vacaresti architectural complex was under restoration, started in 1974–1975, with notable results. The church's paintings, one of the largest iconographic programs of Romanian art, and all the constructions were highly representative of traditional Romanian architecture and well known in southeast Europe(89). A second letter referring to both Vacaresti and Mihai Voda monasteries was signed by seven scholars, all members of the Central State Commission for the National Cultural Patrimony. The same letter was sent to the same high authority on January 24, 1985. The letter stressed the special significance of these two monuments and the damage that had already been inflicted. It also made an insistent appeal that measures be taken to preserve and to restore the two architectural complexes, symbols of Romanian history and civilization: "Every nation legitimizes its existence through its creativity. When the evidence of this creativity is suppressed piece by piece, the very identity of a nation is gradually lost. The present generation and those to come will live in towns with few traces of our (and their) history left"(90).

A last attempt, through a third officially registered letter, was made on October 21, 1985(91). It drew no results and one year later there was an empty space where the Monastery of Vacaresti once stood. As for Mihai Voda Monastery, the church itself and the main entrance tower were moved 227 meters and completely screened off by new tall structures.

The house of Nicolae Iorga, a prominent Romanian historian (1871–1940), was pulled down. It was located at 6 Boulevard Ilie Pintilie and was a listed historic monument(92). The demolition had taken place at the beginning of July 1986, although the City Hall and the Institute for History had completed all the required formalities to remove the building to a nearby site and to save it. Although a letter of protest was sent to several prominent periodicals, it was to no avail—the text was never published(93).

There is no way to discover how many letters and memorandums have been sent to the political and administrative authorities on the issue of urban and rural restructuring(94). Some of them are known in the West. For example, five letters to various authorities were sent between October 1985 and May 1986(95).

[6]Special structures, characteristic of Romanian architecture of the 17th–18th centuries.

An oral and written request submitted to the Council of the Archbishopric of Bucharest at its annual meeting, to bring to a halt the demolition of churches, was sharply rebuked (December 8, 1985)(96).

Outside Romania, the overall urban and rural restructuring has repeatedly triggered reactions unequivocally voiced by architects, urban planners, writers, scholars and journalists.

An Association internationale pour la protection des monuments et des sites historiques en Roumanie was founded in Paris on March 1, 1985(97). Its aim is to inform the public and governmental and nongovernmental, national and international associations and to enlist their support for the defense of the monuments and of the urban and rural historic sites of Romania(98). The Association participated in the Annual General Meeting and Symposium organized by Europa Nostra, "Bureau Europeen de l'Environnement" (Paris, September 10–12, 1986)(99); and the second international meeting for the protection of the cultural heritage (Avignon, France, November 5–7, 1986). The association also undertook to inform UNESCO and ICOMOS representatives in 1986 and 1987(100); the latter inquired of the Romanian leadership and of the Council of Culture in Bucharest about the fate of the architectural heritage in Romania(101). The Association informed Keston College in the U.K.(102) and the Archbishop of Sinai(103) of rumors about the possible destruction of the Romanian patriarchal church; whereas notice of the planned destruction of the vernacular rural architecture in Romania was sent to the International Council on Monuments and Sites (ICOMOS)(104), to the International Union of Architects (IUA) and to UNESCO's Division for Cultural Heritage(105).

Between November 1984 and January 1988 approximately 19 articles and analyses were made and released by the Research Department of Radio Free Europe on the same issue. They provided a regular account of the implementation of systematization, mainly in Bucharest, with precise data on the demolished churches or other monuments. English versions of articles reached a large audience and the Romanian versions were regularly broadcast(106). Efforts to save this architectural heritage have been made by ICOMOS UK(107), by Christian Solidarity International in Salzburg(108) and by individual initiatives(109). Extensive press coverage was given in the USA(110), France(111), West Germany(112), the United Kingdom(113), Switzerland(114), Belgium(115), Spain(116), Italy, Canada(117) and Brazil(118).

When rumors spread in the fall 1987 on the possible demolition of the patriarch's cathedral and residence in Bucharest, this news was flatly denied by the Romanian Embassy in Paris and by the Romanian Patriarch(119).

In 1988, the demolition continued in Bucharest and other urban centers. The implementation of the rural systematization continued as well(120).

NOTES: CHAPTER 4

1) In several places in Bucharest where the consolidation of damaged constructions was no longer possible, new buildings were started in 1977–1978 and completed in 1979–1980: Professor Arch. Cezar Lazarescu, "Noi ansambluri de locuinte in Bucuresti" (New dwellings in Bucharest), *A.,* XXVIII, 1–2 , 1980, pp. 10–11.

2) *Lista monumentelor de cultura de pe teritoriul RPR* (Cultural monuments list of the Romanian Popular Republic), published by the Academy of the Romanian Popular Republic, The Scientific Commission for Museums, Historic and Art Monuments, Bucharest, 1956, p. 15, no. 12. Grigore Cerchez, prominent Romanian architect (died 1927), author of several important constructions, well known in the evolution of urban architecture.

3) The law (No. 58) was approved by the Grand National Assembly on October 29, 1974, *Official Bulletin,* X, 135, Part I, Friday, November 1, 1974, pp. 1–7.

4) The Law for the territorial, urban and rural systematization was approved by the Grand National Assembly (see above, note no. 3).

5) Ibid, chapter IV, articles 25 to 27.

6) Ibid, article 28.

7) Decree no. 442, *Official Bulletin,* XIII, 127, Part I, November 28, 1977, pp. 1–5.

8) According to the provisions of the article, dismantling was ordered to start December 1, 1977.

9) Ibid, articles 18 and 5Bc and d.

10) In the post-1977 period, repairs and restoration work was carried out in Bucharest: at the churches of Saint Gheorghe, with funding from the Orthodox Patriarch, and Saint Spiridon Nou; at the Baratiei tower, Roman Catholic Church; at Lahovary, Vernescu, Stirbei, Manu, Asan and Tattarescu mansions, all considered or listed as historic monuments; at the Central State Library building; at the Cantacuzino Palace, where a music museum is planned; and at the Ghika-Tei Palace. Repairs and restoration work have been implemented in the countryside at Putna, Roman, Bogdana, Viforita, and Bistrita Monasteries, all in Moldavia; Buzau, Sinaia, Govora, Pasarea and Tismana, in Wallachia; and Hodos-Bodrog, Rimet and Bicsad, in Transylvania. The same was true at the Transylvanian wooden orthodox churches in Cehu Silvaniei, Ip, Strimbu, (Salaj County); Povergina (Timis County) and Fizesu Gherlii and Caian (Cluj County).

 Similarily in Cluj: at Banffy Palace, the Matthias Corvin House and the National Theater; in Tirgu Mures: Toldalagi and Kendeffi houses; the Gornesti (Teleki family) and Lazarea castles; the Chioar castle; in Iasi, Bassota and Bals houses; the Ruginoasa palace; the old town hall of Sibiu; and the Mateias and Marasesti mausoleums. This list is contained in Opris, *Heritage,* pp. 186–187. The author refers mainly to the repairs undertaken in the aftermath of the 1977 earthquake. For post-1977 restorations, see also Arch. Gheorghe Petrescu, "Restaurarea unei semnificative constructii brailene—Hotel Danubiu" (The restoration of Hotel Danubiu in Braila), *A.,* XXIX, 1(188), 1981, pp. 70–72; Stefan Bals, "Casa Domneasca de la Putna. Istoricul proiectului de restaurare" (The princely house at the Putna monastery. History of the restoration project), in *Monuments Review,* 2/1982, Bucharest, pp. 11–14; A. Teodorescu, "Lucrari de conservare, restaurare si amenajare la ansamblul brincovenesc din Rimnicul Sarat" (Conservation, restoration and improvement work at the Brancovan architectural complex in Rimnicul Sarat), idem, 1, 1983, pp. 25–31; Arch. Ion Barabas, "Restaurare Palatul Ghica-Tei Bucuresti" (Restoration. The Ghica-Tei palace in Bucharest), *A.* XXXII, 2(207), 1984, pp. 18–22; Architects Stefan Bals, Virgil Antonescu, "Proiecte pentru restaurari-completari-reconstruiri. Casa domneasca de la Putna" (Projects for restoration, completion and reconstruction. The princely house at Putna), A., XXXIII, 1(212), 1985, pp. 26–27; Maria Marcu, "Casa din strada Spatarului number 19 Bucuresti" (The dwelling on 19 Spatarului Street, Bucharest), *A.* XXXIII, 1(212),

1985, pp. 28–32; O. Dimitriu, "Consolidarea, restaurarea si remodelarea unui edificiu din zona Lipscanilor" (The consolidation, restoration and remodeling of a building in the Lipscani area, Bucharest), *Monuments Review,* 1, 1984, Bucharest, pp. 7–17; Calin Hoinarescu, "Ansamblul cultural "Nicolae Iorga" din Valenii de Munte" (Nicolae Iorga's cultural buildings at Valenii de Munte), idem, 2, 1984, Bucharest, pp. 5–10.

11) Opris, *Heritage,* pp. 186–187.

12) No. 56, *Official Bulletin,* XIV, 14, Part I, March 3, 1978, pp. 1–5.

13) No. 57, *Official Bulletin,* XIV, 14, Part I, March 3, 1978, pp. 5–6.

14) "Documente adoptate de Conferinta Nationala a Partidului Comunist Roman, 7–9 decembrie 1977" (Documents adopted by the National Conference of the Romanian Communist Party, December 7–9, 1977), *Official Bulletin,* XIII, 142–143, December 31, 1977, p. 25, point IX/2a.

15) No. 467, *Official Bulletin,* XVI, 3, Part I, January 4, 1981, pp. 1–2. According to a note printed in the *Official Bulletin,* the annex with the compensation schedule will be forwarded to the institutions involved in the payments.

16) "State Council decree for the protection and the reuse of materials, objects or components resulting from demolition, rehabilitation or restoration of constructions and for documentary records of zones, group of buildings and mansions"—decree no. 120, May 13, 1981, *Official Bulletin,* XVII, 35, Part I, May 21, 1981, pp. 1–3.

17) The decision of the Legislative Chamber of the Popular Councils for the territorial implementation of the 1980 plan, article 3b, *Official Bulletin,* XV, 101, Part I, December 18, 1979. Similar decision of the same legislative body on the 1981 plan and on the five-year plan 1981–1985, *Official Bulletin,* XVI, 87, Part I, October 21, 1980, and idem, XVII, 46, July 9, 1981, pp. 1–4. While stressing implementation of the systematization projects, the above-mentioned decisions point out nevertheless that "demolition of existing constructions and dwellings should be avoided. . . ."

18) Decision no. 1, December 11, 1984, *Official Bulletin,* XX, 90, Part I, December 21, 1984. See also Decision no. 1, December 10, 1986, *Official Bulletin,* XXII, December 1986.

19) Adopted on June 27, 1986, *Official Bulletin,* XXII, 42, Part I, July 2, 1986, pp. 2–12.

20) Ibid., 47.

21) Chapter XI: "The development of the counties and the economic and social systematization of the territory," ibid., pp. 11.

22) The decision of the plenary session of the Romanian Communist Party, *Official Bulletin,* XXII, 38, Part I, June 25, 1986, p. 3, point 5. Previously, the Grand National Assembly had adopted a special resolution for an increase of the agricultural output and for a better use of the country's land. A better systematization of localities is mentioned among other measures to increase arable land: *Official Bulletin,* XIX, 49, Part I, July 6, 1983, p. 17 (the whole text at pp. 13–21). See also, the laws for the 1984 and 1985 plans, *Official Bulletin,* XIX, 101, Part I, December 24, 1983, pp. 1–9, article 8; idem, XX, 91, Part I, December 21, 1984, pp. 2–10 (p. 4, article 106).

23) The National Conference of the Romanian Communist Party was held in Bucharest, December 14–16, 1987. The resolution, *Official Bulletin,* XXIII, 59, Part I, December 18, 1987; for quotations, see p. 4.

The systematization in the capital city of Bucharest is mentioned in the communique on the fulfillment of the 1987 plan; *Official Bulletin,* XXIV, 8, Part III, February 4, 1988, p. 5. The main principle of the systematization concept and its rural implementation in three phases (1990–1995–2000) was reiterated in the resolution adopted by the National Conference of the Popular Councils, Bucharest, March 3–4, 1988; *Official Bulletin,* XXIV, 14, Part III, Saturday, March 5, 1988, pp. 6–7. See also the joint Plenary Session of the National Council of Workers and the National Council of Agriculture, *Romania libera,* XLVI, 13,553, June 3, 1988: a 50 percent reduction in

the number of villages was again mentioned as well as the year 2000 deadline for the systematization of all communes.

24) See *A*, XXVI, 4(173), 1978, Bucharest, pp. 26–50, 62–64 and 69–72. For example, Dr. Arch. Alexandru M. Sandu, "Nevoia de continuitate in constructia urbana (observatii privind preocupari actuale de modernizare a oraselor romanesti)" (The need for continuity in urban building—some remarks on present concerns regarding modernizing Romanian towns), pp. 37–48 (English summary, pp. 3–4); Dr. Arch. Sanda Voiculescu, "Centrul istoric—definire si delimitare" (The historic center—definition and limits), ibid., pp. 56–57; Professor Dr. Arch. Grigore Ionescu, pp. 69–72, on restorations carried out prior to 1939 (the fourth article on the topic); Professor Dr. Arch. Gheorghe Curinschi-Vorona, "Scoala romaneasca de restaurare.." (The Romanian school of restoration), ibid., pp. 49–55. See also, articles by Dr. Arch. Mircea Enache (pp. 26–27), Dr. Arch. Boris Grinberg and Arch. Mariana Celac (pp. 27–29) and Arch. Mihai Opris. See also, Dr. Arch. Cosma Jurov, "Integrarea centrelor civice in structura localitatilor" (Integration of civic centers into locality plans), *A.*, XXVIII, 3(184), 1980, pp. 19–24 (English summary, pp. 4–5) (a methodological approach).

25) A brief communique, *A.*, XXVII, 4(179), 1979, p. 5.

26) The debates were not published. Arch. Eugenia Greceanu echoes these discussions in, "Aspecte juridice privind conservarea monumentelor si ansamblurilor istorice" (Juridical aspects on the conservation of monuments and historic centers), *A.*, XXIX, 2–3(189–190), 1981, p. 91, column 1.

27) A short summary, *A.*, XXVII, 6(181), 1979, pp. 6–7. Senior scholars and architects such as Professor Virgil Vatasianu and Hermann Fabini, as well as professionals of the postwar generation—Eugenia Greceanu, Petre Derer, Maria Multescu and Serban Popescu-Criveanu—have been unequivocal on the issues.

28) A translation of the program of the session: December 11, 1979 (9 a.m.–1 p.m. and 4–7 p.m.): Arch. Ana Maria Orasanu and Carmen Cantemir (Council for Culture and Socialist Education), "An inventory of 19th-century urban architecture —achievements and objectives;" Professsor Dr. Vasile Dragut (Institute of Fine Arts Nicolae Grigorescu), "Artistic values of Romanian 19th-century architecture;" Dr. Arch. Vasile Mitrea (Polytechnic Institute Cluj-Napoca), "The 19th century's contribution to the present urban identity of Cluj;" Arch. Undina Neamtu (Popular Council of Cluj), "An important neo-Gothic monument in Cluj-Napoca;" Arch. Mihaela Strimbu (Office for National Cultural Patrimony, Cluj), "Volumetric integration of the 19th-century architecture of Cluj;" Maria Mirel (Transylvanian history museum), "On some 19th-century architectural monuments in Cluj;" Professor Dr. Zoltan Szekely and Gabriel Lambescu (Office for National Cultural Patrimony, Covasna), "Representative buildings in the towns of St. Gheorghe, Tirgu Secuiesc and Baraolt;" Dr. Arch. Hermann Fabini (Popular Council of Sibiu), "Criteria to evaluate Sibiu's architecture (19th century and the beginning of the next);" Gheorghe Lanevschi (Office for National Cultural Patrimony, Arad), "On secession monuments of Arad;" Rodica Medelet" (Office for National Cultural Patrimony, Timis), "On the secession architecture of Timisoara at the end of the 19th century;" Adriana Buzila (idem), "Documents on 19th-century urbanism in Timisoara;" Arch. Dan Chinda (idem), "The National Theater of Timisoara, a 19th-century monument of architecture;" Professor Dr. Paul Rezeanu (Art Museum Craiova), "On the urban development of Craiova, 1830–1916;" Mihai Oproiu, Gh. Bulei and Adriana Boescu (Office for National Cultural Patrimony, Dimbovita), "Urban 19th-century architecture of Tirgoviste;" Architects Maria and Adrian Multescu (Institute for Planning, Arges County), "On the evaluation of the 19th-century urban architecture of Cimpulung."

December 12, 1979, morning session: Professor Dr. Dinu C. Giurescu (Institute of Fine Arts Nicolae Grigorescu, Bucharest), "The town, a permanent component of Romanian civilization;" Cezara Mucenic (idem), "Urban 19th-century architecture

in Bucharest;" Mihai Ispir (Institute of Art History, Bucharest), "The architecture of old Bucharest houses;" Liviu Rotman (Central State Library, Bucharest), "Projects and achievements in modernizing Bucharest in the second half of the 19th century;" Oliver Velescu (Museum of the Bucharest history), "On Bucharest's systematization at the end of the 19th century;" Maria Paleolog (Institute of Fine Arts Nicolae Grigorescu, Bucharest), "On gardens in the Romanian urban environment, of the 19th century;" Tereza Sinigalia (Office for Exhibitions), "Dwellings (Invoirea)—landmark for the study of Bucharest's architecture at the end of the 19th century.'"

December 12, 1979, afternoon session: Dr. Arch. Eugenia Greceanu (National Museum of History), "Tradition and innovation in the 19th-century urban architecture of Botosani;" Cornelia Filip (Office for National Cultural Patrimony, Botosani), "Inventory of 19th-century urban architecture of Botosani;" Magdalena Balan (Office . . . Vaslui), "Architecture of old Birlad;" Arch. Florin Buimistruc (idem, Iasi), "Four types of residential houses built in Iasi in the 19th century;" Eugen Sendrea (Office . . . Bacau), "Features of 19th-century urban architecture in Bacau County;" Professor Dr. Viorica Guy Marica (Institute of Art History, Cluj), "19th-century eclectic style;" Ioan Opris (Council for Culture and Socialist Education), "European juridical systems for the protection of historic centers."

29) Ibid, XLIV, 2, 1980.

30) Dr. Razvan Theodorescu, "Monuments of Bucharest, documents of the Romanian civilization;" Dr. Paul Cernovodeanu, "Views on old Bucharest in foreign travelers' diaries;" Professor Dr. Virgil Candea, "Bucharest—a Romanian and southeast cultural center in the 17th and 18th centuries;" Professor Dr. Edgard Papu, "Romania's capital city in literature;" Dr. Serban Radulescu-Zoner, "Demography and urbanism in Bucharest at the end of the 19th century;" Cik Damadian, "Artist sketches of Bucharest;" Professor Dr. Ileana Berlogea, "The theater in Bucharest;" Professor Dr. Florian Potra, "Bucharest and the cinema; Professor Dr. Dinu C. Giurescu, "Architectural heritage of Bucharest;" Professor Petre Dache, "Administrative regulations on the urban development of Bucharest;" Viorel Cosma, "Music in old Bucharest."

31) See above, Dinu C. Giurescu's paper. Economic, environmental, historic and cultural reasons have been employed in defense of urban heritage. Significant parts of the paper were published under the title: Dinu C. Giurescu, "Patrimoniul arhitectonic si constructiile oraselor" (Architectural heritage and the town's constructions), *Monuments Review,* XLIX, 1980, 2, pp. 4–6 (English summary, p. 6). See also Dinu C. Giurescu, "Patrimoniul arhitectonic, o permanenta a civilizatiei" (Architectural patrimony, a permanency of civilization), *Flacara,* XXIX, 6(1287), February 7, 1980.

32) At the Bucharest Museum of History.

33) Dinu C. Giurescu, "Bucurestii in imagini" (Bucharest in pictures), *Informatia Bucurestiului,* XXX, 8,974, August 14, 1982.

34) Cornelia Preda, "Constructiile urbane in dezbaterea arhitectilor" (Urban constructions discussed by architects), *Romania libera,* XL, 11,734, July 22, 1982, p. 1 and 3; summaries of views expressed by Panait I. Panait (historian), Arch. Eugenia Greceanu, Professor Dr. Arch. Aurelian Triscu, Arch. Gh. Sebestyen, Arch. Cezar Niculiu and Professor Dinu C. Giurescu.

35) A note on the third annual session, *A.,* XXX, 2(195), 1982, pp. 6–7. The first panel—study of monuments: 11 papers presented by Vasile Dragut, Corina Popa, Peter Derer, Maria Paleolog, Iuliana Ciotoiu, Gh. Sebestyen, Anisoara Sion, Liana Tugearu, Ana Maria Orasanu, Tereza Sinigalia, Sebastian Duicu and Marcel Berendei.

The second panel—conservation and restoration: 14 papers by Ioan Opris, Gh. Sion, Stefan Bals and Virgil Antonescu, Zoltan Thurman, Gyula Keresztes, Ladislau Demian, Dorin Crainic, Gh. Lanevschi, Cosmin Boghita, Al. Multescu and Iulian Rizea, Carmen Jinga, Valeriu Manu, Cristian Moisescu and Dan Mohanu.

The third panel—historic centers and their integration: 18 papers (22 partici-pants) by Nicolae Pruncu, Elena Budaca and Gh. Leahu, Liviu Rotman, Cezara Muce-nic, Carmen Cantemir, Nicolae Vladescu, Cristian Bracacescu, Cornel Talos, Serban Sturdza, Liliana Rosiu, Octavian Gog and Octavian Dogaru, Vasile Mitrea and Aurel-ian Giurgiu, Undina Neamtu, Mihaela Strimbu and N. Sabau, Corneliu Ionescu, Gh. Cantacuzino, Alba Delia Popa and Cristian Moisescu.

36) Dr. Arch. Eugenia Greceanu, "Aspecte juridice privind conservarea monumentelor si ansamblurilor istorice" (Juridical aspects of the conservation of monuments and his-toric areas), *A.*, XXIX, 2–3(189–190), 1981, pp. 85–91.

37) Ibid. p. 90.

38) Ibid, p. 91. This decision has been carried out: Emil I. Emandi, Architect Eusebie Latis, Professor Stefan Ceausu and Arch. Constantin Rabininc, "Evolutia orasului Suceava" (The evolution of the town of Suceava), *A.*, XXXII, 5(21), 1984, pp. 25–32.

"Commercial buildings with dwellings on the second floor dating from the end of the 18th and the 19th century were still in place not long ago around Sfintu Dumitru Church (Saint Demeter) (Stefan cel Mare and Karl Marx Streets); these constructions, now in an advanced state of deterioration and of imminent collapse, have been re-placed by apartment buildings with commerical spaces on the ground floor (the Stefan cel Mare zone now in construction)," p. 29 of the article.

The "state of imminent collapse" is a concept introduced into the official vo-cabulary after the 1977 earthquake. It was used to indicate a building considered by the administration to be in an advanced state of deterioration, on the point of collapse at any moment.

39) Arch. Dan Budica, "Monumentele istorice ale Craiovei" (Historic monuments in Craiova), *A.*, XXX, 3(196), 1982, pp. 49–58, see especially pp. 57–58 (English sum-mary, p. 4).

40) Arch. Ina Hariton, Florentin Cristian, "Tirgoviste, case martori din vechiul centru" (Tirgoviste, characteristic houses of the old center), *A.*, XXXI, 5(204), 1983, pp. 40–44.

41) Architects Florin Buzatu, Adrian Pinzaru, Mircea Purdea, Venera Savu, Aurelian Ste-fan and Petre Zaharescu, "Studii de renovare urbana a unor zone din municipiul Giurgiu" (Studies on urban renovation in some parts of the town of Giurgiu), *A.*, XXXI, 3(202), 1983, pp. 57–63. The article is a direct and convincing demonstration of how to integrate the architectural heritage into the contemporary landscape.

42) Paul Dorin Crainic, "Propuneri de reintegrare a centrului vechi din Arad in viata social-economica" (Some proposals to integrate the old Arad center into the contemporary so-cial and economic life), *A.*, XXXI, 4(203), 1983, pp. 41–52, "a strong plea for traditional heritage."

43) Student arch. Cristina Mihoc, "Renovare urbana, propunere de refacere in spiritul traditiilor locale, a unei strazi din municipiul Deva" (Urban renovation according to local traditions, a proposal to rebuild a street of Deva), *A.*, XXXI, 6(205), 1983, pp. 61–63.

44) Arch. Liliana Rosiu, "Interventii contemporane in centrul istoric al Timisoarei" (Con-temporary infill in the historic center of Timisoara), *A.*, XXXII, 6(211), 1984, pp. 44–46: advocates maintaining this center in its integrity and recalls that the infill on Russel Square or 11 Iunie Street is totally inappropriate (see also photographs no. 7, 8 and 9 at p. 45).

45) Student Arch. Kazimir Kovacs, "Renovare urbana Bistrita-Sugalete (proiect de di-ploma 1984)" (Urban renovation Bistrita-Sugalete, thesis 1984), *A.*, XXXIII, 3(214), 1985, pp. 65–68.

For what has been demolished in Ploiesti in the Lipscani zone: Student Arch. Daciana Daraban, "Glissando—eseu comparativ asupra zonei Lipscani, vechi si nou in Ploiesti" (Glissando—a comparative essay on the old and new Lipscani zone in

Ploiesti), *A., XXXIII*, 3(214), 1985, pp. 69–70 (with only facades of the buildings demolished in 1977–1978).

46) Arch. Sorin Pentilescu, "Opinii asupra sistematizarii zonei centrale a orasului Radauti" (Systematization of the Radauti central zone), *A., XXXIV*, 1(218), 1986, pp. 30–31.

47) Arch. Ioan Dumitrescu, "Din trecutul arhitectdurii Burcurestilor" (Bucharest's past architecture), *A., XXIX*, 4–5(191–192), 1981, pp. 139–142; "Convorbire cu arhitectul Paul Emil Miclescu—Bucurestiul era un oras-gradina avant la lettre, interviu realizat de arh. Stefan Manciulescu" (Bucharest used to be a garden city . . ., interview with Arch. Paul Emil Miclescu by Arch. Stefan Manciulescu), *A., XXIX*, 4–5(191–192), 1981, pp. 39–41 (English summary, pp. 4–5); Arch. Ioan Dumitrescu, "Faze stilistice ale arhitecturii Bucurestilor—Barocul" (Stylistic phases of Bucharest's architecture—the Baroque), *A., XXX*, 2(195), 1982, pp. 51–52; Cezara Mucenic, "Tipologia arhitecturii civile in centrul istoric al orasului Bucuresti—secolul al XIX–lea" (Typology of civil architecture in Bucharest's historic center), *A., XXX*, 4(197), 1982, pp. 45–51, based on numerous archival data; Arch. Sandu Tomasevschi, "Casa Economu—un imobil de restaurat in str. Plantelor nr.4, Bucuresti" (A dwelling to be restored at No. 4 Plantelor Street, Bucharest), *A., XXXIII*, 3(214), 1985, pp. 35–37.

 See also: Arch. Nicolae Lascu, "Urbanistica si valorificarea patrimoniului construit in primele decenii ale secolului XX" (Urbanization study and preservation in the first decades of the 20th century), *A., XXXI*, 3(202), 1983, pp. 41–46.

48) *Contemporanul,* 11(1,896), March 11, 1983, Bucharest, p. 6, columns 1–2, interview given by Dinu C. Giurescu.

49) Dinu C. Giurescu, interview, *Flacara, XXXII*, 9(1,447), March 4, 1983, p. 15.

50) Dinu C. Giurescu, "Memoria necesara a oraselor" (The necessary memory of the towns), interview *Contemporanul,* 11(l,896), March 11, 1983, pp. 6–7.

51) Ibid.

52) Idid.

53) Dinu C. Giurescu, "Arhitectura Pitestilor" (The architecture of Pitesti), *Arges,* XVIII, 2(138), February 1983, pp. 1 and 9.

54) Dinu C. Giurescu, "Istoria se pastreaza si prin arhitectura" (History is kept in architecture, too), *Arges,* XX, 12, December 1985, p. 5. For the second time the editorial board of *Arges* invited historians and architects to make their opinions known.

55) Dinu C. Giurescu, "Istoria unei case" (The story of a house), *Magazin istoric,* XIV, 3 (156), March 1980, p. 39.

56) Dinu C. Giurescu, "Ce se intimpla cu Hanul Galben?" *Flacara,* XXXII, 10(1,448), March 11, 1983.

57) George Macovescu in Almanahul Literar 1985 (The 1985 Literary Almanac), Bucharest, Asociatia Scriitorilor din Bucuresti (The Bucharest Union of Writers), 1985, pp. 129–131. English tranlation in Dan Ionescu, "Destruction of old Bucharest continues," *Radio Free Europe Research,* 10, 34, August 23, 1985, p. 27.

58) See *A., XXXII*, 1(206) 1984, Bucharest, pp. 11–151, with the following articles: Dr. Arch. Aurelian Triscu, "O zestre care poate fi intregita" (A dowry that may be completed); Arch. Sanda Ignat, "Coordonate actuale ale politicii de conservare integrata a patrimoniului arhitectural" (Present coordinates in the conservation policy of architectural heritage); Paul Gherasim, "Frinturi de gind" (Fragments of thoughts); Dr. Arch. Peter Derer, Arch. Dan Zamora, "Fondul locativ traditional, stare—valoare—utilizare" (The traditional building stock, condition—value—utilization); Dr. Razvan Theodorescu, "Un capitol al istoriei nescrise: monumentul de arhitectura intre morfologie si ideologie" (An unwritten chapter of history: the architectural monument between morphology and ideology); Arch. Gheorghe Leahu, "Vechiul centru al Bucurestilor—zona Curtea Veche—Lipscani—propuneri de restaurare si amenajare" (The old center of Bucharest. The Old Court zone. The Lipscani Street. Suggestions for restoration and development); Nicolae Pruncu, "Microzona Palatului Voivodal. Curtea Veche a

Bucurestilor" (The Bucharest microzone. Princely Palace in the Curtea Veche—Old Court); Dr. Arch. Peter Derer, Arch. Dan Zamora, student arch. Nicolae Barbu, "Calea Mosilor—ipoteza de revitalizare" (Calea Mosilor, how to revitalize it); "Monumentele nu au vrut sa ma paraseasca, interviu cu arch. Stefan Bals, realizat de arh. Cristina si Stefan Manciulescu" (Monuments did not want to leave me, Arch. Stefan Bals interviewed by Architects Cristina and Stefan Manciulescu); Dr. Ion Stoica, Arch. Ioan Antonescu, "Noua stralucire a unui important monument de arhitectura—Biblioteca Centrala Universitara Bucuresti" (New brilliance in an important architectural monument—the University Central Library of Bucharest); Arch. Dan Zamora, "Casa Iuliu Zane—Bucuresti (restaurare—modernizare)" (The Iuliu Zane mansion—Bucharest (restoration—modernization); Dr. Arch. Adrian Mahu, "Acordarea premiului Herder arhitectului Gunther Schuller din Brasov" (Awarding of the Herder Prize to Architect Gunther Schuller of Brasov); Dr. Arch. Eugenia Greceanu, "Arhitectii si etnologia" (Architects and ethnology); Dr. Arch. Gheorghe Sebestyen, "Ginduri despre istoria arhitecturii" (Thoughts about the history of architecture); Arch. Radu Dragan, "Agora;" Arch. Calin Hoinarescu, "Restaurarea si punerea in valoare a ansamblului arheologic si istoric de la Tirgsorul Vechi-Prahova" (Restoration and development of the historic and archaeological ensemble of Tirgsorul Vechi-Prahova). See English titles and summary, pp. 1–4.

59) Dr. Arch. Aurelian Triscu, ibid., p. 12.

60) Dr. Arch. Peter Derer, ibid., pp. 15–16, see also Peter Derer, "Rezervatii orasenesti, muzee ale constructiei urbane" (Town conservation areas—museums of urban architecture, *Monuments Review*, 1, 1982.

61) Arch. Sanda Ignat, *A.*, XXXII, 1(206), 1984, pp. 12–13, see also title of the article above, footnote no. 58.

62) Dr. Arch. Peter Derer, Arch. Dan Zamora and student Arch. Nicolae Barbu, ibid., pp. 21–23.

63) Senior Arch. Stefan Bals, of the prewar generation, with 48 major restorations and 8 new dwellings to his credit. See interview, ibid., pp. 25–27.

64) Arch. Gunther Schuller, laureate of the international Herder prize, with dozens of restorations to his credit. See interview, ibid., pp. 36–37.

65) Arch. Dan Adrian, "Urbanism fara inima" (Pitiless urbanism), *A.*, XXXIV, 1(218), 1986, p. 39, (no English summary).

66) Arch. Octavian Gheorghiu, "Buzau—oras medieval" (Buzau, medieval town), *A.*, XXIV, 1(218), 1986, pp. 41–50 (no English summary).

67) Arch. Mircea Possa, "Consideratii privind organizarea in sistem a localitatilor rurale" (On systematizing rural communities), *A.*, XXXI, 1(200), 1983, pp. 25–28.

68) Ibid., p. 25.

69) Ibid., p. 28.

70) Arch. Gheorghe Chirila, Engineer Teodor Buliga, "Cu privire la sistematizrea localitatilor si teritoriului judetului Suceava" (On the territorial systematization of Suceava County), *A.*, XXXII, 5(210), 1984, pp. 20–22, quotation on p. 21. A projected reduction of 11.1 percent of the number of villages has been extended over a long period, ibid.

71) Arch. Eusebie Latis, "Actualitatea locuintelor cu putine niveluri si numar redus de apartamente" (The present interest in houses with a small number of flats and apartments), *A.*, XXX, 2(195), 1982, p. 23.

72) Dr. Arch. Andrei Panoiu, "Arhitectura traditionala din zona centrala a Gorjului" (Traditional architecture of the Gorj central zone), edited in the series *Historical architectural sites* by Muzeul National de istorie (National Museum of History), Bucuresti, 1982, 155 p., French and English foreword and summary; Dr. Arch. Andrei Panoiu, "Arhitectura si sistematizarea rurala in judetul Mehedinti (secolele XVIII–XIX)" (The architecture and the rural systematization in Mehedinti County, 18th–19th century),

same series and editor, Bucharest, 1982, 227 p., French and English foreword and summary. Vernacular architecture has been studied in various national zones of Romania.

73) Constantin Joja, *Sensuri si valori regasite* (Rediscovered significances and values), foreword by Paul Petrescu, Editura Eminescu, 1981, Bucharest, especially p. 72–102 and 129 in Romanian; Constantin Joja, *Actualitatea traditiei arhitecturale romanesti* (The modernity of the Romanian architectural tradition), Editura Tehnica, 1984, Bucharest, p. 191 and 56 pages with 112 photographs.

Articles: Arch. Calin Hoinarescu, Sociologist Elena Suzana Calciu, "Cladiri de locuit in mediul rural specifice judetului Prahova" (Rural dwellings from Prahova county), *A.*, XXVIII, 3(184), 1980, pp. 40–42; Arch. Serban Nadejde, "Locuinta pentru zona montana si submontana a judetului Bistrita-Nasaud" (Dwellings for the mountainous and submountainous area of the Bistrita-Nasaud district), *A.*, XXVIII, 3(184), 1980, pp. 34–38 (English title, p. 5); Professor Gh. Vecerdea, "Imagini reprezentative ale arhitecturii traditionale din satul dobrogean" (Representative images of the Romanian traditional rural architecture of the village of Dobrogea), *A.*, XXIX, 4–5(191–192), 1981, p. 119 (English title, p. 8); Arch. Iuliana Ciotoiu, "Locuinte traditionale in comuna Salciua, jud. Alba," I si II (Traditional dwellings in the Salciua village, Alba County, Part I and II), *A.*, XXVIII, 5(186), 1980, pp. 61–62 and XXIX, 1(188), 1981, pp. 56–57; Arch. Ion Enescu, "Elemente semnificative ale locuirii traditionale" (Significant components of the traditional lifestyle), *A.*, XXIX, 6(205), 1981, pp. 64–67; Arch. Daniela Tutunea, "Relatia comportament uman—mediu arhitectural, din perspectiva specificului romanesc" (Human behavior and architectural environment from the specific Romanian standpoint), *A.*, XXXI, 5(204), 1983, pp. 59–62; Traian Dinorel Stanciulescu, "Transylvania—cind catedralele erau de lemn" (When the Transylvanian cathedrals were of wood), *A.*, XXXII, 2(207), 1984, pp. 50–52; Arch. Calin Hoinarescu, "Studiu de inventariere, cartare si punere in valoare a monumentelor de arhitectura, istorice si memoriale din judetul Prahova" (An inventory of rural and urban mansions and dwellings in Prahova County), *A.*, XXXIV, 1(218), 1986, pp. 34–35; Arch. Gh. Patrascu, "Citeva consideratii asupra gospodariei taranesti in context european" (Some opinions on the rural household from a European perspective), *A.*, XXXIV, 5(222), 1986, pp. 29–38; Dr. Arch. Andrei Panoiu, "Date generale privind arhitectura traditionala din zona Buzaului de sus . . ." (General data on the traditional architecture of the Buzau upper valley . . .), *A.*, XXXV, 2(225), 1987, pp. 37–46; idem, "Arhitectura traditionala si organizarea structural-functionala a asezarilor din Gorj" (On the traditional architecture and structural-functional organization of Gorj villages), *A.*, 5(228), 1987, pp. 41–54; Arch. Christian Nicolescu, Engineers Cornel Nicut, Alexandru Marinescu, Alexandru Constantinescu, "Cladiri de locuit cu putine niveluri in mediul rural si urban realizate cu metode industrializate" (Rural and urban houses with a few stories built by industrialized methods), *A.*, 6(229), 1987, pp. 39–41; Arch. Adrian Cristescu and team Ana-Maria Drugheanu, Gabriel Negoescu, Lucilia Belei, Nicolae Ioana, Dan Vartanian, Dan Bota, Constantin Apostolescu, Doina-Ancuta Romanescu, "Cladiri de locuit cu putine niveluri in mediul rural" (Rural houses with few stories), *A.*, 6(229), 1987, pp. 42–45. For the modernity of the Romanian folk architecture, see also, Professor Arch. Adrian Gheorghiu, "Prelucrari de arhitectura populara romaneasca" (Processing Romanian folk architecture), *A.*, XV, 2(105), 1967, pp. 42–45 (English summary, p. 3).

74) *A.*, XXXV, 5(228), 1987, Bucharest, p. 41.

75) Dinu C. Giurescu, "Memoria necesara a oraselor" (The necessary memory of towns), *Contemporanul*, 11(1,896), March 11, 1983, Bucharest, p. 7. See also, comment on A. Panoiu's Gorj, note no. 72 by Dinu Giurescu, "Arhitectura traditionala romaneasca" (Romanian traditional architecture), *Contemporanul*, 43(1,876), October 22, 1982, Bucharest, p. 2; also Dinu C. Giurescu's interview, *Flacara*, XXXII, 9(1,447), March 4, 1983, Bucharest, p. 15.

60

76) Daniela Costin Tutunea, "Actualitatea necesara a gindirii traditionale romanesti" (The contemporaneity of Romanian traditional thinking), *A.,* XXXIII, 3(214), 1985, pp. 74–76, quotation on p. 76. See also, Marcian Bleahu, "Case moderne cu elemente traditionale" (Modern dwellings with traditional elements), interview by Cici Iordache-Adam, *Flacara,* XXXVII, 24(1,721), June 17, 1988.

77) The memorandum was written by Dinu C. Giurescu and registered at the Central Committee under no. 10,460, December 22, 1979. The answer to Dinu C. Giurescu (14, March 17, 1980): " . . . you have expressed judicious ideas which will be taken into account by the urban planners," in order to integrate constructions of value from the past into the new architecture. The answer was given by the Director for systematization, planning and constructions.

78) Large-scale demolition and reconstruction have been carried out in other towns, including: Tirgu Neamt, Adjud, Panciu, Tirgu Ocna and Buhusi in Moldavia; Urziceni, Oltenita, Alexandria, Zimnicea, Rosiorii de Vede, Caracal and Turnu Magurele in Wallachia; and Hirsova, Babadag and Isaccea in Dobrogea (see complete list in "Conclusions.")

79) Special issues, *A.,* focused on "the Metro in Bucharest," XXVIII, 4(185), 1980, pp. 10–36; "Romanian planning in other countries," XXVIII, 5(186), 1980, pp. 9–53 and 6(187), 1980, pp. 9–31; "Apartment buildings," XXIX, 6(193), 1981, pp. 10–59; "The reconstruction of the town of Iasi," XXIX, 2–3(189–190), 1981, pp. 9–81; idem, for Craiova, XXX, 3(196), 1982, pp. 1–57, with the exception of one article that recalls and advocates traditional constructions; on "Commerce and services," XXX, 4(197), 1982, pp. 1–44; on "New achievements," XXX, 5(198), 1982, pp. 1–38; on "Systematization," XXXI, 1(200), 1983, pp. 11–53; on "Teaching and youth," XXXI, 2(201), 1983, pp. 1–46; on "Hotels and tourism," XXXI, 3(202), 1983, pp. 1–40; on "Balneology," XXXI, 5(204), 1983, pp. 1–39; "Romanian architectural planning for other countries," XXXII, 3(208), 1984, pp. 1–39; "Four decades of great architectural achievement," XXXII, 4(209), 1984, pp. 1–36, etc.

80) Arch. Nicolae Munteanu, "Centrul Vasluiului" (The center of Vaslui), *A.,* XXIX, 5(192), 1981, pp. 64–69 (English summary, p. 7). See also; Arch. Corneliu Ionescu, "Locuintele municipiului Tirgoviste" (The dwellings of Tirgoviste), *A.,* XXX, 2(195). 1982, pp. 25–30 (the author refers to the blocks that have been restructured in the central town area); "Noi interventii arhitecturale in zona centrala a Municipiului Rimnicul Vilcea" (New infill in the central zone of the town of Rimnicul-Vilcea), interview with Architects Liviu Ioan Bene and Dan Zamora, by Arch. Adrian Ciocanau, *A.,* XXX, 5(198), 1982, pp. 57–61; Arch. Constantin Rabiniuc, "Aspecte legate de sistematizarea orasului Siret" (On the systematization of the town of Siret), *A.,* XXXII, 6(211), 1984, pp. 20–21; on the map at p. 20 there is one historic monument, the Holy Trinity Church, which remains within the new structure.

81) Interview with Dr. Arch. Alexandru Budisteanu, chief architect of Bucharest, *A.,* XXVIII, 1–2 (182–183), 1980, pp. 12–17, quotation at p. 15, interview by Architects Andrei Feraru and Mihai Popescu.

82) Arch. Mircea Cardas, "Sistematizarea si reconstructia localitatilor rurale din Romania" (Rural settlement planning and rebuilding in Romania), *A.,* XXVIII, 3(184), 1980, pp. 10–12 (English summary, p. 3).

83) The maximum paid by the state authority for a privately owned, two-story villa is approximately 80,000 lei, an amount that cannot be exceeded. A four-room apartment, 81 to 93 square m., is sold to citizens by the state at a price of 204,660 to 234,000 lei, whereas a five-room apartment is sold at 246,740—275,800 lei; decree no. 256, July 14, 1984, *Official Bulletin,* XX, 57, Part I, July 20, 1984, p. 4, see also pp. 1–7. A two-story villa with basement, garden, central heating or stoves, and running water is at least 50 percent higher in value than a five-room flat. Compare 80,000 lei, the compensation received by the former owner to approximately 390,000 lei, the real value of the

villa, according to official prices (the average of 246,700 + 275,800 is 260,270, to which 50 percent has been added = 390,405 lei).

84) More data on these churches in Nicolae Stoicescu, *Repertoriul bibliografic al monumentelor feudale din Bucuresti* (Bibliography of Bucharest's feudal monuments), Publishing House of the Romanian Academy (Editura Academiei), Bucharest, 1961. The monuments are listed in alphabetical order. After the demolition of the Seventh Day Adventist Church and the Sephardic Jewish Synagogue, on August 7, 1986, the U.S. Department of State registered an official protest in Bucharest and at the Romanian Embassy in Washington, D.C. See also the declaration of Congressman Frank Wolf on the same issue, August 7, 1986.

85) Opris, *Heritage,* p. 193. The church is made of 745 metric tons of material; the same operation was undertaken at Olari Church (1,278 metric tons, ibid).

86) *Lista monumentelor* (see above footnote no. 2), 112, p. 19.

87) Data on churches that have been moved and hidden from view, in Nicolae Stoicescu, op.cit. Three other churches have been either completely hidden by new blocks (Doamnei [The Lady's church], 28 Calea Victoriei, a historic monument built in 1683, repaired in 1869, 1906 and 1931) or screened on three sides (north, east and south) by new construction: Domnita Balasa (Princess Balasa's Church), 1 Calea Rahovei, built in 1750–1751, repaired in 1831, entirely rebuilt in 1838–1842 and a second time in 1881–1885; and Zlatari (The Goldsmiths' Church), 12 Calea Victoriei, built in 1705, demolished and reconstructed in 1850–1852, repaired in 1864, 1876, 1898 and restored in 1907–1908.

88) See *Lista monumentelor* (see above footnote no. 86), no. 94, p. 18.

89) The letter was signed by three members of the Central State Commission for the National Cultural Patrimony: Professor Dr. Arch. Grigore Ionescu (born 1904), prominent historian of Romanian architecture and former director of the Historic Monuments; Dr. Razvan Theodorescu, art historian and Professor Dinu C. Giurescu, historian.

90) The letter was registered under no. 377, January 24, 1985, and was signed, in addition to the three above-mentioned persons, by four other prominent scholars and researchers: Professor Dionisie M. Pippidi (born 1905), archaeologist and specialist in Ancient History and member of the Romanian Academy; Professor Dr. Vasile Dragut, art historian (1928–1987), former Director of The Directorate for National Cultural Patrimony and member of the Romanian National Committee ICOMOS; Dr. Radu Popa, archaeologist and well-known specialist on Romanian medieval culture and civilization and Dr. Arch. Aurelian Triscu, associate professor at the School of Architecture, Bucharest.

 The letter discloses some details. On January 3, 1985, the General Office for Housing Development and Administration (DGDAL in Romania) asked the Archbishop of Bucharest to agree to the demolition of the Mihai Voda Church. This request was soon followed by the demolition of the buildings around the church (all listed as historic monuments).

 On December 14, 1984, a memorandum addressed to the Central Committee of the Romanian Communist Party (Section for Press and Propaganda) requested an immediate stop to demolition at the Vacaresti monastery. "Thus on December 30, 1984, the two small towers of the main church were pulled down. Several structures belonging to the monastery were razed on January 12, 1985. On January 21 the big tower of the main church was also pulled down" (English translation of the Romanian text of the letter, *Radio Free Europe Research,* 11, 3, January 17, 1986, pp. 20–21, article by Dan Ionescu).

91) This letter is signed by Professor Dr. Arch. Grigore Ionescu, Dinu C. Giurescu, Razvan Theodorescu, Vasile Dragut and Virgil Candea, all members of the Central State Commission for the National Cultural Patrimony. The letter was registered under no. 6368, October 22, 1985, at the Central Committee of the Romanian Communist Party.

92) *Lista monumentelor* (see above footnote no. 86), no. 2, p. 167.

93) The letter was written by Dr. Andrei Pippidi, researcher at the Institute for Southeast European Studies, Bucharest, and grandson of Nicolae Iorga. "The blind mutilation of our city has to be halted," writes Andrei Pippidi. "The time comes when one learns to express aloud a protest thought out for a long time but never before uttered." (English translation, *Radio Free Europe Research,* 11, 41, part IV, October 10, 1986, pp. 35–36, article by Dan Ionescu).

94) On the demolition of Mihai Voda, memoranda were sent by Dinu C. Giurescu to: the State Presidency (No. 1790, January 12, 1985); the Secretary for Press and Propaganda at the Central Committee (2 letters, No. 150, January 12, 1985, and No. 211, January 15, 1985); to the President of the Council for Culture and Socialist Education (January 14, 1985); to the Patriarch of the Romanian Orthodox Church (No. 240, January 12, 1985) and to the Central State Commission for the National Cultural Patrimony.

95) Dan Ionescu, More protests against demolition in Bucharest, *Radio Free Europe Research,* 11, 41, part IV, October 1986, p. 35.

An anonymous article in English reached the west in 1985. It reviews postwar urbanization and its developments in the last years, including the destruction of churches and historic monuments: "The Romanian traditional urban architecture, part of the European heritage, vanishes every day. . . . At stake now are the Transylvania towns (listed by name) . . . as well as Bucharest, Braila, Curtea de Arges, Cimpulung Moldovenesc, Calafat and other smaller towns. . . .

There is little time left to save the traditional, vernacular Romanian urban and rural architecture. Everyone must raise his voice to help preserve this part of the European heritage. Every single effort is welcome and useful. Will you join us?" The English version sent from Romania was published by Dan Ionescu, "An underground essay on urban and rural redevelopment," ibid., 11, 7, Part I, February 14, 1986.

96) The request written by Dinu C. Giurescu was submitted orally to the Council at its annual meeting in Bucharest at the Patriarch's residence. The memorandum requested an immediate stop to the demolition of churches; the moving of monuments to other sites, if this was the only way to save them; and the restoration of the architectural complex of Vacaresti.

97) The International Association for the Protection of Historic Monuments and Sites in Romania was founded by Architect Stefan Gane; it is located 38, Boulevard Saint Jacques, 75014 Paris, France.

98) See the statues of the Association, articles 1 and 6 ("Moyens d'action").

99) Stefan Gane's appeal was titled, "Ceterum censeo Bucurestios non esse delendos." (I think therefore that Bucharest should not be destroyed.)

100) In 1986 UNESCO representatives were not favorable to the requests of the Association; see UNESCO's response CC/CH/01/7.3M5 of March 24, 1986. A new appeal of the Association was submitted to UNESCO on February 2, 1987, with the list of monuments demolished in Bucharest in 1986 and the first half of 1987. The new Director General of UNESCO reacted positively and inquired at the Romanian Embassy about the demolition in Bucharest. See Stefan Gane's letter to Meredith Walker, Australian ICOMOS Advisory Committee, August 1, 1987.

101) Letter RDS/MT/17, February 15, 1988, Paris, signed by Roberto Di Stefano, ICOMOS President. The same letter was sent to Sherban Cantacuzino, Vice-Chairman, ICOMOS U.K.; Y.R. Isar, representative of the World Heritage Committee at UNESCO; the Romanian delegation at UNESCO; and the Central Committee of the Romanian Communist Party.

102) Heathfield Road, Keston, Kent BR2 6BA, U.K. Keston College specializes in the study of religious communities in the Soviet Union and Eastern Europe. See letters dated March 2 and 12, 1988.

103) See the letter written by Archbishop Damianos to the Association, April 29, 1988.

104) Letter to Roberto Di Stefano, ICOMOS President, Paris, May 10, 1988.

105) See the letters sent by UIA (Union Internationale des Architectes/International Union of Architects), A-191:88 (Paris, May 16, 1988) and A-242:88 (Paris, June 27, 1988) and UNESCO letter signed by Y.R. Isar to UIA, CC/CH/01/7.3/M5, June 22, 1988.

106) Thirteen articles and analyses have been written by Dan Ionescu, art historian: "Razing the Romanian past," *Radio Free Europe Research,* 9, 45, November 9, 1984, pp. 10–14; "Destruction of old Bucharest continues," ibid., 10, 34, August 23, 1985, pp. 25–30; "Historians protest against church demolition," ibid., 11, 3, January 17, 1986, pp. 19–22; "An underground essay on urban and rural development," ibid., 11, 7, Part I, February 14, 1986, pp. 9–13; "Romania responds to western criticism of urban demolitions," ibid., 11, 71, March 7, 1986, pp. 9–11; "More protests against demolition in Bucharest," ibid., 11, 41, Part IV, October 10, 1986, pp. 33–36; "A second capital for Romania?" ibid., 11, no. 46, part III, November 14, 1986, pp. 21–24; "Hard times for the Romanian Orthodox Church," ibid., 12, 9, Part I, March 6, 1987, pp. 29–32; "Ceausescu urges the rebuilding of Bucharest," ibid., 12, 24, Part IV, June 19, 1987, pp. 13–14; "Patriarch Teoctist visits Austria," ibid., 12, 26, Part III, July 3, 1987, pp. 11–13; "The Orthodox Church and the State: a change in attitude?" ibid., 12, October 15, 1987, pp. 25–29, with appendix 1: "Orthodox churches and monuments known to have been razed in Bucharest since 1977," and appendix 2: "Other Bucharest churches affected by urban renewal—partially destroyed, moved or screened off by high-rises;" "Housing as a political tool," ibid., 12, 44, Part IV, November 6, 1987, pp. 29–32; "Orthodox priest writes to the World Council of Churches," ibid., 13, 2, Part I, January 15, 1988, pp. 43–37; two other articles or analyses by Paul Gafton, "Ceausescu lays foundation stone for Grand Bucharest project," ibid., 9, 31, August 3, 1984, pp. 7–10; by Vladimir Socor, ibid., 10, 36, Part II, September 6, 1985, pp. 3 and 11–14.

 Four other analyses focus on rural systematization: "The party's hunt for more land," ibid., 8, 27, Part I, July 8, 1983, pp. 14–15; Sophia M. Miskiewicz, "Housing in eastern Europe: Romania," ibid., 11, 25, Part I, June 20, 1986, pp. 25–27; "Rural reorganization," ibid., 12, 29, Part I, July 24, 1987, pp. 13–16; Paul Gafton, "Rural reorganization planned," ibid., 13, 25, Part II, June 24, 1988, pp. 15–18.

107) Architect Sherban Cantacuzino, Vice-Chairman of ICOMOS U.K., and Secretary of the Royal Fine Arts Commission, and Jean-Louis Michon, "Reconstruction in Bucharest and its consequences for the architectural heritage," *ICOMOS Information,* April/June, 2, 1987, pp. 9–18; see also Sherban Cantacuzino, "Cultural shambles in Romania," *The Architectural Review,"* CLXV, 984, February 1979, London, p. 64; cf., idem, "Fortified houses in Wallachia," ibid., CLI, 900, February 1972, pp. 106–108.

108) An "Open Letter" written by Christian Solidarity International (Postfach 1, 5013, Salzburg, Austria) to the Romanian Embassy in Vienna, January 11, 1988.

109) As for example:

 Norman St. John Stevas, chairman of the Royal Fine Art Commission, U.K., at the Helsinki Cultural Forum organized at Budapest, November 21, 1985;

 Dr. Dionisie Ghermani, "Zur Lage der Kirchen in Rumanien" (The situation of religious sects in Romania), paper presented at the 37th International Congress "Kirche in Not" (Churches in need), Konigstein/Taunus, Federal Republic of Germany, September 3–6, 1987;

 Jessica Douglas-Home, who visited Bucharest in the fall of 1987, in two letters written to *The Times,* October 5, 1987, and *The New York Times;*

 Reverend Father Ion Dura, principal of the Orthodox communities in the Netherlands, Belgium and Luxembourg, in his open letter to the Secretary General of the World Council of Churches, Geneva, Switzerland, October 29, 1987; and

 Professor Claudio Magris, "Ditta Ceausescu, demolizioni e traslochi," *Corriere della Sera,* August 7, 1988, p. 3; idem, in his travel book on the Danube River, 1987.

64

Other unavailable valuable private or institutional initiatives were not included in this study.

110) The quotations of the newspaper coverage that follows are illustrative only. It was not possible to trace all articles published in the United States, and in principal European Western countries. In the United States: The *Boston Globe,* August 20, 1985; The *Washington Times,* October 1, 1985, and June 23, 1986; The *New York Times,* October 6, 1985, and July 2, 1988; The *Washington Post,* November 1, 1985, and January 6, 1986; *The Sun,* November 17, 1985; Associated Press, From London, November 4, 1985; *Los Angeles Times,* December 17, 1985; *Reader's Digest,* January 1986; The *Wall Street Journal,* February 7, 1986, and May 19, 1988; The *Christian Science Monitor,* March 25, 1986; The *New York Tribune,* February 17, 1988; The *Philadelphia Inquirer,* May 15, 1988; The *New York Times,* Thursday, August 18, 1988, CXXXVII, 47, 601; idem, September 1, 1988, CXXXVII, 47, 615; idem, September 4, 1988, CXXXVII, 47, 618; *Time,* September 5, 1988, pp. 31–32. . . .

111) In France: *Liberation,* August 27, 1984, and November 9–10, 1985; *Le Monde,* August 31, 1984, June 16–17, 1985, February 17, 1988; *Le Figaro,* September 5, 1984, and April 2, 1985; *L'Alternative* (Paris), January-February 1985; *Le Quotidien de Paris,* March 28, 1985, and May 24, 1985; *Le Matin,* April 1, 1985; *Le Point,* November 4, 1985, and May 15, 1987; *L'Express,* December 20, 1985; *AFP* (Agence France Press), August 20, 1984, April 18, 1985, and November 27, 1985.

112) In West Germany: *Frankfurter Rundschau,* November 2, 1984; *Der Spiegel,* November 26, 1984; *Die Weltwoche,* March 7, 1985; *Handelsblatt,* October 28, 1985; *Suddeutschezeitung,* November 9–10 and 23–24, 1985; *Actuel,* November 18, 1985; *Die Zeit,* November 22, 1985; *Die Welt,* December 18, 1985, and January 6, 1986; *Stuttgarterzeitung,* September 4, 1987; and *DPA,* German Press Agency, January 23, 1986, etc.

113) In the United Kingdom: *The Sunday Telegraph,* May 5, 1985; *The Times,* September 11, November 4 and December 21, 1985; *The Spectator,* December 7, 1985, and January 4, 1986; *Reuter,* from Bucharest, October 24, 1984; *BBC Report,* Current Affairs Research and Information Section, 44/85, April 9, 1985.

114) In Switzerland: *L'Hebdo,* Lausanne, April 25, 1985; *24 Heures,* Lausanne, June 23, 1985; *Neue Zurcher Zeitung,* January 27, 1986.

115) In Belgium: *La Libre Belgique,* April 3 and 12, 1985; November 28, 1985.

116) In Spain: *ABC,* Madrid, May 7, 1985.

117) In Canada: *Le Devoir,* Montreal, June 13, 1985.

118) In Brazil: *Istoe,* Brasilia, April 24, 1985.

119) In January 1988.

120) New voices have been raised to defend Romania's architectural heritage, namely:
James Cellan Jones, director of the BBC Television serial "Fortunes of War," in *The Times,* London, United Kingdom, October 1987.

Charles Knevitt, architecture correspondent, in *The Times,* London, United Kingdom, February 9, 1988.

Prebendary Edward Shotter, in *The Times,* London, United Kingdom, February 20, 1988.

Architect Sherban Cantacuzino, in *The Times,* London, United Kingdom, February 27, 1988.

The Duke of Gloucester, in the February 1988 issue of "Frontier," published by Keston College, Kent, United Kingdom.

Ion Popescu, in *Le Point,* Paris, France, July 4, 1988, pp. 38–39.

Gavin Stamp, in *The Spectator,* United Kingdom, July 9, 1988.

Colin Amery of *The Financial Times,* London, United Kingdom, in a letter to The Samuel H. Kress Foundation, New York, N.Y., USA, July 13, 1988.

Appeal from the President of ICOMOS, Roberto Di Stefano, for Romanian heritage in *ICOMOS Information,* July–September, No. 3/1988, p. 43.

An article in *Le Monde,* Paris, France, No. 13,546, August 17, 1988.

Kenneth W. Banta, correspondent from Bucharest in *Time* magazine, New York, N.Y., USA, September 5, 1988, Vol.132, No. 10, pp. 31–32.

Alexander Johnson in *The Daily Telegraph,* London, United Kingdom, September 8, 1988.

Veronique Soule in *Liberation,* Paris, France, October 20, 1988, p. 20.

John Whitehead, U.S. Deputy Secretary of State, at the Press Conference held in Budapest, Hungary, October 1988.

Hannes Reichmann in the business weekly, *Wirtschaftswoche,* Dusseldorf, Federal Republic of Germany, English translation in *World Press Review,* Volume 35, No. 11, November 1988.

Arnold Berke in *Preservation News,* Washington, D.C., November 1988, pp. 4 and 15.

Janet Heller in *The New York Times,* Volume CXXXVIIIL, No. 47, 717, December 12, 1988, New York, N.Y., USA.

Professors Natalie Z. Davis, Istvan Deak and Carl E. Schorski, in a letter published by *The New York Review of Books,* January 19, 1989.

Five Romanian citizens living in Romania have sent an open letter to the President of the state asking for an immediate stop to the demolition of the villages. The letter is signed by Doina Cornea, professor, Cluj-Napoca; George Vasilescu, a retired lawyer, Cluj-Napoca; Julius Filip, medical worker and human rights activist, Cluj-Napoca; Dumitru Pop, worker and human rights activist, Turda; Haralambie Chirca, historian, Sibiu; and Samoila Popa, physical education teacher, Sibiu. The letter has been published in *The Free Romanian,* Volume 4, No. 10, October 1988, London, United Kingdom.

Professor Mark Almond of Wolfson College, Oxford, in a letter to *The Independent,* London, United Kingdom.

The author wishes to acknowledge the many appeals made throughout the world, to focus attention on the demolitions underway in Romania, that could not be cited at the time this document was prepared for publication.

In Romania, the concept of urban renewal has taken a dramatic and unexpected turn since the "Urban and Rural Systematization Law" was enacted in 1974, providing the framework for comprehensive rebuilding. Since then, at least 29 towns have been 85–95 percent razed and rebuilt according to principles supposed to represent progress and modernity. The towns known to have been rebuilt are: Suceava, Botosani, Pascani, Iasi, Roman, Piatra-Neamt, Bacau, Vaslui, Husi, Birlad, Tecuci, Focsani, Galati (all in the former Principality of Modavia); Rimnicul-Sarat, Buzau, Mizil, Ploiesti, Pitesti, Slatina, Craiova, Rimnicul Vilcea, Giurgiu, Slobozia, Calarasi (all in the former Principality of Wallachia); Medgidia, Tulcea, Constanta, Mangalia (all in Dobrogea); Baia Mare (all in Transylvania).

The traditional architecture and, indeed, the entire urban fabric have been leveled and replaced by multistory tenement buildings and a different street network. An urban world with few connections to the past has emerged, eradicating the national architectural identity.

At least 37 additional towns are undergoing large-scale demolition and resettlement: Tirgu Neamt, Adjud, Panciu, Odobesti, Tirgu Ocna, Buhusi (all in Moldavia); Calimanesti, Urziceni, Oltenita, Alexandria, Zimnicea, Rosiorii de Vede, Turnu Magurele, Calafat, Caracal, Turnu Severin (all in Wallachia); Hirsova, Babadag, Isaccea, Cernavoda (all in Dobrogea); Bistrita (Bistritz), Beclean, Reghin, Miercurea Ciuc (Csikszereda), Tirgu Mures (Marosvasarhely), Sfintu Gheorghe (Sepsiszentgyorgy), Odorheiu Secuiesc (Szekely-udvarhely), Fagaras, Orastie, Dej, Deva, Tirnaveni, Aiud, Alba Iulia (Gyulafehervar), Satu Mare, Zalau, Sighet (all in Transylvania).

Traditional structures have also been demolished in the following urban centers: in Transylvania, at Brasov (Kronstadt), Sibiu (Hermannstadt), Cluj (Koloszvary, Klausenburg), Sighisoara (Schassburg), Sebes (Muhlbach), Timisoara (Temeschwar, Temesvar), Resita, Oradea (Nagyvarad, Grosswardein), Arad; and Radauti and Baia (Moldavia).

Vacaresti Monastery, Bucharest. View of the chapel; in the background, scaffolding erected for the restoration work conducted before November 1977.

Bucharest, Vacaresti Monastery

 Built in 1716–1722, the Vacaresti monasterial complex represented, according the late Romanian art historian Vasile Dragut, "the most outstanding achievement of 18th-century Romanian architecture." (in *Dictionar Enciclopedic de Arta Medievala Romaneasca*, Editura Stiintifica si Enciclopedica, Bucharest, 1976, p. 313). Restoration of the buildings, all listed historic monuments, began in 1974–1975 and continued through 1977, when the Commission for Historic Monuments was dismantled. The demolition of the Vacaresti monasterial complex began in December 1984 and was completed in the winter of 1986–1987. The following photographs were taken in January 1985.

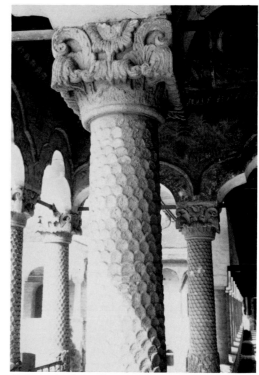

Column in the gallery on the second floor of the eastern buildings.

Residence of the founder, Nicolae Mavrocordat, ruling prince of Moldavia (1709–1710, 1711–1715) and Wallachia (1715–1716, 1719–1730).

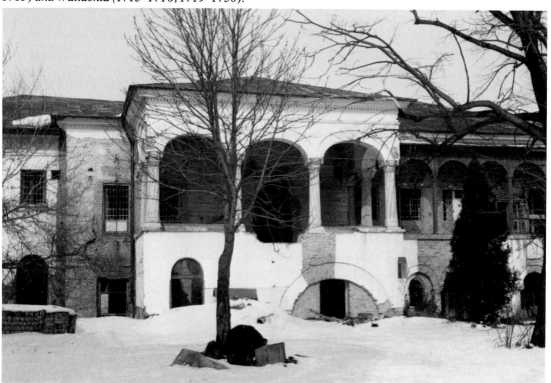

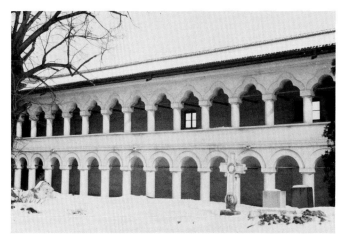

A double gallery, restored 1974–1977.

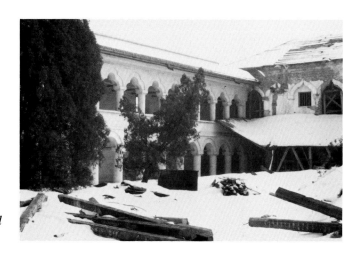

View of the eastern buildings and one of the southern buildings.

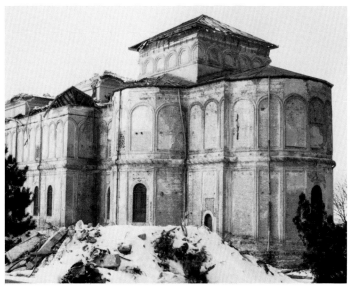

The main church, as viewed from the southeast.

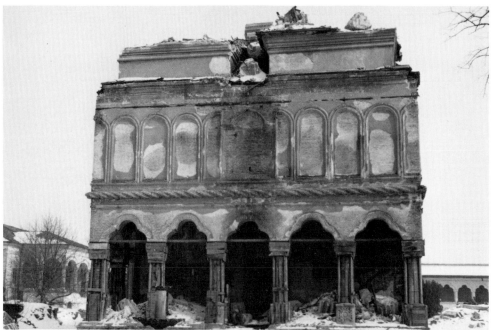

The western facade after demolition began. The city of Bucharest destroyed the three towers of the main church of Vacaresti from December 1984–January 1985, dumping the rubble into the structure.

View inside the main church, with the rubble from the destruction of the three towers.

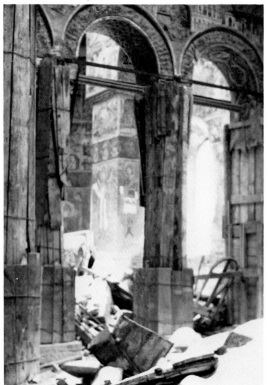

View of the apse and altar table.

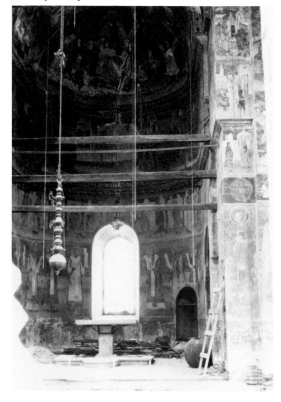

After the Vacaresti Monastery had been completely destroyed, fragments of the sculptured columns were dumped approximately 20 kilometers away in the courtyard of the Mogosoaia Palace (photos taken July 1987).

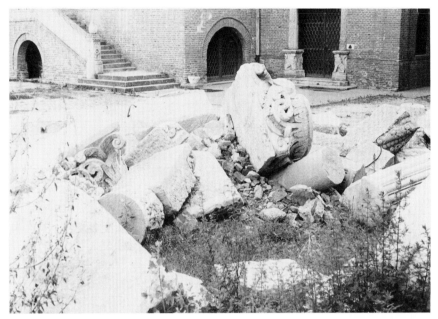

Capitals

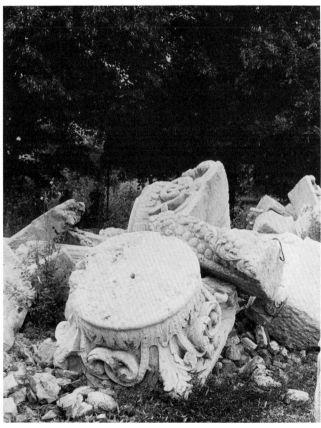

Columns

Sculptured armorial bearings of Nicolae Mavrocordat.

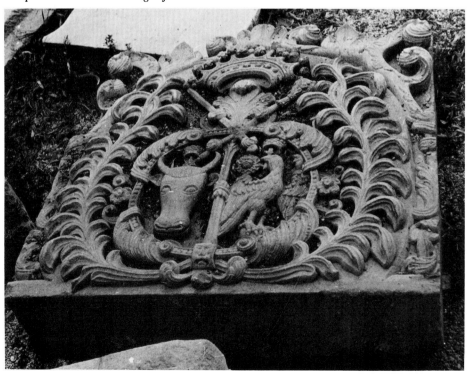

Bucharest

Implementing systematization: in Bucharest, approximately 150 buildings were destroyed in a small central area bordered by Berzei Street, Stirbei Voda Street, Virgiliu Street and the Calea Plevnei. From August–November 1987, every structure was leveled, with the exception of one church, one school and four houses. The majority of the photographs preserve the image of the buildings and the streets that have now vanished.
(Photos taken July–August 1987)

View along Stirbei Voda Street; this segment has disappeared completely.

View along Ocolisului Street, which has disappeared.

Administration building on Lipova and Ocolisului streets during demolition (August 1987).

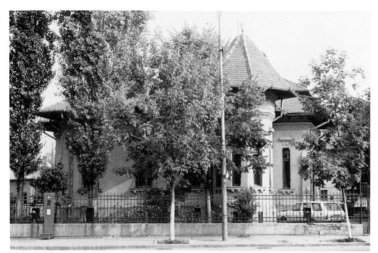

160–162 Stirbei Voda Street; former residence of Engineer Tiberie Eremia.

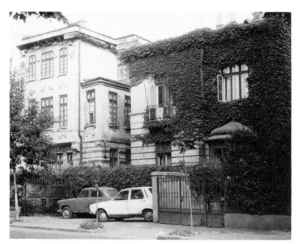

160–163 Stirbei Voda Street.

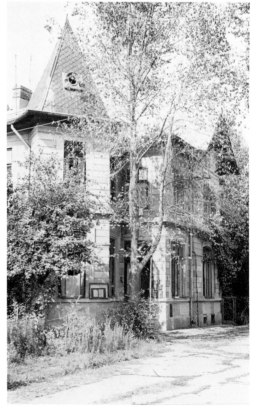

Dwellings on Calea Plevnei, presumably razed by now.

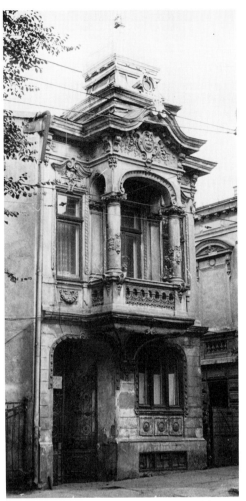

35 Berzei Street, late 19th-century residence.

113 Stirbei Voda Street, house from the interwar period with two apartments. Demolition was initiated in September 1987 and the tenants were required to move. Shortly afterwards, urban planners decided to retain the house and the residents returned. Some weeks later, the demolition began anew, the tenants were again obliged to relocate, and the razing was completed by late fall 1987.

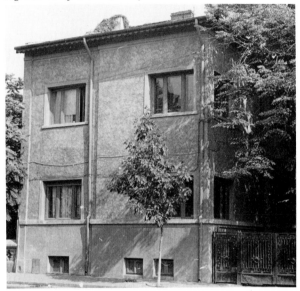

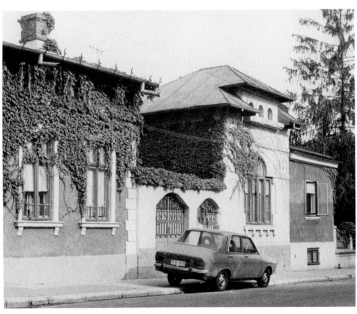

13–15 Fagaras Street, single-family house.

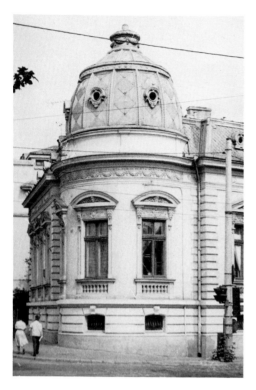

Stirbei Voda and Berzei streets; the former Dobrescu residence, a late 19th-century structure that is now a clinic. The demolition stopped at this intersection in the fall of 1987, sparing the building for the time being.

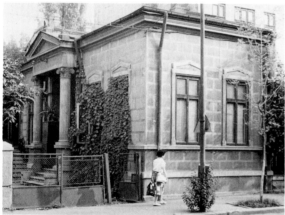

164 Stirbei Voda Street, single-family house.

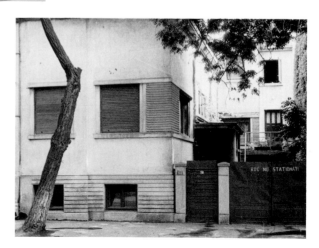

79 Virgiliu Street, single-family house.

Demolition in Bucharest

During the summer of 1985, demolition advanced along the left bank of the Dimbovita River, at the center of Bucharest. Almost every building and the entire network of streets were leveled from August–October 1985. Unless otherwise noted, photographs were taken in August–September, 1985.

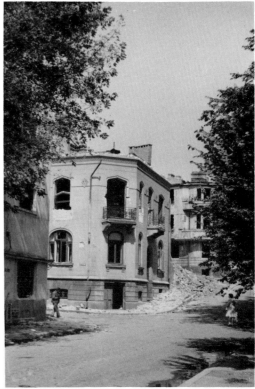

The area around Banu Maracine and Negru Voda streets.

A four-story building near Calea Vacaresti, destroyed in the fall of 1985.

Rapid demolitions on Negru Voda Street.

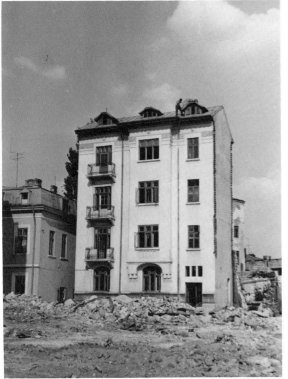

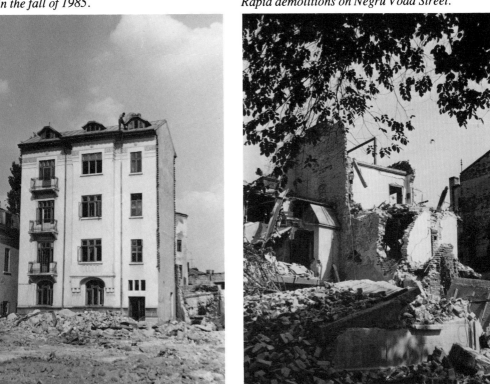

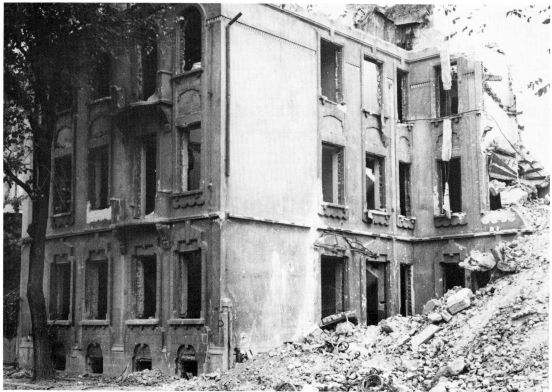

Splaiul Unirii, left bank, near the intersection with Marasesti Boulevard.

Splaiul Unirii, left bank; a late 19th-century public building under demolition.

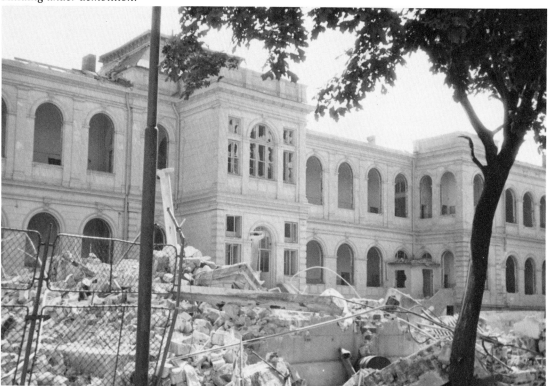

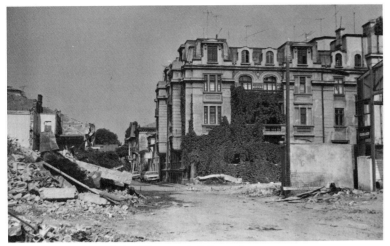

Demolitions along Calea Vacaresti. It is not known whether the apartment building on the right side has survived.

Two excavators and a bulldozer—the primary instruments of rapid destruction—on Calea Vacaresti at the corner of Clucerul Udricani Street.

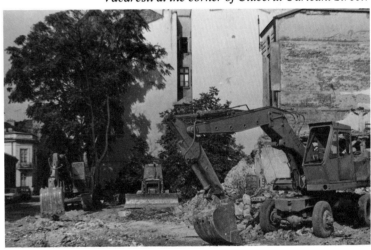

Building near the Institute for Forensic Medicine, Splaiul Unirii, left bank. Demolished in the late fall of 1985.

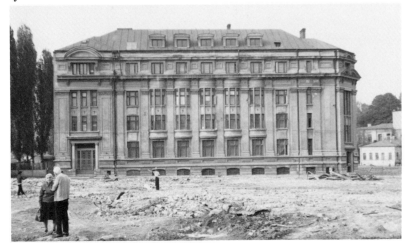

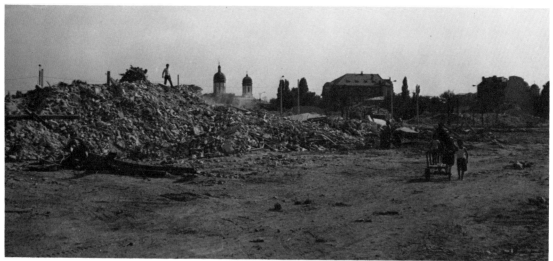

Rubble on Calea Vacaresti, seen from Olteni Street.

The former Calea Vacaresti, near the Unirii Plaza area.

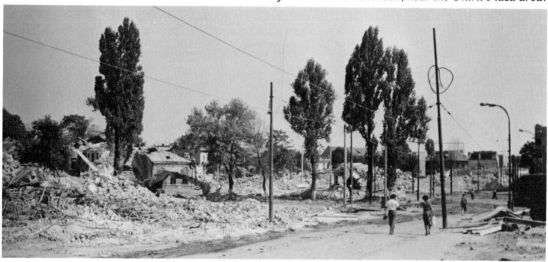

Area near the former Institute for Forensic Medicine.

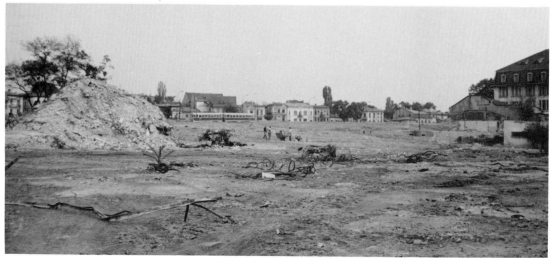

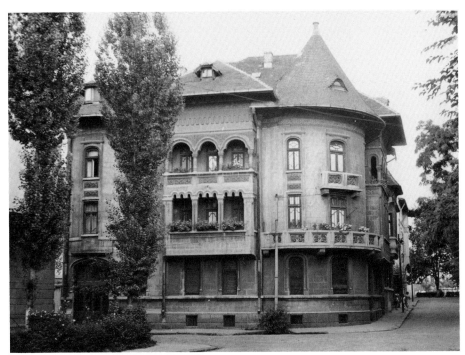

Early 20th-century apartment building, on Militiei and Captain Ferraru streets, in the center of Bucharest; demolished with the surrounding area in 1987.

Apartment building, dating from before World War II, at the corner of Smeurisului Street. This building was demolished September–October 1985.

Buildings along the Splaiul Unirii, left bank, opposite the Institute for Forensic Medicine. These buildings disappeared in the fall of 1985.

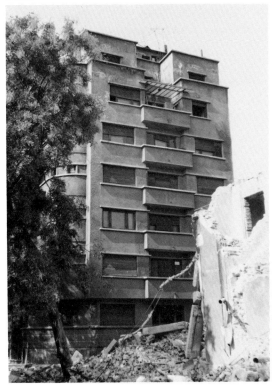

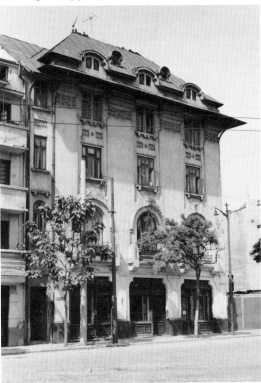

The area around Banu Maracine and Negru Voda streets under destruction.

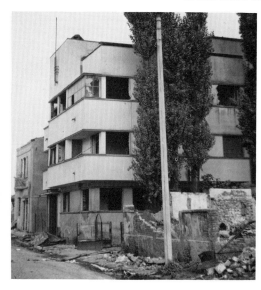

International Style building, 30 Negru Voda Street, during the razing of traditional structures.

An excavator at work; a typical image in the cities, towns and villages of Romania.

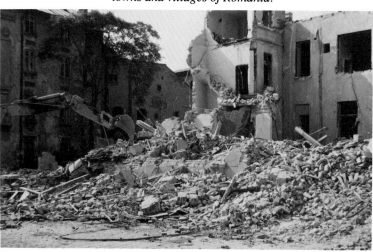

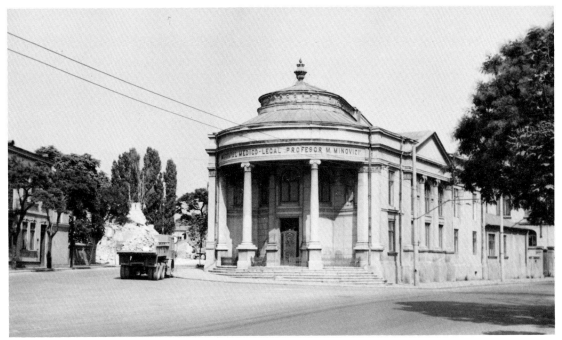

*The Minovici Institute for Forensic Medicine on
Splaiul Unirii and Cauzasi Street. In August 1985,
demolition was carried out throughout the area.*

*By August 1985, the destruction of the front of the
Institute for Forensic Medicine had been com-
pleted. The razing of the chapel and other struc-
tures followed.*

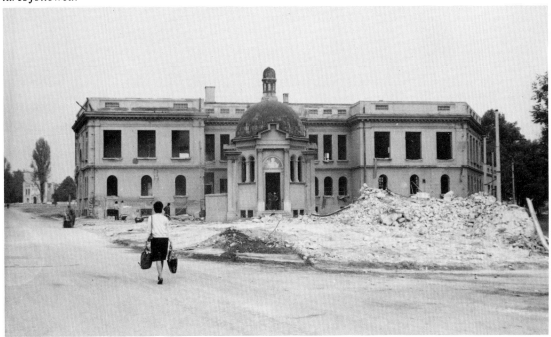

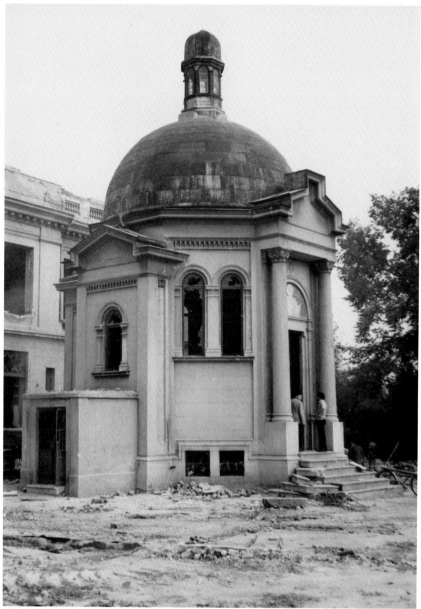

The demolition of the Institute's chapel at the end
of September 1985.

Bucharest

At least 18 Orthodox Churches, among which 5 were listed historic structures, were destroyed in Bucharest to clear the ground for systematization.

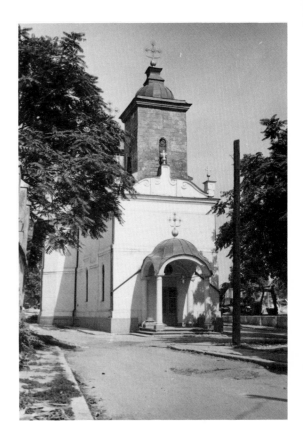

2 Nicolae Popescu-Jitnita Street, Saint Nicholas Jitnita church; built in 1711–1718, restored in 1851 and later. As seen in August 1985.

A view of the same church in September 1985. The surrounding buildings have all been destroyed. The church was leveled August 18–23, 1986.

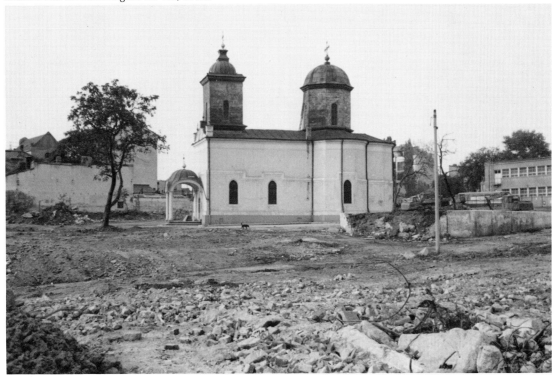

2 Apolodor Street, the Church of Saint Spiridon the Elder (17th century); restored in 1746–1748. A listed historic monument that had been well preserved. On August 26, 1987, the church was destroyed suddenly, within a few hours. By the time word of the demolition had spread, only an empty space remained. (Photo taken in 1986).

33 Olteni Street, the Olteni church (17th century); rebuilt in 1722 and 1863–1865. By September 1985 the razing had advanced as far as Olteni Street. The church disappeared in June 1986.

11 Pitagora Street, Saint Nicholas church; built in the 17th century and restored and renovated several times. The church was razed in September 1985. The photograph was taken in August 1985, while the destruction of the whole of Pitagora Street was underway.

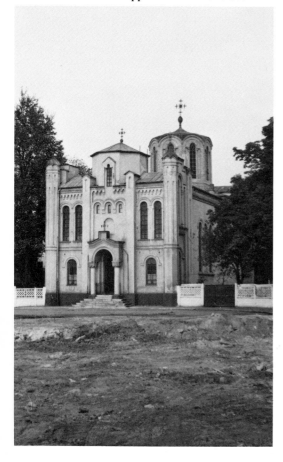

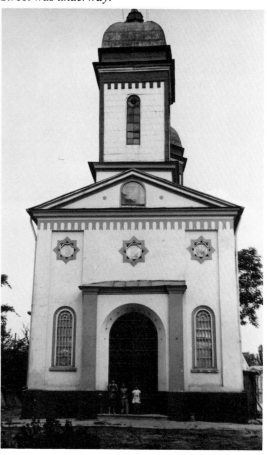

Craiova (Dolj county)

By the mid-1980's, the central zone of Craiova was the only surviving urban center with traditional architecture. Demolition began in 1986 and has continued since. All photographs were taken in August 1986.

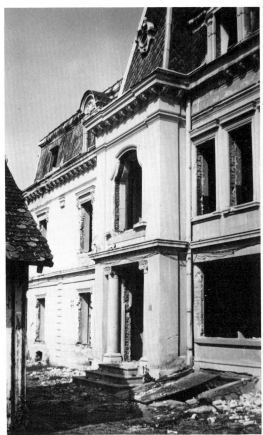

34 Calea Bucuresti, during demolition.

Razing old buildings. In the background on the left, the crane of a new construction site. On the right, the top of an apartment building. In the foreground, single-family dwellings, late 19th-century eclectic style. Considered obsolete and out of scale by the municipal administration, these houses will eventually be torn down.

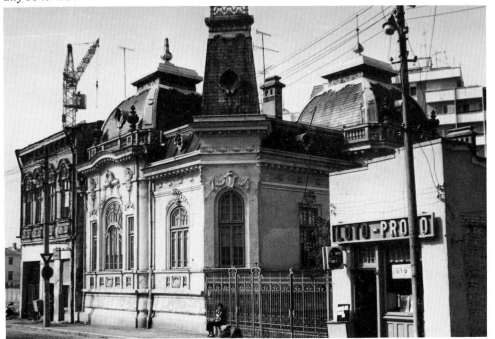

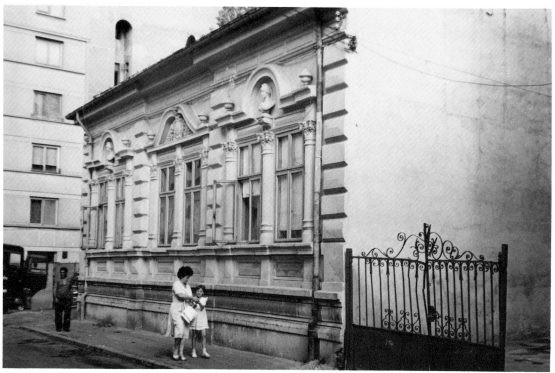

A view of systematization in Craiova: on the right, a single-story residence with an interesting facade; on the left, a standardized tenement building.

The editorial board of the magazine Ramuri *has been working in this neoclassical building surrounded by two apartment buildings. How long will it survive?*

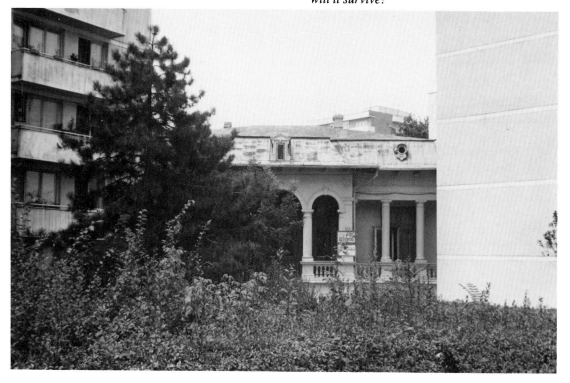

Pitesti (Arges county)

During the 1970's and 1980's, more than 90 percent of the traditional architecture of Pitesti was torn down. In 1985, old buildings remained on some streets of the Tirgu din Vale (Lower Market Town). An appeal for the preservation of this part of the town was published in the magazine *Arges* (Pitesti) in December 1985.

The photographs show two structures on Constantin Brancoveanu and Sfinta Vineri streets during the first phase of demolition. It is not known whether the area still exists in 1989. The photographs were taken in November 1985.

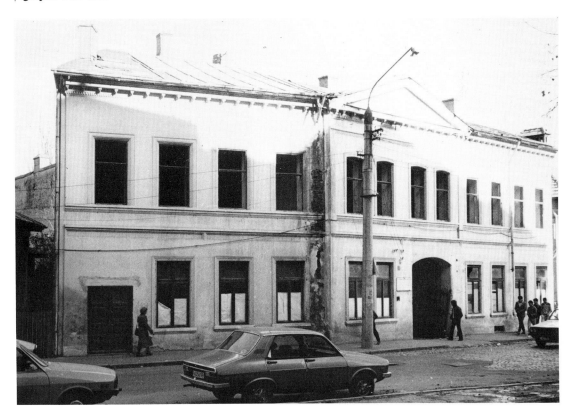

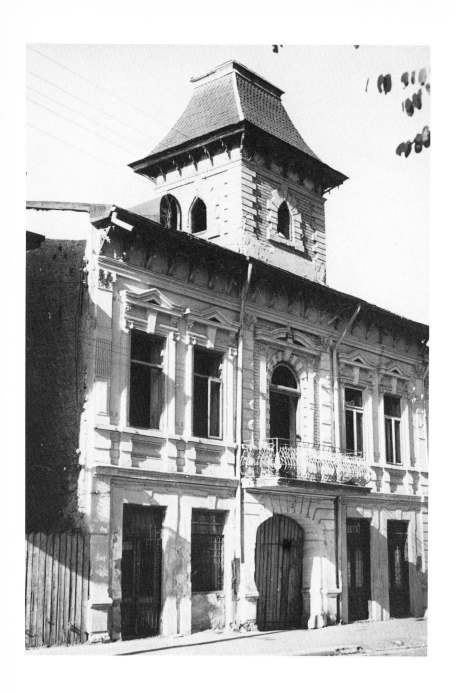

Since the effective dismantling of the Commission for Historic Monuments in November 1977, the number of restoration sites has dropped significantly. The damage inflicted on the architectural heritage through dereliction and neglect increases each year. This process becomes a pretext for tearing down historic monuments, in addition to urban and rural residential structures and sites.

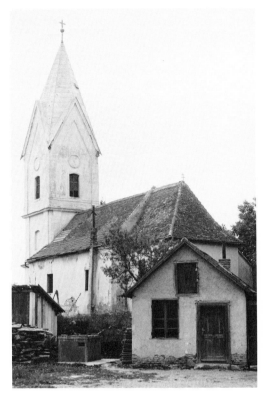

The 14th-century Roman Catholic church in the village of Vlaha (Magyarfenes), Cluj county. (Photos: Gabor Boros)

Gateway to the Banffy castle (17th century, with extensions added after 1750 and in 1850), village of Bontida (Bonchida), Cluj county.

A tower of the Saxon citadel (14th to 17th centuries) at Risnov (Rosenau), Brasov county.

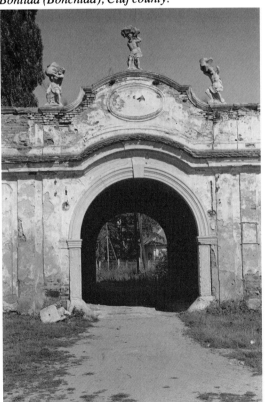

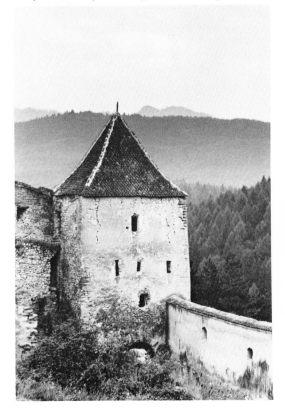

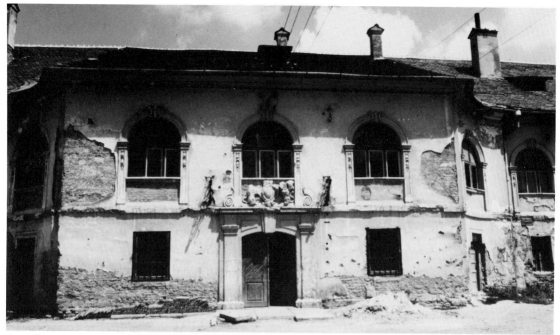

Apor Manor (17th century), town of Alba Iulia (Gyulafehervar), Alba county. (Photos: Oliver A. I. Botar, Jr.)

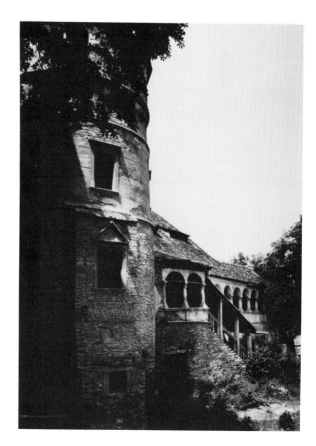

Bethlen castle (16th and 17th centuries) at Cris (Keresd), Mures county. Restoration began here in the 1970's, prior to 1977.

Urban and rural residents receive only short notice that their homes will be destroyed immediately. As systematization proceeds, any structure is at risk at any time. These houses, still standing in Bucharest in 1987, may be destroyed at any time. The photographs were taken in July 1987.

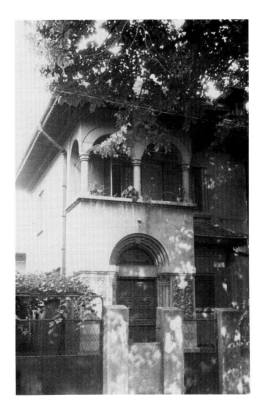

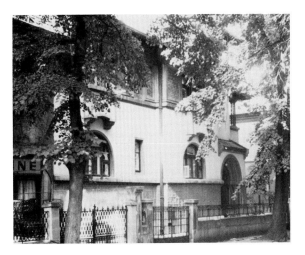

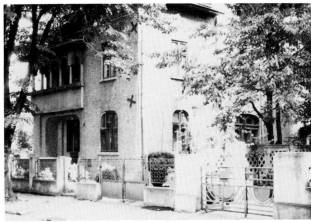

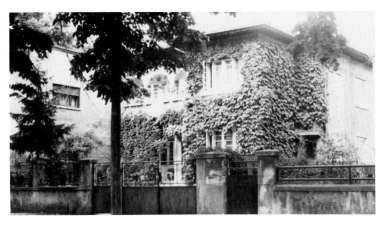

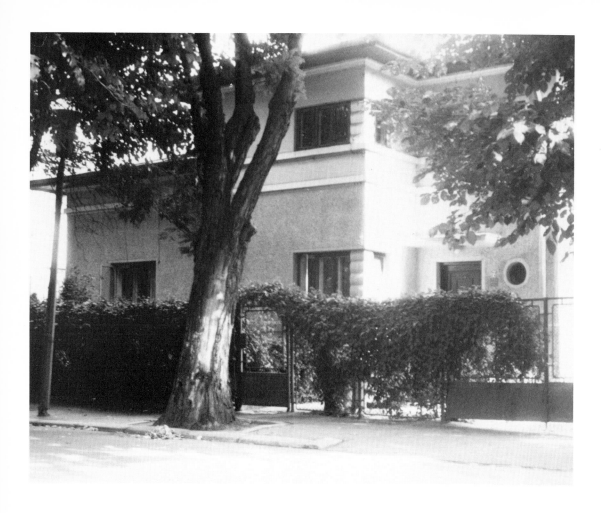

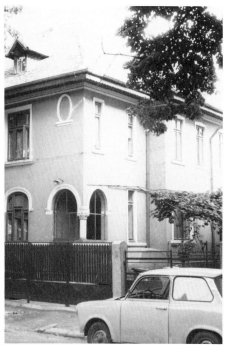

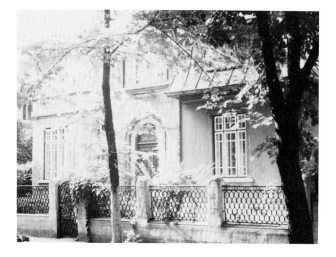

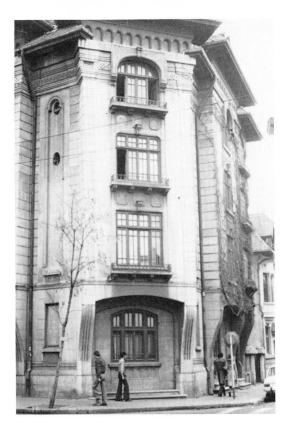

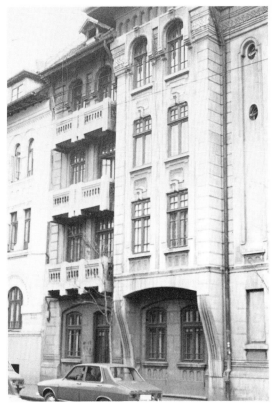

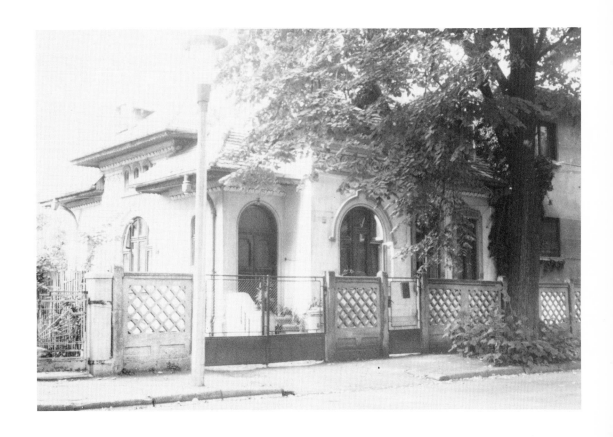

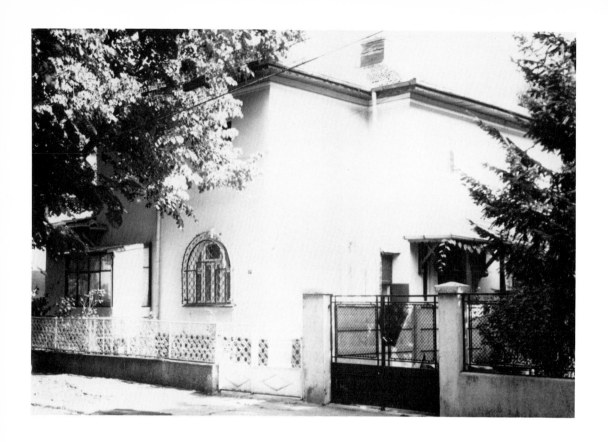

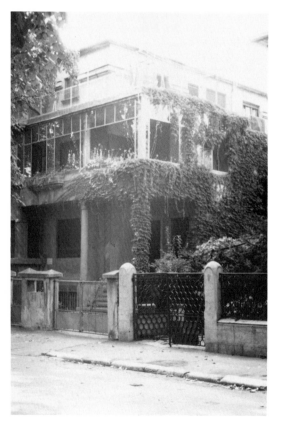

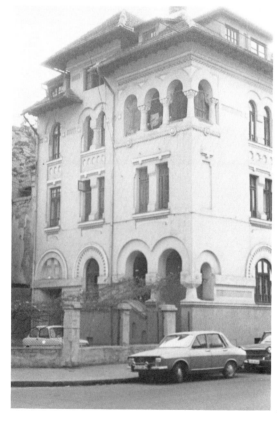

A pervasive feeling of imminent destruction looms throughout Romania. Rumors of future targets for systematization circulate without any means of verification. The unthinkable eventually proves to be true; other reports prove to be false, if only for the time being. In 1987, persistent rumors circulated concerning the demolition of two large churches in Bucharest: Casin (1937–1946), on Marasti Boulevard at the intersection with Casin Street, and the church on Piata Muncii on Mihai Bravu and Muncii boulevards, of a similar architectural style. At the second site, a new subway station was planned. Both buildings appear to have been spared for now.

The church, Casin, in Bucharest.

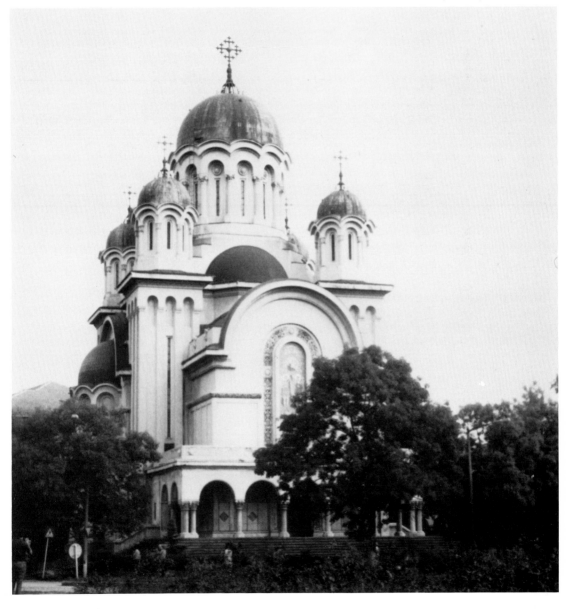

CONCLUSIONS

Everywhere, the development of towns with a gradual renewal of the architecture is in the nature of things. In Romania the situation has taken a different turn.

Systematization means: a) the destruction of the traditional urban constructed area almost in its entirety and its replacement by tenement apartment buildings; and b) the resettlement of the entire rural population of more than 11,000,000 people from privately owned, one-family houses into apartment buildings where they become tenants.

Twenty-nine Romanian towns have already been 85–90 percent razed and rebuilt according to new principles enacted in the name of progress and modernity. In approximately 37 other towns, demolition is going on and the bulldozers are advancing every week. These figures are low estimates.[1]

It has been officially stated that 7,000–8,000 out of 13,123 villages will disappear in the next decade, while the remaining rural sites will be replaced by standardized 4–5 story buildings. Systematization represents a two-fold expropriation: depriving individuals of their property and uprooting an entire nation from its architectural heritage.

Hundreds of thousands of urban property owners have already lost their houses. Millions of peasants face the same fate, as the process gets underway around Bucharest and in other areas.

An entire country, obliged to live in collective dwellings, is subjected to a kind of social engineering never recorded in Europe's history.

For the Romanian nation as for the national minorities living in Romania—Hungarians, Germans, Serbians—the destruction of traditional urban and rural architecture leads to the expropriation of significant parts of history and identity.

The traditional architectural heritage is not negotiable. It must be maintained and preserved. This heritage is an essential condition of the national and European individuality.

Modernity and higher standards of living are not achieved by eliminating the one-family house and an entire historic past.

Modernity and higher standards of living are attained by a rational implementation of contemporary amenities in urban and rural structures as they have evolved over the centuries.

For any or all of the following reasons, professionals and non-professionals share a responsibility in the implementation of this nationwide expropriation and social engineering: the memories of past individual and collective experiences of the late 40's and of the 50's; the fear of losing a job; the social conformism; the selfishness of some individuals eager to keep their positions; the reality of a system in

[1]Large scale demolition is being carried out in the following 37 towns: Tirgu Neamt, Adjud, Panciu, Tirgu Ocna, Buhusi and Odobesti (in Moldavia); Calimanesti, Turnu Severin, Calafat, Caracal, Zimnicea, Alexandria, Turnu Magurele, Rosiorii de Bede, Oltenita and Urziceni (in Wallachia); Hirsova, Babadag, Isaccea and Cernavoda (in Dobrogea); and in Transylvania, Satu Mare, Sighet (Maramarossziget), Zalau, Bistrita (Bistritz), Beclean, Reghin, Miercurea Ciuc (Csikszereda), Dej, Deva, Orastie, Tirnaveni, Aiud, Alba Iulia (Gyulafehervar), Fagaras, Tirgu Mures (Marosvasarhely), Sfintu Gheorghe (Sepsiszentgyorgy) and Odorheiu Secuiesc (Szekelyudvarhely).

In the following urban centers, traditional structures have been demolished: Brasov (Kronstadt), Sibiu (Hermannstadt), Cluj (Koloszvary, Klausenburg), Sighisoara (Schassburg), Sebes (Muhlbach), Timisoara (Temeschwar, Temesvar), Resita, Oradea (Nagyvarad, Grosswardein) and Arad (all in Transylvania); and Radauti and Baia in Moldavia.

which open contest ends in internal or external exile or even prison; the ignorance of the average citizen (many former property owners have signed declarations stating their agreement with the demolition of their houses by the state authority) and the fear and inertia instilled in every citizen.

There is little time left to save significant parts of the capital city, Bucharest; the towns of Transylvania; some remaining urban centers in other historical provinces of Romania and the entire rural heritage.

In this last hour of hope against hope, every personal and institutional contribution is needed and appreciated.

Dinu C. Giurescu

ABOUT THE AUTHOR

Dinu C. Giurescu is a distinguished historian who has published numerous books, articles and reviews on political, economic, cultural and artistic history in Romania and Europe. He has lectured extensively in Eastern and Western Europe. An IREX grant recipient in 1982, 1983 and 1985, Professor Giurescu lectured at universities throughout the United States.

Born in Bucharest in 1927, Dinu Giurescu received both his M.A. and Ph.D. at the Faculty of History at the University of Bucharest where his father and grandfather, prominent historians and members of the Romanian Academy, led distinguished academic careers. Through 1987, Dr. Giurescu taught history of European civilization at the Nicolae Grigorescu Institute of Fine Arts, Bucharest. Previous work includes, from 1964 to 1968, positions as a researcher and lecturer on history of diplomacy and international relations at the Ministry of Foreign Affairs and the Faculty of Juridical Studies, Bucharest and, from 1956 to 1964, Curator of the Art Museum of Romania, Bucharest.

Dinu Giurescu was a member of the Romanian Central Commission of the National Patrimony from 1975 to 1985. Between 1980 and 1985, through numerous articles and interviews, he joined innumerable colleagues in protesting the destruction of historic monuments and indigenous architecture that has become official state policy.

On April 12, 1988, Dinu Giurescu and his wife with their younger daughter were admitted to the United States as refugees, joining their elder daughter. The Giurescus presently reside in New York City.